THE TAIZÉ
PICTURE BIBLE

THE TAIZÉ

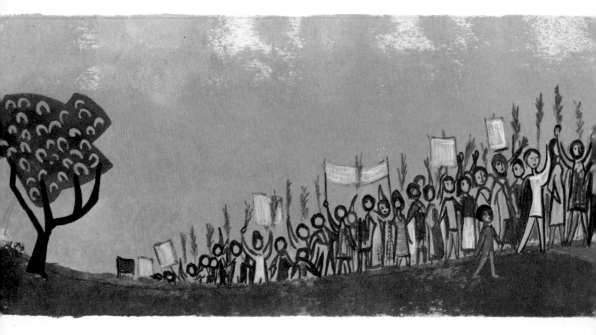

FORTRESS PRESS Philadelphia

Stories from the Scriptures, adapted from the text of The Jerusalem Bible
with illustrations by Brother Eric de Saussure of the Taizé Community

PICTURE BIBLE

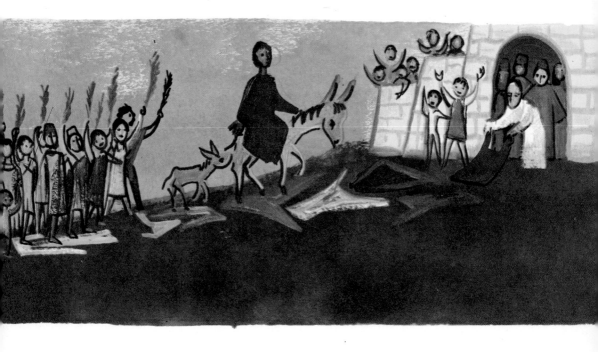

NOTE TO AMERICAN READERS

The guiding editorial policy in this adaptation has been to facilitate understanding by readers of many age levels while remaining faithful to the words and meaning of the Biblical text. The requirements of cooperative international publication have curtailed the number of special alterations which might otherwise have been made in the American edition. It is the hope and belief of the publisher, however, that—as with *The Jerusalem Bible* itself—the general clarity, simplicity, and accuracy of this adaptation compensate for occasional unfamiliar usages in punctuation and spelling.

Text © 1968 by Darton, Longman & Todd, Ltd., based on the text of *The Jerusalem Bible*,©1966 by Darton, Longman & Todd, Ltd. and Doubleday & Company, Inc. Used by permission of the publishers.

This book is published in Great Britain under the title *Bible Stories for Children*.

Fourth Fortress Press edition 1978

Library of Congress Catalog Card Number: 69–11860

ISBN 0–8006–0005–3

CONTENTS

From the New Testament

FROM THE
OLD TESTAMENT

GOD MAKES THE EARTH

In the beginning God made the heavens and the earth. The earth had no shape and there was nothing, only darkness. But God's spirit was there.

God said, 'Let there be light', and there was light. God saw that light was good, so he divided light from darkness. God called light 'day', and he called darkness 'night'. Evening came and morning came: that was the first day.

God said, 'Let there be a dome in the waters to separate them.' And so it was. God made the dome, and it divided the waters above the dome from the waters under the dome. God called the dome the 'heavens'. Evening came and morning came: that was the second day.

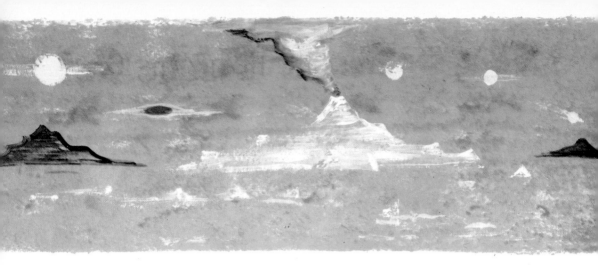

God said, 'Let the waters under the heavens come together into a single mass, and let dry land appear.' And so it was. God called the dry land 'earth' and he called the mass of waters 'seas'; and God looked at what he had made, and saw that it was good.

God said, 'Let the earth produce plants of every kind, those that have seed outside and those that have seed within their fruit.' And so it was. The earth produced a great many different plants of both kinds. God looked at what he had made, and saw that it was good. Evening came and morning came: that was the third day.

God said, 'Let there be lights in the dome of the heavens to divide day from night, and let them mark out days and years. Let there be lights in the dome of the heavens to shine on the earth.' And so it was.

God made the two great lights; the brighter one to shine

in the day, the smaller one to shine in the night; and God also made the stars. God set them in the dome of the heavens to shine on the earth, to govern the day and the night and to divide light from darkness. God looked at what he had made, and saw that it was good. Evening came and morning came: that was the fourth day.

God said, 'Let the waters be full of living creatures, and let birds fly above the earth within the dome of the heavens.' And so it was. God created great sea-serpents and every kind of living creature with which the waters are filled, and every kind of winged creature. God looked at what he had made, and saw that it was good.

God blessed all these creatures living in the waters, saying, 'Be fruitful, increase in numbers, and fill the waters of the seas; and let the birds increase in numbers upon the earth.' Evening came and morning came: that was the fifth

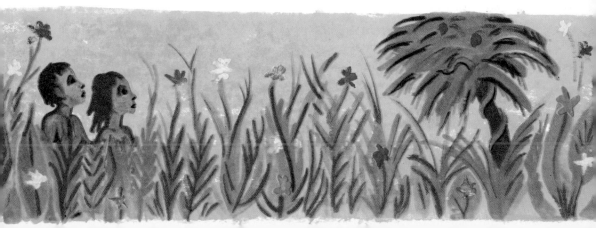

day.

God said, 'Let the earth produce every kind of creature that lives on land: cattle, reptiles, and every kind of wild beast.' And so it was. God made every kind of wild beast, every kind of cattle, and every kind of land reptile. God looked at what he had made, and saw that it was good.

God blessed all these creatures living on land, saying, 'Be fruitful, increase in numbers, and fill the land of the earth.'

Then God said, 'Let us make man in our own image, in the likeness of ourselves, and let man be master of the fish of the sea, master of the birds in the heavens, master of the cattle, and master of all the wild beasts and all the reptiles that crawl upon the earth.' So God made man in the image of himself, he made him in the image of God, and he made both male and female.

God blessed man, saying, 'Be fruitful, increase in numbers, fill the earth and conquer it. Be master of the fish of the sea, master of the birds in the heavens, and master of all living animals on the earth.' And God said to man, 'See, I give you all the fruit which has seeds inside it; this is to be your food. To all wild beasts, all birds in the heavens, and all living reptiles on the earth I give all the leaves of plants for food.' And so it was. God looked at all that he had made, and he saw that it was very good indeed. Evening came and morning came: that was the sixth day.

The heavens and the earth were now complete in all their magnificence, so by the seventh day God had finished the work he had been doing. God rested on the seventh day after all the work he had been doing, and he blessed the seventh day and made it a holy day, because on that day he rested after all his work of creating.

This is the story of the beginnings of the heavens and the earth when God created them out of nothing.

GOD MAKES MAN

At the time when God made earth and heaven there were no bushes or plants of any kind on the earth, for God had not sent rain, and there was no man to work the earth. A flood began to rise from the earth and to soften and seep through all the surface of the soil. God made man from the earth. Then he breathed life into his nostrils, and so man became a living creature.

God planted a garden in Eden which is in the east, and there he put the man he had made. Then God caused every kind of tree to spring up from the soil, pleasing to look at and with good fruit. In the middle of the garden grew the tree of life and the tree of knowledge of good and evil. A river flowed from Eden to water the garden, and then it divided to make four streams. The first is named the Pishon, and this encircles the whole land of Havilah where the purest gold is found. Other precious stones are found there also. The second river is named Gihon, and this encircles the whole land of Cush. The third river is named the Tigris. The fourth river is named the Euphrates. God settled the man in the garden of Eden to cultivate and take care of it. Then God gave the man this warning, 'You may eat from all the trees in the garden except the tree of knowledge of good and evil. You are not to eat the fruit of that tree, for on the day when you do, you will most surely die.'

God said, 'It is not good that the man should be alone. I will make other living things to keep him company. So from the earth God made all the wild beasts and all the birds of the air. He brought these to the man to see what he would call them. The man gave names to all the cattle, the birds of the air and the wild beasts. But in spite of all the animals, the man was still lonely, for they were not real companions for him. So

God made the man fall into a deep sleep and took one of the man's ribs and covered it in flesh. God built this rib into a woman, and brought her to the man. The man exclaimed: 'This at last is bone from my bones, and flesh from my flesh! This is to be called woman, because she was taken from man.'

That is why a man leaves his father and mother and lives with his wife, and the two become one.

Now both of them were naked, the man and the woman, but they felt no shame in front of each other.

MAN DISOBEYS GOD

The man and the woman whom God had made were living in the garden of Eden where God had put them. For food they used the plants and the fruits of the trees which God had provided for them. They were living as God had always meant them to live.

Now among the many creatures living in the garden with the man and the woman, there was the serpent. The serpent was the most cunning of all the wild beasts that God had made. It came to the woman and asked her, 'Did God really say you were not to eat from any of the trees in the garden?' The woman answered the serpent, 'No. We may eat the fruit of all the trees in the garden, except the fruit of that tree in the middle. God warned us about it and said, "You must not eat it, nor touch it, on pain of death." ' Then the serpent said to the woman, 'No! You will not die! God knows very well that on the day you eat it your eyes will at once be

opened and you will become like gods, knowing good and evil.'

The woman saw that the fruit of this tree looked pleasing and good to eat, and she began to want it very much for the knowledge that it could give. So she took some of its fruit and ate it. She gave some to her husband who was with her, and he ate it too. Then they began to understand many new things and they knew good and evil. They realised that they were naked and for the first time they felt ashamed of this; so they sewed fig-leaves together and put them on to cover up their nakedness.

In the cool evening of the day the man and his wife heard God walking in the garden, and they hid from God among the trees of the garden. But God called to the man, 'Where are you?' The man replied, 'I heard the sound of you in the garden, and I was afraid because I was naked, so I hid.' God asked him, 'Who told you that you were naked? Have you been eating the fruit of the tree I told you not to eat?' The man replied, 'It was the woman you put with me; she gave me the fruit, and I ate it.' Then God asked the woman, 'What is this you have done?' The woman replied, 'The serpent tempted me and I ate the fruit.'

Then God said to the serpent, 'Because you have done this, you shall be cursed more than all cattle and all wild beasts. You shall crawl on your skin and eat dust every day of your life. I will make you and the woman enemies of each other, and your offspring and her offspring too. Hers will crush your head, and yours will strike their heel.'

God said to the woman, 'You shall suffer pain when your children are born. And in spite of all the love you have for your husband, it is he who will have the power over you.'

God said to the man, 'Because you listened to the voice of your wife and ate the fruit from the tree I told you not

to eat, the ground is cursed because of you. Every day of your life you shall get your food from the ground with toil and trouble. It will grow brambles and thistles, and you will eat wild plants. You will eat your bread with sweat still running down your brow, until you die and you yourself turn into earth again, the earth from which I made you. For you are only dust and in the end you shall turn into dust again.'

The man named his wife 'Eve' because she was the mother of all people born. God made clothes out of skins for the man and his wife, and they put them on. Then God said, 'See, with this knowledge of good and evil the man has become like one of us. Next he will stretch out his hand and eat the fruit from the tree of life and be able to live for ever. He must not be allowed to do this.' So God drove the man out of the garden of Eden, to plough the earth from which God had made him. To protect the way to the tree of life, God posted angel guardians and a flashing sword of flame in front of the garden of Eden.

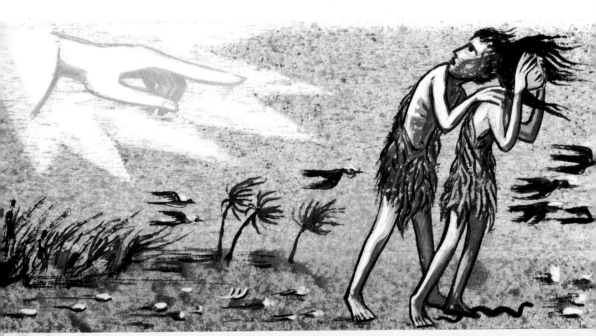

CAIN AND ABEL

In time Eve gave birth to a son, and she and Adam named him Cain. Eve cried out with joy, 'With the help of the Lord I have gained a new man.' Later still, she gave birth to a second child, and they called him Abel. The boys grew up together and Abel became a shepherd and kept flocks. Cain ploughed to grow crops. After quite a long time had passed Cain brought some of his crops as an offering for God. Abel also brought an offering of the first-born of his flock and some pieces of their fat. God was pleased with Abel and his offering, but he was not pleased with the one brought by Cain.

Cain was very angry and it showed in his face. God asked Cain, 'Why are you angry like this? Why all these black looks? If you mean well, you should hold your head high. But if you have bad feelings, it is because evil is lying in wait to catch you, and then you must overcome it.' But Cain shut his mind to God and said to Abel, 'Let us go out into the fields.' So they went, and in the open country Cain attacked his brother and killed him.

God asked Cain, 'Where is your brother Abel?' Cain answered, 'I do not know. Am I supposed to look after my brother all the time?' God replied, 'What have you done? I saw your brother's blood on the ground and I know very well that your brother is dead. Now a curse be on you. You shall be driven away from the ground that has soaked up your brother's blood. When you till the ground it shall no longer grow anything for you. You shall be a wanderer over the earth, for ever fleeing from one place to the next.'

Then Cain said to God, 'My punishment is greater than I can bear. Look, today you are driving me from my ground and banishing me from your sight; you are turning me into

a wanderer for ever fleeing from one place to another over the earth. Why, whoever comes across me will kill me!' 'Very well, then;' God replied 'if anyone kills Cain, seven-fold revenge shall be taken for him.' So God put a mark on Cain for all to see, to prevent anyone who might meet him from striking him down. Then Cain cut himself off from God and went away and settled in the land of Nod, east of Eden.

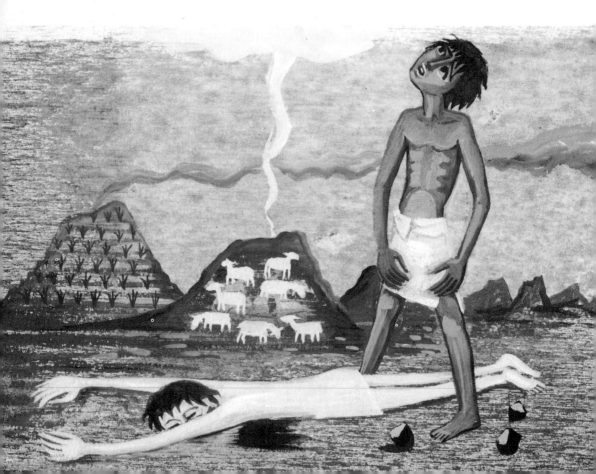

THE FLOOD

When man had been on the earth for a long time after God had created him, and when man had increased greatly in numbers, God looked at the earth and saw that the wickedness of man was great, and that in his thoughts he planned nothing but wickedness all day long. God was sorry that he had ever made man on the earth, and his heart was saddened. God said, 'I will get rid of man from the face of the earth, even though I made him; and I will get rid of the animals and the reptiles also, and the birds in the heavens. For I am sorry I ever made them.'

Now at this time there lived a man called Noah and he was six hundred years old. He had three sons: Shem, Ham, and Japheth, and among all the people then living he was known as a good honest man who obeyed God's will.

God was pleased with Noah and one day he said to him, 'I have decided to make an end of all living things, because the earth is full of violence caused by man. I am going to wipe them all out from the earth. Build yourself an ark out of the wood which has the sticky resin in it. Finish the upper parts with reeds and line it inside and out with tar. The length of the ark is to be four hundred and fifty feet, and it is to be seventy-five feet wide and forty-five feet high. Make a first, a second and a third deck in the ark, and make a roof over it, and put the door of the ark high up in the side.

'I am going to send a flood of water over the earth to destroy every living creature under the heavens; everything on earth shall perish. But I will make you a promise. You must go on board the ark, you, your sons, your wife, and your sons' wives as well. You must take on board with you two of every kind of living creature on land, a male and a female, two of every kind of bird, two of every kind of

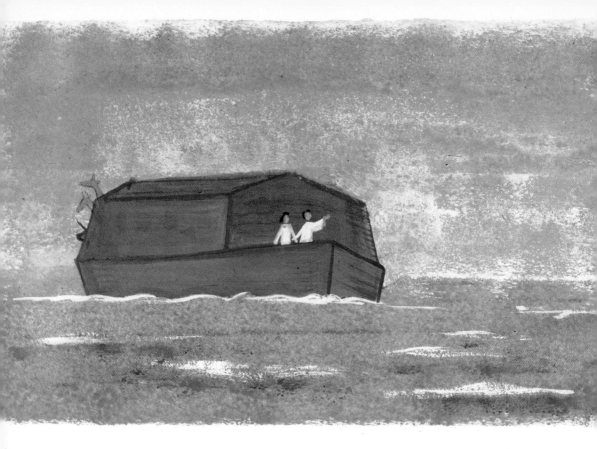

animal and two of every kind of reptile living on the land,
so that their lives may be saved with yours. Provide yourself
with all kinds of things to eat, and lay in a store of them to
serve as food for yourself and the animals.' Noah got
everything ready, just as God had ordered him to.

Then God said to Noah, 'Now go aboard the ark with all
your household. In my judgement you are the only good
man among all those now living. In seven days' time I am
going to make it rain on the earth for forty days and forty
nights, and I am going to wipe out from the earth every
living thing that I made.'

That very day Noah and his sons Shem, Ham and Japheth
boarded the ark, with Noah's wife and the three wives of
his sons. With them went in one pair, male and female, of
wild beasts of every kind, cattle of every kind, reptiles of
every kind that crawls on the earth, birds of every kind, all

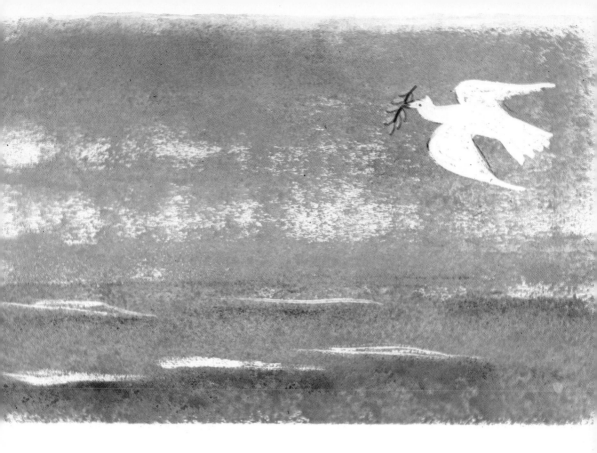

that flies, everything with wings, just as God had ordered.

When everyone and all creatures had entered the ark, God closed the door behind Noah. Seven days later the rain began. On that day all the springs of the great deep sea broke through, and the flood-gates of the heavens opened, and it rained on the earth for forty days and forty nights. The waters rose, lifting the ark until it floated free and sailed along on the flood-waters.

The water went on rising and rising until all the highest mountains were covered with more than twenty feet of water. So all things living and breathing on dry land perished: birds, cattle, wild beasts, everything that swarms on the earth, and every man. God destroyed every living thing on the face of the earth. He got rid of them, so that only Noah was left and those with him in the ark.

But God kept Noah in mind and all the creatures that

were with him. After the waters had covered the earth for a hundred and fifty days, God sent a wind across the earth and the springs of the great deep sea and the flood-gates of the heavens closed and the rain stopped. Gradually the waters began to sink, and in the seventh month of the year the ark came to rest on the mountains of Ararat. For another three months the water went on gradually draining away until on the first day of the tenth month of the year the mountain peaks appeared again.

After another forty days Noah opened the porthole in the ark and set free a raven. It went off and flew back and forth as the waters slowly sank. Then Noah sent out a dove, to see whether any dry land was yet uncovered. The dove found nowhere to perch because there was still water over the whole surface of the earth, so it returned to the ark and Noah put out his hand, took hold of the dove and brought it back into the ark again. After waiting another seven days, Noah again sent out the dove. In the evening it came back to him with an olive twig in its beak. So Noah knew that the waters had uncovered some dry land. After yet another seven days he sent out the dove a third time and it did not return.

At the beginning of the first month of the next year, when Noah was six hundred and one years old, he lifted back the hatch of the ark and looked out. The ground on the mountain around the ark was dry! During the next month after that, the whole earth had dried out thoroughly.

Then God said to Noah, 'Come out of the ark, you, your wife, your sons, and your sons' wives, and all the animals, birds and reptiles. Set them free to be fruitful and increase and cover the earth.' So they all came out one after another.

Noah built an altar for God and he offered sacrifices there. God was pleased with this and said to himself, 'Never

again will I curse the earth just because man does evil right from his childhood. Never again will I strike down every living thing as I have done this time. Sowing and reaping, cold and heat, summer and winter, day and night, these shall never cease as long as the earth lasts.'

God blessed Noah and his sons and said, 'Increase and fill the earth. Rule all the wild beasts, all the birds, everything that crawls on the ground and all the fish of the sea. They are handed over to you. Every living and crawling thing shall provide food for you, as well as the leaves of plants. I give you everything, with this exception: you must not eat flesh with blood in it. And you must not shed man's blood; whoever sheds man's blood, shall in turn have his blood shed by man, for man was made in the image of God. Now increase, fill the earth, and rule over it.'

God also said to Noah and his sons, 'See, I make this Covenant, this Promise, for you, for your descendants, and for every living creature to be found with you, birds, cattle and every wild beast that came out of the ark with you and lives on the earth. I promise that no living thing shall be swept away again by the waters of the flood. There shall be no flood to destroy the earth again.

'And here is the sign of this Covenant that I have established for all generations between myself and every living thing that is found on the earth: I will set my bow in the clouds. When I gather the clouds over the earth and the rainbow appears, I shall see it and remember the Covenant. And so the waters shall never again become a flood to destroy all living things.'

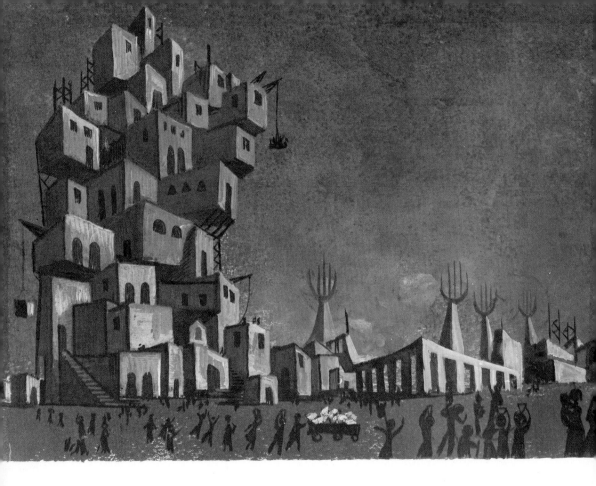

THE TOWER OF BABEL

After the flood had ended, the sons of Noah's sons, and their
sons too, increased greatly in numbers and began to spread
out over the earth. And all these grew into tribes and nations,
and the tribes and nations spread out to the north, to the
east, to the south, and to the west towards the Great Sea and
its islands. At that time men everywhere spoke the same
language and used the same words.

When some of the tribes were moving eastwards they
came to a plain in the land of Shinar and settled there. They
said to one another, 'Come, let us make bricks and bake
them in the fire and build ourselves a town.' They used

bricks instead of stone, and for mortar they used thick tar. Then they said, 'Come, let us build a great tower so high that its top reaches the heavens. In this way we can make ourselves famous.'

Now God came to see the town and the tower that the descendants of Noah had built. God said, 'This is only the start of their doings! Soon, nothing will be too difficult for them. So they are all one people with one language, are they! I will go and confuse their language at once, so that they will no longer understand one another.' So, by confusing their language, God stopped them building the town and scattered them over the whole face of the earth. That is why the place was named Babel.

GOD ASKS THE HELP OF ABRAHAM

Abraham had two brothers, Nahor and Haran, and he was a son of Terah who was a descendant of Shem, one of Noah's sons. All Abraham's family lived in Ur in the country of the Chaldaean people. Abraham's wife was called Sarah and she was very beautiful. After a time, Terah decided that the family should move to the country of the Canaanites, but on the way they settled in the town of Haran instead. There Terah died. At Haran God said to Abraham, 'Leave your country, the rest of your family and your father's house, and go to another land which I will show you. I will make your children into a great nation; I will bless you and make your name so famous that it will be used as a blessing. I will bless those who bless you: I will curse those who speak against you. All the tribes of the earth shall bless themselves by you.'

So Abraham did as God told him. He was seventy-five years old. He took with him his wife Sarah, his nephew Lot, their people and all the servants and possessions they had collected during their stay at Haran, and they made their way to the land of Canaan. It was still occupied by the Canaanites and Abraham travelled through it as far as Shechem's holy place, the Oak of Moreh. There God appeared to Abraham and said, 'I will give this land to your descendants.' So Abraham built an altar there for God. Then he moved on to the mountainous district east of Bethel, and from there on again southwards, stage by stage, to the Negeb. Lot remained with him all the way.

THE PARTING OF ABRAHAM AND LOT

When Abraham and Lot and their families were living in the Negeb, a severe famine came over the land, so they moved down into Egypt. Just before they arrived, Abraham said to his wife Sarah, 'Listen! You are a beautiful woman. When the Egyptians see you they will very likely kill me in order to take you for themselves. So tell them you are my sister, then they may spare my life because they think so well of you.' It turned out just as Abraham had said. Pharaoh's officials were loud in their praises of Sarah's beauty, so Pharaoh had her brought to his court and made her one of his wives. He also treated Abraham well because of her and gave him many rich gifts. But the Lord sent severe plagues on Pharaoh and his household because of Sarah, and Pharaoh learned that Sarah was Abraham's wife. So he summoned Abraham and said, 'Why did you not tell me that she was

your wife? Why did you say she was your sister, so that I took her for my wife? Now, here is your wife. Take her and go!' Pharaoh then sent Abraham away under an escort of men to make sure he left the country.

From Egypt Abraham returned to the Negeb and then by stages to Bethel again, and there he prayed to the Lord.

Lot, who was still with Abraham, had flocks and cattle and tents of his own, and there was not enough land for both to live in the same place. Quarrels broke out between their herdsmen. So Abraham said to Lot, 'There must be no quarrels between us. Is not the whole land spread out before you? Let us separate: if you go off to the left, I will go right; if you take the right, I will go left.' Lot looked out over the well watered, rich land of the Jordan plain and chose it for himself. He moved off eastwards and settled among the towns of the plain, pitching his tents on the outskirts of Sodom. Abraham settled in the land of Canaan.

After Lot had gone the Lord said to Abraham, 'I will give all the land within sight to you and your descendants for ever. I will make your people as many as the specks of dust on the ground; when men succeed in counting the specks of dust, then they will be able to count your descendants! Go, travel throughout the land, for I am going to give it to you.' So Abraham pitched his tents at the Oak of Mamre at Hebron, and he built an altar there to the Lord. Later God spoke to Abraham in a vision. 'Have no fear, Abraham,' he said 'I am your protector; your reward will be very great.'

'My Lord God,' Abraham replied 'what do you intend to give me? I am childless. Some man of my household will be my heir.' Then God spoke to him, 'Not just any man shall be your heir; your heir shall be of your own flesh and blood.' Then taking Abraham outside the tent God said, 'Look up to heaven and count the stars if you can. Your descendants will

be as many.' Abraham decided to trust in God, and God said to him, 'I am your God, the Lord, who brought you out of Ur to make you heir to this land.'

GOD VISITS ABRAHAM

While Abraham was living at the Oak of Mamre, God said to him, 'I will bless your wife Sarah and give you a son by her. Nations and kings will descend from her.' Abraham bowed to the ground, and he laughed as he thought to himself, 'A child to be born to a man a hundred years old, and Sarah to become a mother at the age of ninety!' And he said to God, 'But there is Ishmael, my son by Hagar the slave-girl my wife gave me to bear me a son for her.' But God replied, 'No, your wife Sarah will bear you a son whom you are to call Isaac, at this time next year. It is with him

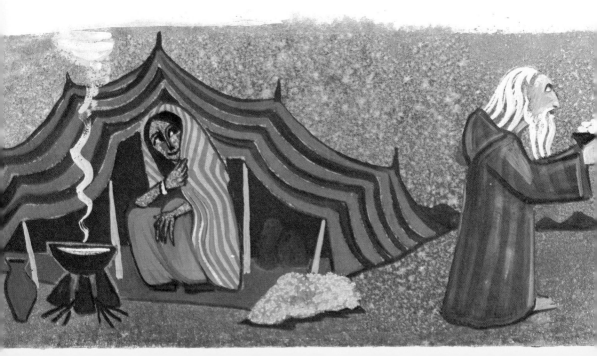

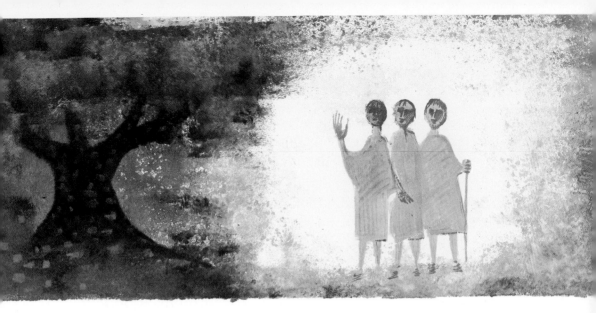

that I will make my Covenant for ever. I will bless Ishmael
too and make him fruitful, and his descendants shall become
a great nation. But I will make my Covenant with Isaac.'
Later God came to visit Abraham while he was sitting inside
the entrance to his tent at the Oak of Mamre during the
hottest part of the day. When Abraham looked up, he saw
three men standing nearby. He bowed to greet them. 'My
lords,' he said 'I beg you, do not pass me by. Water shall be
brought, and you can wash your feet and lie down under the
tree. Let me fetch some bread and you can eat before going
on your way.' The three men replied, 'Do as you say.'

Abraham hastened to find Sarah. 'Hurry,' he said 'knead
three bushels of flour and make loaves.' Then running to the
cattle Abraham took a fine and tender calf and gave it to a
servant to prepare quickly. When the calf was ready, he laid
it before the visitors with cream and milk, and they ate.

'Where is your wife Sarah?' the men asked him. 'She is in
the tent' he replied. Then one of them said, 'I shall visit you
again next year and when I come, your wife will have a son.'

Now Sarah had been listening to all this from inside the
tent, and she laughed to herself, thinking, 'Now that I am

past the age for having children and my husband is an old man, surely I shall not have this kind of delight again!' But God asked Abraham, 'Why did Sarah laugh and say, "Am I really going to have a child, now that I am so old?" Is anything beyond the power of God? Remember, at the same time next year I shall visit you again and Sarah will have a son.' 'I did not laugh' Sarah said, lying because she was afraid. But he replied, 'Oh yes, you did.'

Then the men left and Abraham accompanied them to show them the way until they came within sight of Sodom.

ABRAHAM PLEADS FOR SODOM

At his tent by the Oak of Mamre, Abraham had received three mysterious visitors, and one had said that his wife Sarah would have a son although she was ninety. Abraham had begun to suspect that the visitors were God's messengers and that one of them might even be God himself. As was the custom, Abraham was walking with his guests a little way on the next stage of their journey to the town of Sodom.

As they walked along, God was thinking to himself, 'Since I have picked out Abraham to show the way of the Lord by just and honest living, and since his descendants will grow into a great nation and all other nations of the earth will bless themselves by him, ought I to hide from him what I am going to do to the town of Sodom? I will carry out my promise to Abraham in this way.' Then God said to Abraham, 'What a great outcry there is among all people against those towns Sodom and Gomorrah! How terribly wicked the people in them are! I am going to visit them to

see whether they have done all that is said about them. I am determined to know the truth.'

At this point two of the three men went on to Sodom, and Abraham waited in the presence of God. Abraham went up to God and said, 'Are you really going to wipe out the whole town and destroy the good man with the sinner? There may be fifty good men in the town. Will you really destroy them? Will you not spare the town because of the fifty good men in it? You must not even think of doing such a thing! Kill the good man along with the sinner, and treat the good and the sinner in exactly the same way—you must not even think of it! You are judge of the whole earth. Will you not see that justice is done?' God replied, 'If I find fifty good men in Sodom, I will spare the whole town because of them.'

Abraham said, 'I am very bold to speak like this to my Lord God, I who am only dust and ashes. But perhaps the good men may be five short of fifty: will you destroy the whole city for the lack of five?' 'No,' God replied 'I will not destroy it if I find forty-five good men.' Again Abraham said to him, 'Perhaps there will only be forty good men?' 'I will not do it' God replied 'even if there are only forty.'

Abraham said, 'I trust my Lord God will not be angry, but allow me to say this: perhaps there will only be thirty good men there?' 'No, God replied 'I will not do it if I find thirty good men there.' Again Abraham spoke, 'I am bold indeed to speak like this, but perhaps there be only twenty good men there?' 'For the sake of those twenty,' said God 'I will not destroy the town.' Abraham persisted, 'I trust my Lord God will not be angry if I speak once more: perhaps there will only be ten?' God promised, 'For the sake of the ten good men, I will not destroy Sodom.' When he had finished talking to Abraham, God went away, and Abraham returned home.

THE DESTRUCTION OF SODOM AND GOMORRAH

The two travellers who had been Abraham's guests at the Oak of Mamre, and who were really God's messengers, left Abraham standing in the presence of God and went on their way. They reached Sodom in the evening and found Lot sitting at the gate of the town. As soon as Lot saw them he rose to meet them and bowed to the ground. 'I beg you, my lords,' he said 'please come down to your servant's house to stay the night and wash your feet. Then in the morning you can continue your journey.' 'No,' they replied 'we can spend the night in the open street.' But he begged them so hard that they went home with him. They had not yet gone to bed when the house was surrounded by all the men of the town, both young and old. They called out to Lot, 'Where are the men who came to you tonight? Send them out to us so that we may have our way with them.'

Lot went to meet them outside, and after closing the door behind him he said to them, 'I beg you, my friends, do no such wicked thing. Listen, I have two daughters and I am ready to hand them over to you, if I must. But these two men are my guests, so by strict custom it is impossible for me to betray them to you.' But the men of the town replied angrily, 'Get out of the way! You, who came to us as a foreigner, do you really think you can set yourself up as our judge! We'll certainly give you an even worse time than those other two.' And they forced Lot back and moved forward to break down the door. But the two messengers reached out through the door, pulled Lot back into the house, and shut the door. Then they struck blind every man in the crowd outside the house.

The two messengers said to Lot, 'Collect your sons, your daughters, all your people in the town, and take them away.

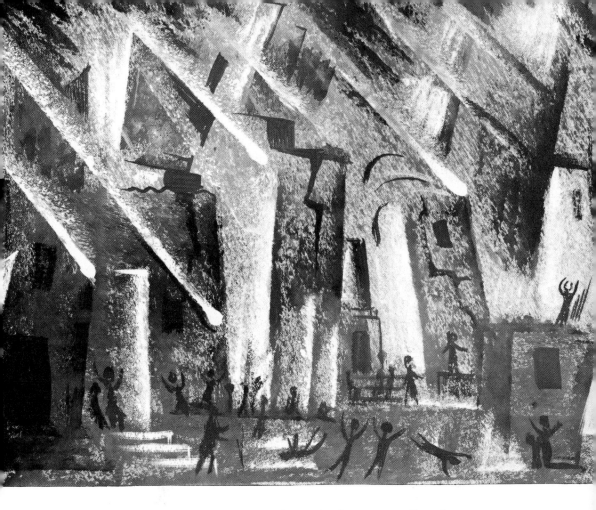

We are about to destroy the whole town, for the outcry against its people has reached the ears of God. The Lord has sent us to destroy them.' Lot went to tell the two men who were going to marry his daughters; but they thought he was joking and would not believe him.

When dawn came the messengers urged Lot, 'Come, take your wife and daughters and get away, or you will all be destroyed.' But Lot could not make up his mind about going. Then, because God felt pity for him, the two messengers took him and his wife and two daughters by the hand and led them away and left them outside the town.

As they were leading Lot away, one of the messengers warned him, 'Run for your life. Do not look behind you or

stop anywhere on the plain. Make for the hills if you do not want to be destroyed.' Lot said, 'No, I beg you, my lord; no doubt you wish me well, but I would get caught by the destruction and die before I could ever reach the hills. That town over there is near enough to reach. Let me make for that. It is only a little one, and you could spare it and save my life.' The messenger answered, 'I will grant you this request, and I will not destroy that little town. But hurry, escape to it now, for I can do nothing until you reach it.'

As the sun rose and Lot entered Zoar, God rained fire and brimstone on Sodom and Gomorrah. He destroyed these towns and the whole plain, with all the people and everything that grew there. Now Lot's wife did not obey the messenger's warning and she looked back at the destruction. Immediately she was turned into a pillar of solid salt.

Early in the morning Abraham got up from his tent at the Oak of Mamre and went to the place where he had stood in the presence of God the day before. He looked towards Sodom and Gomorrah across the plain and saw smoke rising from the whole country, as if from a furnace. Lot was afraid to stay in Zoar, so he left and settled in the hill country and made his home there in a cave with his two daughters.

In this way God kept his promise to protect Abraham, and he rescued Lot from destruction as well.

ABRAHAM IS WILLING TO SACRIFICE ISAAC

After Abraham had seen the destruction of Sodom and Gomorrah and the other towns in the plain, he left the region for the land of the Negeb and settled for the time being at Gerar in the country of the Philistines. Again he told his

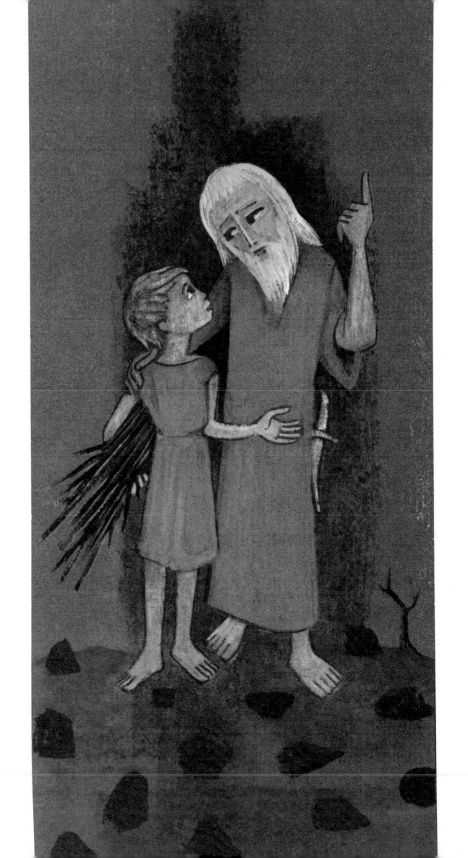

wife Sarah to say she was his sister; and Abimelech who ruled there took her to make her his wife. But God showed him his mistake in a dream, so he gave Sarah back to Abraham and gave him many rich presents as well, and said to him, 'See, my land lies before you. Settle where you please.'

God kept his promise and a son was born to Sarah, named Isaac. When he was old enough to stop feeding from his mother, Abraham gave a great feast, and at the feast Sarah noticed that Isaac was playing with Ishmael, the son born to Abraham by Hagar her slave-girl. Now when Sarah was childless she had seen that Hagar despised her, so she said to Abraham, 'Drive away that slave-girl and her son; he is not to share the inheritance with Isaac.' Abraham was very sad at this because he loved Ishmael, but God told him to do as Sarah asked and promised to protect Hagar and her little son when they were turned out into the desert the next day with nothing but a skin of water and some bread. In course of time Ishmael took an Egyptian wife and his descendants grew into a whole nation.

Some time later God decided to test Abraham, so he called Abraham and said to him, 'Take your son Isaac whom you love, and go to the land of Moriah. There you are to offer him as a sacrifice on a mountain that I will show to you.' Abraham trusted God completely, so early next morning he saddled his donkey and chopped some wood for the sacrifice fire. Then he set out with Isaac and two servants. On the third day Abraham saw the mountain. He said to his servants, 'Stay here with the donkey. The boy and I will go up there; we will worship and come back to you.' Abraham gave the wood to Isaac, and he himself carried some glowing embers and the knife. On the way up, Isaac said to Abraham, 'Father, we have the fire and the wood, but where is the lamb for the sacrifice?' Abraham answered, 'My son, the

Lord himself will provide the lamb.' When they arrived at the place God had shown him, Abraham built an altar and arranged the wood on it. He bound his son Isaac and put him on top of the wood. Then he took up the knife to kill his son. At that moment God called to him, 'Abraham, Abraham! Do not lift your hand against the boy. Do not harm him, for now I know you respect your God. You have not refused me your only son.' Abraham saw a ram caught by its horns in a bush; so he sacrificed it instead of Isaac.

God called Abraham a second time and said, 'Because you have not refused me your only son, I will shower blessings on you, I will make your descendants as many as the stars in the heavens and the grains of sand on the seashore. All the nations of the earth shall bless themselves by your descendants, as a reward for your obedience.'

Abraham and Isaac then rejoined the servants, and together they all set out on their way back.

ISAAC AND REBEKAH

By now Abraham was a very old man and God had blessed him in every way. Abraham said to the manager of all his property, 'I want you to swear by the Lord God of heaven and earth, that you will not choose a wife for my son from the women here. Instead, go to my own land and my own relations to find a suitable woman.' The manager asked, 'What if the woman does not want to come to this country? Is your son then to go back to the country from which you came?' Abraham answered, 'On no account take my son back there. The Lord took me from my father's home and

swore to me that he would give this country to my descendants. Now he will send his messenger ahead of you to help you choose rightly.' And the manager swore to do this.

The manager took ten of his master's camels and the best of his master's goods, and set out for the town where Nahor, Abraham's brother, lived. In the evening, he made the camels kneel near the well outside the town. And he prayed, 'Lord, God of my master Abraham, be with me today, and show your kindness to my master Abraham. Here I am by the well as the young women come to fetch water. I will say to one of the girls, "Please give me some water to drink." If she answers, "Drink, and I will give water to your camels too", let her be the one you have chosen for your servant Isaac. By this sign I shall know your choice.'

He had not even finished speaking when Rebekah came out. She was a very beautiful girl and a relation of Abraham's. On her shoulder she carried a water pot which she filled at the well. The manager ran to meet her and said, 'Please give me a little water to drink.' She replied, 'Drink, my lord.' When he had finished drinking, she said, 'I will get water for your camels, too, until they have all had enough.' Whilst she was doing this the man watched her in silence, wondering whether the Lord had made his journey successful.

When the camels had finished drinking, the manager gave her gold ornaments and said, 'Please tell me, whose daughter are you? Is there room at your father's house for us to spend the night?' She answered, 'I am the daughter of Bethuel, the son whom Milcah bore to Nahor.' And she added, 'We have plenty of straw and fodder, and room to lodge.' Then the manager praised God saying, 'Blessed be the Lord, for he has guided my steps to the house of my master's brother.'

Rebekah ran home to tell what had happened. When her brother Laban heard it and saw the ring and the bracelets his

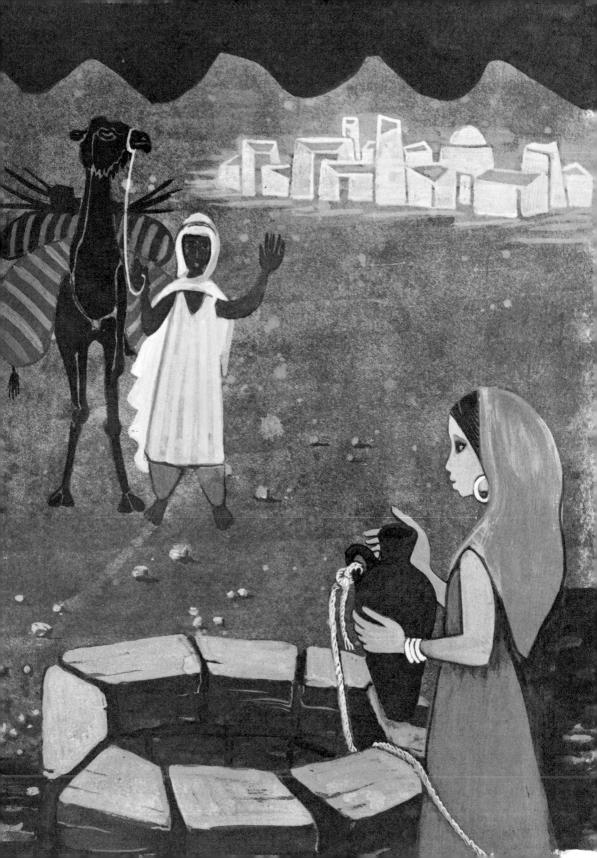

sister was wearing, he ran out to the man at the well and said to him, 'Come to our home. Why stay out here when I have cleared the house and made room for the camels?' So the manager went to the house with his camels and his companions.

Laban was about to offer the traveller food, but the manager said, 'I will not eat until I have told you my story. I am Abraham's manager. The Lord has blessed my master greatly, and Abraham is now very rich. He has flocks and herds, silver and gold, slaves, camels and donkeys. Sarah, his wife, bore him a son in his old age, and all Abraham's property will go to his son. My master sent me to choose a wife for his son from his relations in his own homeland. My master told me that a messenger of the Lord would help me to choose rightly. When I arrived today at the well, I prayed: Lord, God of my master Abraham, give me this sign of success: the right girl will not only give water to me but will offer water for my camels as well. Rebekah did this and then she told me her family is related to my master. So I gave her this ring and these gold bracelets and I blessed the Lord God of my master Abraham, who had allowed me to choose the daughter of my master's brother. Now tell me if you agree that Rebekah should marry Isaac.'

Laban and Rebekah's father, Bethuel, replied, 'This is from God; it is not for us to say yes or no. Take Rebekah and go; and let her become the wife of Isaac as the Lord has planned.' Then Abraham's manager brought out silver and gold ornaments and clothes which he gave to Rebekah; he also gave rich presents to her brother and to her mother.

Then they ate and drank and the manager and his companions spent the night there. Next morning they were ready to leave, but Rebekah's brother and mother said, 'Let the girl stay with us a few days longer.' The manager replied, 'Do not delay me; the Lord has made my journey successful; let

me go back to my master.' The family said, 'Call the girl and let her decide.' They called Rebekah and asked her, 'Do you want to leave with this man?' 'Yes' she replied. So they agreed. Rebekah and her servants mounted the camels and left with the manager and his men.

When they arrived in Canaan, Isaac led Rebekah into his tent and made her his wife; and he loved her greatly.

ESAU GIVES JACOB FIRST PLACE

Isaac was forty years old when he married Rebekah. He prayed to God that Rebekah would have a child. After a long time God heard his prayer and Rebekah felt the child growing in her body; but its movements were so violent that she was worried. So she prayed to God, and God told her, 'You are carrying two babies; that is why they move so much. They will be rivals, and two nations will grow from them. When they are born the elder will serve the younger.'

At last twins were born to Rebekah. The first-born was red and looked as if he were wrapped in a hairy cloak; so they named him Esau. His brother was named Jacob because his hand held on to Esau's heel. Isaac was then sixty years old. When the boys grew up, Esau became a skilled hunter, but Jacob was a quiet man, staying at home among the tents. Isaac liked Esau best, but Rebekah liked Jacob best.

One day Esau came home exhausted from hunting and saw that Jacob had made a stew. He said to Jacob, 'Let me eat that red stew, I am very tired.' Jacob answered, 'First, give me your place as first-born.' Esau said, 'Here I am, tired to death; what use to me will it be to be the first-born?' Then

Jacob said, 'First swear it to me.' So Esau gave his oath and sold his place as first-born to Jacob for a pot of stew. Then Jacob gave him bread and the stewed lentils, and after eating and drinking Esau got up and went. That was all Esau cared about being the first-born son.

JACOB DECEIVES HIS FATHER

Isaac was now very old, and his eyes were so weak that he could no longer see. He called his elder son Esau to him and said, 'You can see how old I am; I do not know when I may die. Now take your weapons, your quiver and bow, and go out into the country and hunt me some game. Make me the kind of dish I like and bring it to me, so that I may eat and give you my blessing before I die.'

Rebekah happened to be listening while Isaac was talking to his son Esau. So when Esau went into the country to hunt game for his father, Rebekah said to her son Jacob, 'I have just heard your father asking your brother Esau to catch some game and make a special dish, so that before your father dies he may eat and bless Esau. Now listen, my son, and do as I tell you. Go to the flock and bring me back two good kid goats so that I can make the kind of dish your father likes. Then you can take it to your father for him to eat, so that before he dies he may bless you instead.'

Jacob said to his mother Rebekah, 'But my brother Esau is hairy and my skin is smooth. If my father happens to touch me, he will see I am cheating him and I shall bring down a curse on myself instead of a blessing.' But his mother answered him, 'I will accept the curse, my son! Just

listen to me; go and fetch me the kids.' So Jacob went to choose and kill them, and brought them to his mother, and she made the kind of dish his father liked. Rebekah took the best clothes of Esau her elder son, which she had in the house, and dressed her younger son Jacob in them. She covered Jacob's arms and the smooth part of his neck with the skins of the kids. Then she gave him the dish and the bread she had made.

Jacob presented himself to his father and his father said, 'Who are you, my son?' Jacob said to his father, 'I am Esau your first-born; I have done as you told me. Please get up and take your place and eat the game I have brought, and then give me your blessing.' Isaac said to his son, 'How quickly you caught the game, my son!' Jacob answered, 'It was the Lord your God who put it in my path.' Then Isaac said, 'Come here, then, and let me touch you, my son, to know if you are my son Esau or not.' Jacob came close to his father and Isaac touched him and said, 'The voice is Jacob's voice but the arms are the arms of Esau!' But Isaac did not recognise him as Jacob, for his arms were hairy like his brother Esau's, and he said, 'Are you really my son Esau?' Jacob replied, 'I am.' Then Isaac said, 'Bring the game here which you have caught, so that I may eat and give you my blessing.' Jacob brought it to him and offered him wine, and he ate and drank. His father Isaac said to him, 'Come closer and kiss me, my son.' He went closer and kissed his father. Isaac could then smell the smell of Esau's clothes, and so he blessed Jacob, saying, 'Yes, the smell of my son is like the smell of a fruitful field blessed by the Lord. May God give you dew from heaven and the richness of the earth, and great quantities of grain and wine! May nations serve you and peoples bow down before you! Be master of your brothers; may the sons of your mother bow down before

you! Cursed be he who curses you; blessed be he who blesses you!'

As soon as Isaac had finished blessing Jacob, and just when Jacob was leaving his father, his brother Esau returned from hunting. He too made a dish and brought it to his father. He said to Isaac, 'Father, come and eat the game your son has brought and then give me your blessing!' His father Isaac asked him, 'Who are you?' 'I am your first-born son, Esau' he replied. At this Isaac was seized with a great trembling and said, 'Who was it, then, that went hunting and brought me game? I suspected nothing and ate before you came; I blessed him, and blessed he will remain!' When Esau heard his father's words, he cried out loudly and bitterly to Isaac, 'Father, bless me too!' But Isaac replied, 'Your brother came

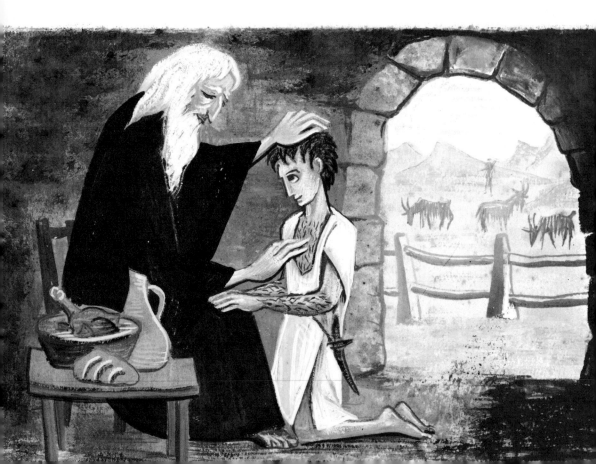

and took your blessing by deceit.' Esau said, 'Is it because his name is Jacob, that he has now twice unjustly taken what is mine? First he took my place as the first-born, and look, now he has taken my blessing! But have you not kept a blessing for me?' Isaac answered Esau, 'Look, I have already made him your master; I have already given him all his brothers as servants, I have already provided him with grain and wine. What can I do for you, my son?' Esau said to his father, 'Was that your only blessing, father? Father, give me a blessing too.' Isaac remained silent. Esau burst out weeping. Then his father Isaac gave him this answer: 'You shall live far from the richness of the earth, far from the dew that falls from heaven. You shall live by your sword, and you shall serve your brother. But when you win your freedom, you shall shake his yoke from your neck.'

Esau hated Jacob because of the blessing his father had given him, and he thought to himself, 'The time will soon be here when my father will be dead. Then I will kill my brother Jacob.' When the words of Esau, her elder son, were told to Rebekah, she went to find her younger son Jacob and said to him, 'Look, your brother Esau means to take revenge and kill you. Now, my son, listen to me; go away and take shelter with my brother Laban in Haran. Stay with him a while, until your brother's anger against you cools and he forgets what you have done to him. Then I will send someone to bring you back. Why should I lose you both on the same day?' Rebekah suggested this partly because she disliked the wives Esau had taken from among the local Hittite women and she hoped Jacob would take a wife from his own people. She said afterwards to Isaac, 'I am sick to death of these Hittite women. If Jacob marries a Hittite woman of this country, like these wives of Esau, what is there left for me to live for?'

JACOB'S LADDER

Isaac sent for Jacob and blessed him, and ordered him, 'You are not to choose a wife from the Canaanite women. Now go to Paddan-aram, the home of Bethuel your mother's father, and choose a wife there among the daughters of Laban, your mother's brother. May the Lord bless you and your descendants; may he make you fruitful and make you grow in numbers so that you become a group of nations and take possession of the land in which you live now, which God gave to Abraham.'

Jacob left Beersheba and set out for Haran. When the sun set, he lay down where he was and passed the night there, using a large stone as a pillow. Then he had a dream: a ladder was there, standing on the ground with its top reaching to heaven; and there were messengers of God going up it and coming down. And the Lord was there, standing over him, saying, 'I am the Lord, the God of Abraham your father, and the God of Isaac. I will give the land on which you are lying to you and your descendants, who shall be as many as the specks of dust on the ground. You shall spread to the west and the east, to the north and the south, and all the tribes of the earth shall bless themselves by you and your descendants. Be sure that I am with you; I will keep you safe wherever you go and bring you back to this land, and I will not desert you before I have done all that I have promised you.' Then Jacob awoke and said, 'Truly, the Lord is in this place and I never knew it! This place makes me afraid; it is nothing less than a house of God, it is the gate of heaven!' Rising early in the morning, Jacob took the stone, set it up as a monument, and poured oil over the top of it. He named the place Bethel.

Jacob made this vow: 'If the Lord goes with me and keeps me safe on this journey, if he gives me bread to eat and clothes

to wear, and if I return home safely, then the Lord shall be my God. This stone shall be a house of God, and I will surely pay the Lord a tenth part of all he gives me.'

Moving on, Jacob went towards Paddan-aram. In the fields he saw a well with three flocks of sheep beside it. Jacob said to the shepherds, 'Brothers, where are you from?' They replied, 'We are from Haran.' Then he asked, 'Do you know Laban, the son of Nahor? Does all go well with him?' 'Yes,' they replied 'and here comes his daughter Rachel, with his sheep.' As soon as Jacob saw Rachel, he came up and watered the sheep. He kissed Rachel, burst into tears of joy and told her he was her father's relative and Rebekah's son. She ran to tell her father, Laban. As soon as he heard the news, he hurried to meet Jacob, embraced him warmly, and brought him to his house. Jacob told Laban all that had happened. He stayed and worked as his shepherd for twenty years; and he married both Laban's daughters, Leah and Rachel.

JACOB WRESTLES ALL NIGHT

After Jacob had been working for Laban for twenty years, he decided to return home to his father Isaac in Canaan. At one place on the way, angels of God met him. On seeing them he said, 'This is God's camp', and he named the place Mahanaim.

Later on in his journey, when he got near the land of Seir where his brother Esau lived, Jacob sent messengers ahead with these instructions: 'Say this to my brother Esau: "Here is a message from your brother Jacob: I have been staying with Laban till now, and I have come to own oxen, beasts of burden and flocks, and men and women slaves. I send this

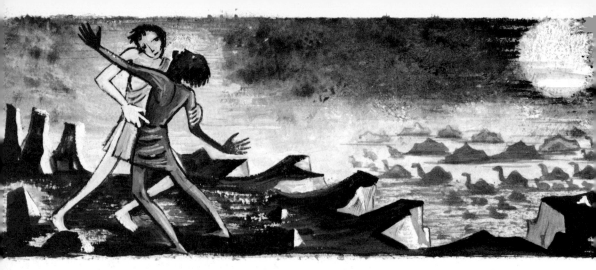

news to you in the hope of winning your approval." '
When the messengers returned to Jacob, they told him, 'We
went to your brother Esau, and he is already on his way to
meet you. But there are four hundred men with him.'

Jacob was greatly afraid and worried, because of the way
he had taken Esau's place as first-born long, long ago. He
divided all his people and flocks and cattle into two groups,
and said, 'If Esau comes to one group and attacks it, the other
group will be left to escape.' Then Jacob prayed, 'O God of
my father Abraham, and God of my father Isaac, you said to
me, "Go back to your country and family, and I will make
you prosper." I am unworthy of all the kindness and good-
ness you have shown to me. When I first crossed the Jordan
here, I had nothing but my stick. Now I own two large
groups of men and women and animals. I beg you, save me
from my brother, for I am afraid of him. He may come and
attack us and the mothers and their children too. But it was
you who said, "I will make you prosper, and make your
descendants like the sand on the seashore, so many that they
cannot be counted." ' Then Jacob halted for the night.

The next day Jacob thought to himself, 'I will try to make
him feel better towards me by sending gifts on ahead; so
when I meet him face to face he may perhaps receive me
kindly.' So he chose gifts for his brother Esau out of all that

he had with him: two hundred she-goats and twenty he-goats, two hundred ewes and twenty rams, thirty camels with young calves, forty cows and ten bulls, twenty she-donkeys and ten he-donkeys. He put them in charge of his servants, each kind separately, and told his servants, 'Go ahead of me, leaving a space between each group of animals and the next.' He gave the first group this order: 'When my brother Esau meets you and asks, "To whom do you belong? Where are you going? Whose are those animals that you are driving?" you will answer, "To your servant Jacob. They are a gift sent to my lord Esau. Jacob himself is following." ' He gave the same order to the second and the third and all the following groups, 'You must say to Esau when you find him, "Yes, your servant Jacob himself is following." ' So the gifts went on ahead and Jacob himself spent another night in the same camp. During the night he got up and took his two wives and his two slave-girls and his eleven children across the ford of the Jabbok stream, and he sent all his possessions over too. Then Jacob returned and was left all alone by himself in the camp.

But a stranger came in the darkness and wrestled with him. This struggle went on until dawn was beginning to come; then his opponent, seeing that he could not win, struck him on the hip, and Jacob's hip was put out of joint in the struggle. His opponent said, 'Day is breaking. Let me go away.' But Jacob answered, 'I will not let you go unless you bless me.' Then the stranger asked, 'What is your name?' Jacob gave his name and the stranger said, 'Your name shall no longer be Jacob, but Israel. Because you have held fast to God, you shall be victorious against men.' Jacob then asked, 'Please, tell me your name', but the stranger replied, 'Why do you ask my name—surely you must know it?' And the stranger blessed him then and there.

Jacob named the place Peniel, 'Because I have seen God face to face,' he said 'and I have not been destroyed.' He left Peniel at sunrise, limping because of his hip. Even to this day the Israelites do not eat the nerve which is in the hip-joint of any animal, because Jacob was struck in the hip-joint on this nerve.

JACOB MEETS ESAU AGAIN

When Jacob saw Esau arriving with four hundred men, he divided his children into groups: the slave-girls and their children in front, Leah and her children following, and Rachel and Joseph behind. He himself went ahead and bowed to the ground seven times before going up to his brother. But Esau ran to meet him, took him in his arms and wept. Then he looked up and saw the women and children. 'Who are these with you?' Esau asked. Jacob answered, 'The children whom God has bestowed on your servant.' The slave-girls then came up with their children, and they all bowed low. Then Leah and her children did the same, and finally Rachel and Joseph.

Esau asked, 'What was the meaning of all the animals I met?' 'To win my lord's favour' Jacob replied. Esau said, 'Brother, I have plenty, keep what is yours.' But Jacob protested, 'Please, if you think well of me, accept my gifts. To tell the truth, I came to you in fear, as into the presence of God, but you have received me kindly. So accept the gifts I have brought for you; since God has been generous to me, I have ail I need.' And he urged him, and Esau accepted.

Esau said, 'Let us break camp and move off; I will lead

you.' But Jacob replied, 'My lord knows that the children are weak, and that I must think of the cows that have calved and the sheep. If they are driven too hard, even for one day, the whole herd will die. Please go on ahead. As for me, I will move at a slower pace to suit the animals and the children, until I join you in Seir.' Then Esau said, 'But I must at least leave you some of my own people.' 'Why?' Jacob asked 'All I desire is to win your favour.' So that day Esau started off again on his journey to Seir. But Jacob did not intend to follow him and took another direction towards Succoth.

JOSEPH'S DREAMS

This is the beginning of the story of Joseph, the youngest son of Jacob who lived in the land where his father Isaac had stayed, the land of Canaan.

When Joseph was still young and only seventeen years old, he used to act as a shepherd to the flock with his brothers and the sons of Bilhah and Zilpah his father's other wives. Joseph used to pass on to his father Jacob all the evil gossip spoken about them.

Jacob loved Joseph more than any of his other sons, for Joseph had been born in his old age. Jacob had a coat with long sleeves made for him. But Joseph's brothers, seeing how their father loved him more than all of them, came to hate him so much that they could not say a friendly word to him.

Joseph had a dream, and he told it to his brothers, saying, 'Listen to this dream I have had. We were binding sheaves in the countryside; and my sheaf, it seemed, rose up and stood

upright; then I saw your sheaves gather round and bow to my sheaf.' His brothers answered, 'So you want to be king over us, or to lord it over us?' And they hated him still more, on account of his dreams and the things he said.

Then Joseph had another dream and told it to his brothers, saying, 'Look, I have had another dream. I thought I saw the sun, the moon and eleven stars, bowing to me.' After he had told his father and brothers, his father scolded him. 'A fine dream to have!' he said to him. 'Are all of us then, myself, your mother and your brothers, are we to come and bow to the ground before you?' His brothers were jealous of him, but nevertheless his father kept these things in the back of his mind.

JOSEPH IS SOLD AS A SLAVE

Joseph's brothers had taken their father's flock to Shechem for grazing. Then Jacob said to Joseph, 'Your brothers are at Shechem with the flock. I am going to send you to them.' 'I am ready' Joseph replied. Jacob said to him, 'Go and see how your brothers and the flock are doing, and bring me news.' Jacob sent him from the valley of Hebron, and Joseph arrived at Shechem.

A man found him wandering in the countryside and asked him, 'What are you looking for?' 'I am looking for my brothers,' Joseph replied. 'Please tell me where their flock is grazing.' The man answered, 'They have moved on from here; in fact I heard them say, "Let us go to Dothan." ' So Joseph went after his brothers and found them at Dothan.

They saw him in the distance, and before he reached them

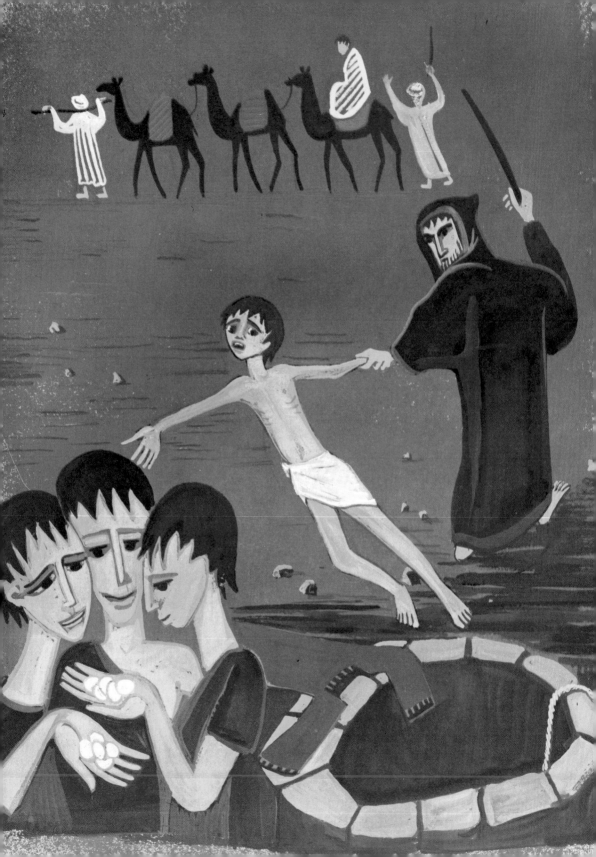

they made a plot among themselves to kill him. They said to one another, 'Here comes the dreamer. Come on, let us kill him and throw him into some well; we can say that a wild beast devoured him. Then we shall see what becomes of his dreams!'

But Reuben overheard the plot, and he saved Joseph from their violence. Reuben said, 'We must not take his life. Do not shed blood. Throw him into this well in the desert but do not lay violent hands on him.' Reuben intended to save Joseph from them and to restore him to his father. So, when Joseph reached his brothers, they pulled off his coat, the coat with long sleeves that he was wearing, and caught hold of him and threw him into the well. Then they sat down to eat. Luckily it was an empty well with no water in it.

As they looked up they saw a group of Ishmaelite merchants coming from Gilead, their camels laden with gum, tragacanth, balsam and resin, which they were taking to Egypt. At this time Reuben was some distance away and Judah said to his brothers, 'What do we gain by killing our brother and covering up his blood? Come on, let us sell him to those merchants; let us not do any harm to him. After all, he is our brother and our own flesh and blood.' His brothers agreed.

So they hauled Joseph up out of the well and sold him to the Ishmaelite merchants who were passing by, for twenty silver coins. When Reuben returned and went to the well, there was no sign of Joseph. Tearing his clothes in despair, he went back to his brothers and said, 'The boy has disappeared. What am I going to do?'

The brothers took Joseph's coat and slaughtered a goat, and dipped the coat in the blood. Then they sent the coat with long sleeves back to their father with the message, 'This is what we have found. Examine it and see whether or not it

is your son Joseph's coat.' He examined it and exclaimed, 'It is my son's coat! A wild beast has devoured him. Joseph has been the prey of some animal and has been torn to pieces.' Jacob tore his own clothes in his sorrow and put on clothes of old sacking and mourned his son for a long time. All his sons and daughters came to comfort him, but he refused to be comforted. 'No,' he said 'I will die still mourning my son and go to rest beside him.' And his father wept for him.

Meanwhile the merchants had taken Joseph to Egypt and sold him to Potiphar, one of Pharaoh's officials and commander of the guard.

JOSEPH WITH POTIPHAR

After the Midianite merchants had bought Joseph from his brothers, they took him to Egypt. There the merchants sold him to Potiphar, one of Pharaoh's officials and commander of his guard. God was with Joseph, so everything went well with him. He lived in Potiphar's house and when Potiphar saw how God was with Joseph and how he was successful in everything he did, he was pleased with Joseph and made him his personal servant. He put him in charge of all his household and his belongings and trusted him over everything. Because of Joseph, God blessed Potiphar from then on, and everything went well with all his belongings, both his household and his land. So Potiphar left Joseph completely in charge and thought of nothing but enjoying his food.

Now Joseph was handsome and had a fine strong body, and after a time Potiphar's wife fell in love with him. She asked him to live with her as if he was her husband. But he

refused and said, 'My master has complete trust in me; he does not worry himself about what happens in the house. He has handed over everything to me to look after, and I am as much master in this house as he. He has kept nothing from me except yourself, because you are his wife. How could I do a thing so terrible both for him and in the eyes of God?' Day after day Potiphar's wife went on asking him, but Joseph would not give in and agree to it.

One day Joseph came to the house in the course of his duties and there was not a single other person there except Potiphar's wife. She seized hold of his clothes and asked him yet again to be her husband. Joseph slipped out of his clothes and ran from the house, leaving his clothes in her hands. She was very angry at his refusal and called her servants and said to them, 'Look at this! My husband brought a Hebrew into the house just to insult me. This man came to attack me, but I screamed, and when he heard me scream and shout he ran out of the house and left his clothes behind.'

She kept the tunic carefully by her until Potiphar came home. Then she told him her story. 'The Hebrew slave you bought us,' she said 'came to insult me. But when I screamed and called out he left his clothes behind and escaped.' Potiphar was furious and he had Joseph arrested and sent him to the jail where the king's prisoners were kept. And there Joseph stayed for a long time.

But God was still with him and Joseph became friends with the chief jailer. This man put Joseph in charge of all the prisoners and made him responsible for everything that needed to be done in the prison. Joseph arranged everything so well that the chief jailer was able to leave everything to be run by Joseph. God was still with Joseph, so that everything Joseph did was successful.

JOSEPH IN PRISON

Joseph was in prison in Egypt on account of the false story told about him by Potiphar's wife. After he had been there some time, the chief butler and the chief baker of the royal palace offended the king. Pharaoh was angry with these two officials and had them put under arrest in the house of the commander of the guard, in the jail where Joseph was a prisoner. The commander of the guard told Joseph to attend to their wants, and they remained under arrest for some time.

One night, both men had dreams, and each dream had its own meaning for the chief butler and the chief baker. When Joseph came to them in the morning, he thought they looked gloomy, and he asked them, 'Why do you look so glum?' They answered him, 'We have each had a dream, but there is no one to explain them to us.' Joseph replied, 'Surely the meaning of dreams is God's business? But tell me your dreams anyway.'

The chief butler described his dream to Joseph and said, 'In my dream I saw a vine in front of me. On the vine were three branches. No sooner had buds started to grow on the vine than it blossomed, and its flowers became ripe grapes. I had Pharaoh's cup in my hand; I picked the grapes and squeezed them into the cup, and gave it to Pharaoh.' Joseph gave him this explanation: 'This is the meaning of your dream. The three branches are three days. In another three days Pharaoh will free you and take you back to the palace. Then you will hand Pharaoh his cup, as you did before when you were his butler. But be sure to remember me when things go well with you again, and please be kind and remind Pharaoh that I am still here in prison, so that I too may be set free. I am only in Egypt because in the beginning I was kidnapped from the land of the Hebrews and while I have

been in Egypt I have done nothing to deserve being thrown into prison.'

When the chief baker saw that the meaning of the other dream had been favourable, he said to Joseph, 'I too had a dream. There were three trays of cakes on my head. In the top tray there were all kinds of Pharaoh's favourite cakes, but the birds flew down and ate them off the tray on my head.'

Joseph gave him this explanation: 'The meaning is that the three trays are three days. In another three days Pharaoh will free you and hang you on a gallows, and the birds will eat the flesh off your bones.'

And so it happened. The third day was Pharaoh's birthday and he gave a feast for all his officials. He freed the chief butler and the chief baker in front of all the other officials. The first was given back his job of handing Pharaoh his cup as chief butler. The chief baker was hanged. The meanings given by Joseph were proved right. The chief butler however did not keep his promise to Joseph; instead he forgot all about him. So Joseph had to remain in prison and it was another two years before anyone remembered he was still there.

PHARAOH'S DREAM

Two years after Pharaoh's chief butler and chief baker had been imprisoned with Joseph, Pharaoh dreamed that he was standing by the Nile; coming up from the river were seven sleek and fat cows, and they began to feed among the rushes.

Then seven other thin and ugly cows came up from the Nile after them and went over and stood beside the fat cows on the bank of the river. And the thin and ugly cows ate the seven sleek and fat cows. Then Pharaoh woke up.

He fell asleep a second time and dreamed that there were seven large ripe ears of corn growing on one stalk. Then another seven ears of corn came sprouting up, but they were thin and all dried up by the east wind. The poor ears of corn swallowed the seven ripe ears of corn. At that point Pharaoh woke up again and realised it was a dream.

In the morning Pharaoh was worried and called all the magicians and wise men of Egypt to him and told them of his dream. No one could explain it for him. Then the chief butler said, 'Today I think back to the time when I offended Pharaoh and Pharaoh was angry and put me and the man who used to be chief baker under arrest in the house of the guard commander. Each of us had a dream on the same night. There was a young Hebrew with us, one of the slaves working for the guard commander. We told our dreams to him and he was able to explain them. Things happened just as he said they would: I was given back my position and the other man was hanged.'

So Pharaoh sent for Joseph, and his men hurried to the prison to fetch him. Joseph shaved himself and changed his clothes and came before the king. Pharaoh said to Joseph, 'I have had a dream which no one can explain. But I have heard it said of you that when you hear a dream you can explain it.' Joseph answered, 'I am nothing. It is God who will give Pharaoh a favourable answer.'

Then Pharaoh told Joseph, 'In my dream I was standing on the bank of the Nile. And there were seven cows, fat and sleek, coming up out of the Nile, and they began to feed among the rushes. And seven other cows came up after them,

starved, ugly and thin; I have never seen such poor cows in
all Egypt. The thin and ugly cows ate up the seven fat cows.
But when they had eaten them up, it was impossible to tell
they had eaten them, for they remained as thin as before.
Then I woke up. And then again in my dream, there,
growing on one stalk, were seven ears of corn, beautifully
ripe; but sprouting up after them came seven ears of corn,
withered, thin and dried up by the east wind. The dried-up
ears of corn swallowed the seven ripe ears of corn. I told the
magicians this, but no one could tell me the meaning.'

Joseph told Pharaoh, 'Both dreams have the same meaning:
God is showing Pharaoh what is going to happen. The seven
fine cows are seven years and the seven ripe ears of corn are
seven years. The seven thin and bony cows coming up after
them are seven years, so are the seven unripe ears of corn
dried up by the east wind. It is as I have said; God is showing
Pharaoh what is going to happen. For the whole land of
Egypt seven rich years are coming; but seven years of
famine will follow them and will use up all the food in the

land. The famine will be so severe that no one will remember
how rich the country was. The reason why Pharaoh had two
dreams is because God knows all this will happen soon.

'Pharaoh should now choose an intelligent and wise man
as governor of the land of Egypt. Pharaoh should take action
and appoint officials to watch over all parts of the land; and
during the seven rich years he should impose a tax which
takes away one part out of every five of all the food that is
grown. This should be collected in the towns during the
good years and stored there in Pharaoh's name; it will serve
as a reserve during the seven years of famine so that the
whole country will not be destroyed.'

Pharaoh and all his ministers agreed on this plan, and
Pharaoh said to Joseph, 'As God has given you knowledge of
all this, there can be no one as intelligent and wise as you.
You shall be my chancellor. I am the king and I say that all
my people are to obey your orders, and without your per-
mission no one is to move hand or foot throughout the whole
land of Egypt. Only this throne shall set me above you. I

hereby make you governor of all Egypt.' Pharaoh took the ring from his own hand and put it on Joseph's hand, and he gave Joseph a new name, Zaphenath-paneah. He clothed Joseph in fine linen and put a gold chain round his neck. He made him ride in the chariot which was the next grandest after Pharaoh's, and in front of the chariot went runners shouting, 'Abrek—make way!' Pharaoh also gave him Asenath, the daughter of a high priest, to be his wife. When all this happened, Joseph was thirty years old.

After being made governor, Joseph began to travel throughout the whole land of Egypt in the course of his duties. During the seven years of plenty, the soil grew very rich crops indeed. All the spare food taken as tax during the seven rich years was collected from the surrounding country-side and stored in Pharaoh's name in each town on Joseph's orders. Joseph stored corn like the sand of the sea; there was so much that they stopped keeping records, because it was impossible to count it all.

Before the years of famine came, Joseph's wife, Asenath, bore him two sons. Joseph named the first-born Manasseh, 'Because' he said 'God has made me forget all my suffering and all my father's household.' He named the second son Ephraim, 'Because' he said 'God has made me fruitful in the country of my misfortune.'

Then, as Joseph had said, the seven years of plenty ended and the seven years of famine began. When the whole country started to feel the famine, the people cried out to Pharaoh for bread. But Pharaoh told all the Egyptians, 'Go to Joseph and do what he tells you.' Then Joseph opened all the granaries and sold corn to the Egyptians. There was severe famine in every other country also, but there was bread enough to eat in Egypt. So people came from many other countries to buy corn from Joseph in Egypt.

JOSEPH'S BROTHERS TRAVEL TO EGYPT

In the years when there was famine in the land of Canaan, Jacob heard that there was corn for sale in Egypt, so he said to his sons, 'Why do you stand there looking at one another, when they say there is corn for sale in Egypt? Get moving and go and buy corn for us there, so that we shall have enough to eat and not starve to death.' So ten of Jacob's sons went to buy corn in Egypt. This was all of Joseph's brothers except one; for Jacob did not send his youngest son, Benjamin, with the others, because he would not take the risk of anything happening to Benjamin.

Jacob's ten sons made the journey along with others who were also going from Canaan to buy corn in Egypt. When they arrived they had to go to see the man in authority over the whole country, who controlled all the selling of corn as well. This man was their brother Joseph, of course, but they did not recognise him. So the ten brothers bowed down in front of Joseph with their foreheads touching the ground, and asked if they could buy corn. Joseph recognised his brothers, but he did not let them know who he was. Instead he spoke harshly to them and asked, 'Where have you come from?' 'From the land of Canaan to buy food' they replied.

Then Joseph remembered the dreams he had had at home about his brothers many years ago, and he said to them, 'You are spies. You have come to discover the country's weak points.' 'No, my lord,' they answered 'we have come to buy food. We are all the sons of the same man. We are honest men, and not spies.' 'I do not believe you!' Joseph said 'You have come to discover the country's weak points.' The ten brothers told him, 'We are a family of twelve brothers, sons of the same father in Canaan. The youngest is still with our father, and the other brother is dead.'

Joseph answered them again, 'No, you are spies. This is how I will test you: you are not to leave here until your youngest brother joins you. One of you is to fetch your brother; the others will remain under arrest, so that I can see whether or not what you say is true, and whether or not you are honest. Otherwise, as sure as Pharaoh is alive, you are spies.' Then he kept them all under arrest for three days.

On the third day Joseph said to the ten brothers, 'I have thought of a different plan for you, for I am a man who believes in God. One of you must remain here under guard and the others may go and take the corn back to help their families. If you are honest men and return to me with your youngest brother, your words will be proved true and you will not have to die!' The ten brothers said to one another, 'Now we are being called to account for what we did to our brother Joseph. We saw his misery when he begged us not to put him down the well and not to sell him to the traders, but we did not listen to him. Now we are in the same position ourselves.' Reuben said, 'I told you not to do wrong to the boy, but you would not listen to me. Now we are having to pay for it.'

In talking with his brothers, Joseph had used a man to translate what they said, so they did not realise that Joseph understood their language. But when Joseph heard what they were saying to one another, he went away and wept. Then he came back and told them he would keep back Simeon. So Simeon was bound as a prisoner while the others watched.

Then Joseph gave orders for their sacks to be filled with corn, and food to be given them for the journey. He also gave orders that the money each man had paid should be put back in his sack. The brothers loaded the corn on their donkeys and set out for home. When they camped on the first night of the journey, one brother opened his corn-sack

to give fodder to his donkey, and he saw his money there. He called to his brothers, 'My money has been given back; here it is in my corn-sack.' They were all afraid and looked at one another in dismay, saying, 'Whatever has God done to us?'

On returning home to their father in the land of Canaan, they gave Jacob a full report of what had happened to them. 'The man who is lord of the land spoke harshly to us' they said 'and thought we had come to spy on the country. We told him we were honest men, not spies. And we told him that we were twelve brothers, sons of the same father; that one of us is dead and that the youngest was left behind with our father in Canaan. But the lord of the land said we must prove our honesty. He made us leave Simeon behind and will not free him until we return with Benjamin. But he let us take with us the corn our family needs. If we bring back our youngest brother, then he will know that we are not spies but honest men, and he will hand over our brother Simeon to us, and we can trade in the country.' After this, they went off to empty their sacks, and each brother discovered that his bag of money had been put back in his sack. This made them all the more afraid.

Jacob their father was also afraid and said to them, 'You are robbing me of my children. Joseph is dead, Simeon is a prisoner, and now you want to take Benjamin. I am the one who has to suffer from all this.'

Then Reuben promised his father, 'You may kill my two sons if I do not bring Benjamin back to you. Put him in my care and I will bring him back.' But Jacob replied, 'Benjamin is not to go down to Egypt with you, for now that his brother Joseph is dead, he is the only one I have left. If any harm came to him on the journey, I would never get over my sorrow even to the day I die.'

THE SECOND VISIT TO EGYPT

The famine in Canaan was very severe, and in the end Jacob's family had finished eating all the corn his sons had brought from Egypt. So Jacob said to his sons, 'Go back to Egypt and buy us some more food.' His son Judah replied, 'But the lord of the land expressly warned us that he would refuse to see us unless we brought our brother with us. If you are ready to send Benjamin with us, we are willing to go and buy food for you. But if you are not ready to send him we will not go, for the man told us, "I will not allow you into my presence unless your brother is with you." ' Then Jacob said to his sons, 'Why did you bring this misery on me by telling the man you had another brother?' They replied, 'He kept questioning us about our family and our relations, saying, "Is your father still alive?" and, "Have you another brother?" That is why we told him. How could we know he was going to say, "Bring your brother down here"?' Judah said to his father Jacob, 'Send the boy with me. Let us make a start and go, so that we may save our lives and not die of starvation, we, you and all our households. I will keep Benjamin safe, and you can hold me responsible for him. If I do not bring him back to you without harm, then let me bear the blame all my life. If we had not wasted so much time arguing, we should have been there and back by now!'

Then their father Jacob said to the brothers, 'If it must be so, then take with you some of the finest produce of our land as a gift to the man in Egypt: balsam, honey, gum, tragacanth, resin, pistachio nuts and almonds. Also take double the amount of money with you and return what was put back into your sacks; it may have been a mistake. Take your brother and go. May God make the man kind to you and allow you to bring back Benjamin, and Simeon as well. And

as for me, if I must lose my sons, then I must lose them.'

The brothers took the gifts, and also double the amount of money, and they took Benjamin as well. When they arrived in Egypt they went straight to see Joseph. When Joseph saw Benjamin with them, he said to his assistant, 'Take these men to my house. Kill some meat and prepare a meal, for these men are to eat with me at midday.' The man did as Joseph had ordered, and took them all to Joseph's house.

The brothers were afraid when they were taken to Joseph's house and they thought, 'We are being taken there because of the money that was put back in our corn-sacks on our first visit. They are sure to attack us and turn us into slaves, and take our donkeys too.' So, at the entrance to the house before they were taken inside, they went up to Joseph's assistant and said to him, 'Please listen to us, sir. We came here to buy food once before. On our journey back, when we camped the first night and opened our corn-sacks, we found that the money each man had paid for the corn had been put back in his sack, to its full amount. We have brought this money back with us, and we have brought more money to buy

more food. We do not know who put the money in our corn-sacks.' The assistant replied, 'Rest at peace and do not be afraid. Your God and your father's God has put a treasure in your corn-sacks. Your money certainly reached me safely.'

Then the assistant brought out Simeon to them and finally took them all into Joseph's house. He gave them water to wash their feet, and gave their donkeys fodder. The brothers had heard they were to dine there at midday, so while they waited for Joseph to come they arranged their gifts.

When Joseph arrived at the house the brothers offered him the gifts they had brought and bowed low before him, right to the ground. He greeted them kindly, and asked, 'Is your father well, the old man you told me about? Is he still alive?' 'Our father is well and he is still alive' they replied, and they bowed low before him again. Then Joseph looked around and saw his brother Benjamin, his own mother's son. 'Is this your youngest brother, of whom you told me?' said Joseph pointing to Benjamin. Then he said to Benjamin, 'God bless you, my son', and hurried from the room because his feelings were so strong at the sight of his brother that he was near to weeping. He went into his own room and there he burst into tears. After washing his face he returned and, hiding his feelings, he ordered the meal to begin. Joseph was served separately; so were his brothers, and so were the Egyptians of his household, because Egyptians were absolutely forbidden to take food with Hebrews. The brothers were placed opposite Joseph, each according to his age, from the oldest to the youngest. To their amazement Joseph ordered portions to be carried to them from his own dish, and they saw that the share for Benjamin was five times larger than any of the others. As the meal progressed, they all drank wine with Joseph and the whole company enjoyed themselves together.

JOSEPH TESTS HIS BROTHERS

When the time came for his brothers to return to Canaan, Joseph ordered his assistant, 'Fill these men's sacks with as much food as they can carry, and put back into each man's sack the money he has paid. And put my own cup—the silver one—into the youngest man's sack as well as the money for his corn.' The assistant did this.

Early the next morning the men set off with their donkeys. They had not gone far from the city when Joseph ordered his assistant, 'Go off after those men and when you catch up with them say to them, "Why did you repay good with evil by taking the silver cup my lord uses for drinking and for reading omens? What you have done is wrong." '

So when the assistant caught up with the brothers he repeated those words. The brothers asked him, 'What does my lord mean? We would never think of doing such a thing. Look, we have just brought back to you all the way from Canaan the money we found in our corn-sacks. Are we likely to steal silver or gold from your master's house? If one of us has the cup he shall die, and we ourselves will be your slaves.' 'Very well, then;' the assistant replied 'but the one who has the cup is to become my slave, and the rest of you can go free.' Each of them quickly lifted his corn-sack to the ground and opened it. The assistant began searching and started from the eldest downwards. When he reached the sack of the youngest brother, Benjamin, he found the cup in it. Then the brothers tore their clothes in dismay, and after reloading their donkeys they returned to the city.

When Judah and his brothers arrived at Joseph's house he was still there and they fell to the ground in front of him. Joseph asked them, 'What is this? Did you not know that a man like me is a reader of omens?' Judah replied, 'What can

we answer my lord? We cannot clear ourselves, so we will become your slaves.' Joseph said, 'I could not think of such a thing. The man who had the cup shall be my slave, but you others can go back safe and sound to your father.'

Then Judah went up to Joseph and said, 'Please my lord, let me have a word privately with you. Do not be too angry with me, for you are like the great Pharaoh himself. You asked us if we had a father or another brother still alive, and we told you we have both. Our youngest brother, Benjamin, is the only son left to his mother, and his elder brother is dead. Our father loves him dearly. Then you said to us your servants, "Bring him down to me so that I can see him." We answered, "The boy cannot leave his father. If he leaves him, his father will die." But you said to us, "If your youngest brother does not come down with you, you will not be allowed into my presence again." When we went back to our father, we repeated to him what you had said. So when our father said, "Go back and buy us a little food", we told him, "We cannot go down unless our youngest brother is with us." So our father said to us, "You know that my wife bore me two children. When one left me, I said that he must have been torn to pieces. And I have not seen him to this day. If you take this one from me too and any harm comes to him, I will never get over my sorrow even to the day I die." If I your servant go to my father now, and we do not have the boy with us, he will die as soon as he realises this, for this boy means everything to him. Now I your servant gave my word to keep the boy safe. I said: If I do not bring Benjamin back to you, let me bear the blame all my life. Let me stay, then, as my lord's slave in place of the boy, I beg you, and let the boy go back with his brothers. How could I ever go back to my father without this young boy? I could not bear to see the misery that my father would suffer.'

JOSEPH AND HIS BROTHERS REUNITED

When Joseph heard his brother Judah's offer to stay behind in Egypt in place of Benjamin and how much the loss of Benjamin would grieve their father, he was no longer able to hide his feelings, so he sent all the servants out of the room and none of them saw what happened after that.

Then Joseph said to his brothers, 'I am Joseph. Is my father really still alive?' They were so thunderstruck when they recognised him that they could not answer. So Joseph said, 'Come closer. I really am your brother whom you sold into Egypt. But do not worry any more about that now. This is the second year of famine here, and there are still five more to come. God must have wanted me to go to Egypt before you to save your lives and the lives of our own people. So it was not you who sent me here but God. Also he has made me lord of all Pharaoh's household and governor of all Egypt. Return quickly to our father and tell him that Joseph says: "God has made me lord of all Egypt. Come here at once with all your people, and everything you possess. You shall live near me in the country of Goshen. There are still five years of famine to come and I will see that your needs are met." ' Then Joseph went on, 'You can all see with your own eyes that these words are spoken to you from the mouth of your own brother. Tell my father everything that you have seen and heard. Then hurry and bring my father here.'

Then Joseph threw his arms round the neck of his brother Benjamin and wept for joy, and Benjamin wept too. Joseph kissed all his brothers and wept over them. Then they all talked happily together.

Joseph made so much noise that his Egyptian servants waiting outside heard all that was going on. So the news quickly reached Pharaoh's palace that Joseph's brothers had

come. Pharaoh was pleased and so were his servants. He told Joseph to say to his brothers, 'Load your animals and go off to the land of Canaan to fetch your father and your families and bring them back here. Take with you wagons from Egypt for your children and your wives to ride on. Make sure you bring your father. Never mind about the land you own in Canaan, for I will give you the best land that Egypt can offer, and you shall feed on the fat of the land.'

Joseph gave each of his brothers clothes as for a special feast, and he gave Benjamin three hundred shekels of silver and five sets of clothes. Joseph sent his father donkeys loaded with the best of everything from Egypt, and corn, bread and food for his father's journey. His final words to them were, 'Do not get worried on the journey.'

When the brothers reached Jacob, they told him, 'Joseph is still alive. In fact he is governor of all Egypt.' At first Jacob could not believe them. But when he heard what Joseph had said and saw the wagons, he was happy once again and said 'That is enough for me! Now I am sure my son Joseph is still alive. I must go and see him before I die.'

JACOB REUNITED WITH JOSEPH

So Jacob and his sons left Canaan to go to Egypt with all their flocks and herds and other animals and with everything they possessed from the land of Canaan. All their families, their little children and their wives, rode in the wagons which Pharaoh had sent to fetch them, and Jacob's sons guided them. On the way, Jacob stopped at Beersheba to offer sacrifices to the God of his father Isaac. There God

spoke to him in a vision at night and called out to him, 'Jacob, Jacob!' 'I am here' Jacob replied. Then God said, 'I am God, the God whom your father knew. Do not be afraid of going down to Egypt, for I will make you into a great nation there. I myself will go down to Egypt with you, and I myself will bring you back again, and Joseph shall be with you when you die.'

So Jacob left Beersheba with fresh courage and he and his great cavalcade continued the journey to Egypt. After a time, Judah was sent ahead to arrange for Joseph to go to meet Jacob in Goshen. When Jacob with all the wagons arrived in the land of Goshen, Joseph set off in his chariot to meet his father for the first time since he was quite a young boy. As soon as Joseph appeared, Jacob threw his arms round Joseph's neck and wept on his shoulder for a long time. Then he said to Joseph, 'Now I can die, for I have seen you again and know that you are still alive.'

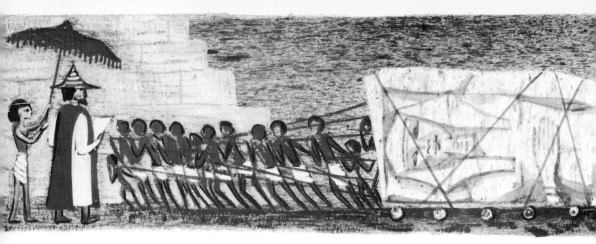

THE ISRAELITES OPPRESSED IN EGYPT

As time went on, Joseph and all his generation grew old and died. But their descendants in Egypt increased greatly in power and in numbers till the whole land was full of them.

After a while there was a new king in Egypt, who knew nothing of what Joseph had done for the country. He said to the Egyptians, 'Look how many and how strong these Israelites have become. They are a danger and we must stop them increasing any further. In a war, they might even join our enemies and so escape out of the country.' So the Egyptians made the Israelites slaves and put slave-drivers in charge of them to break them down by keeping them at work which was too heavy. Their lives were made unbearable and they were given every kind of severe and difficult job: hard work in the fields, work with clay and with bricks, and even building whole cities for storing corn, like Pithom and Rameses. But the more the Israelites were crushed, the more they increased, and the Egyptians came to fear them.

Pharaoh, king of Egypt, also ordered the Hebrew nurses named Shiprah and Puah, 'When you attend the birth of Hebrew children, watch carefully. If a boy is born, kill him; if a girl, let her live.' He also commanded the Egyptians: 'All the young boy-children already born to the Hebrews are to be thrown into the river, but let all the girls live.'

THE BIRTH OF MOSES

In the times when the Egyptians were killing all the boy-children born to the Israelites, a son was born to a man and his wife, both of the Israelite tribe of Levi. As he was a strong and beautiful baby, his mother kept him hidden for three months from the Egyptians. When she could hide him no longer, she made a large basket, painted the outside with pitch, and put the child in it. Then she laid the basket amongst the reeds at the edge of the river Nile. The elder sister of the baby boy hid herself nearby and waited to see what would happen to him.

Pharaoh's daughter, the princess, often used to go down to bathe in the river, accompanied by some of her maid-servants. This time the princess noticed the basket among the reeds and sent one of the girls to fetch it. She opened it and saw the baby boy, crying. She felt very sorry for him and said, 'This must be a child of one of the Hebrews.' Then the baby's sister went up to the princess and said, 'Shall I find you a Hebrew nurse to feed and look after the child for you?' 'Yes, go and do that' Pharaoh's daughter said to her. So the baby boy's sister went off to fetch their own mother. When

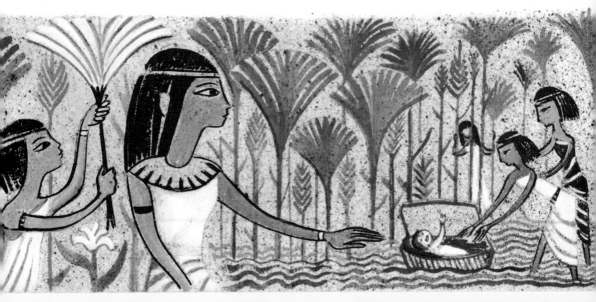

the mother came, the daughter of Pharaoh said to her, 'Take this baby away and feed and look after it for me. I will see you are paid.' So the mother took her own baby boy and fed and looked after it. When the boy grew older, the mother brought him to Pharaoh's daughter who treated him as if he was her son and named him Moses because the name means: 'I-took-him-out-of-the-water.'

MOSES FLEES TO MIDIAN

When Moses had grown up to be a man, he set out to visit some of the Israelites in other parts of Egypt, and he saw what a hard life they were having. He also saw an Egyptian strike one of the Israelites; he looked round and, as no one was in sight, he killed the Egyptian and hid the body in the sand. The next day he came back to the same place and found two Israelites there, fighting. He said to the man who was in the wrong, 'What do you mean by hitting your fellow countryman?' The man replied, 'And who set you over us to be our judge? Are you going to kill me just as you killed that Egyptian?' Moses was frightened because the killing had become known, so he fled from Pharaoh's anger and went off towards the land of Midian.

When he arrived there, he sat down beside a well. Now the seven daughters of the priest of Midian came to the well to draw water to fill the troughs for their father's sheep. Some shepherds also came to the well and tried to drive the women away, but Moses defended them. Then he helped them draw the water. When they returned to their father Reuel, he said, 'You are back early today!' 'An Egyptian

protected us from the shepherds;' they said 'yes, and he drew water for us.' 'And where is he?' Reuel asked, 'Why did you leave the man out there? Go and ask him to eat with us.' So Moses came to Reuel's house to eat a meal, and he stayed there. And after a time Reuel gave him one of his daughters, Zipporah, as a wife. Zipporah bore a son for Moses, and Moses named him Gershom, because it means, 'I-am-a-stranger-in-a-foreign-land', and this is just what Moses was at that time. Then Zipporah bore Moses a second son and Moses named him Eliezer, because it means, 'God-is-my-help' and God had saved Moses from being killed on the orders of Pharaoh. Later on, Moses left his wife Zipporah and they did not meet again until much later when Zipporah came with her two sons to the Israelite camp in the desert at Mount Sinai.

All this happened during a long time, and meanwhile, the king of Egypt died. The Israelites groaned under their slavery and cried out to God for help and God remembered his covenant with Abraham, Isaac and Jacob. God looked down upon the Israelites, and he knew they were suffering.

GOD ASKS THE HELP OF MOSES

Moses was working as a shepherd, looking after the flock of his wife's father, Jethro. He led the flock to the far side of the desert and came to God's special mountain, called Horeb. There the angel of God appeared to him as a flame of fire, coming from the middle of a bush. Moses saw that the bush was blazing but not being burnt, and he said to himself, 'I must go and look at this strange thing and see why the bush

is not burnt.' Now God was watching and saw Moses go forward to look, and He called to him from the middle of the bush, 'Moses, Moses!' Moses answered, 'Here I am', and God said, 'Do not come nearer. Take off your shoes, for this is holy ground. I am the God of your father, the God of Abraham, the God of Isaac, and the God of Jacob.' When Moses heard this he hid his face, because he was terrified of looking at God.

Then God said, 'I have seen how miserable my people are in Egypt. I have heard them beg to be freed from their slave-drivers. I know their sufferings well, and how the Egyptians oppress them. I am going to free them from the Egyptians and bring them out of Egypt to a country where the Canaan-ites and other tribes live, a large and rich country where there is plenty of milk and honey for everyone. So I want you to go to Pharaoh and persuade him to let you lead my people, the Israelites, out of Egypt.'

Moses asked God, 'Who am I to go to Pharaoh in order to bring the Israelites out of Egypt?' God answered, 'I shall be with you, and I will give you a sign by which you shall know that it is I who have sent you to do this. Then, after you have led the people out of Egypt, you are to come to this moun-tain to offer praise to God.'

Then Moses said, 'So I am to go to the Israelites and say to them, "The God of your fathers has sent me to you." But if they ask me what is God's name, what am I to tell them?' God answered Moses by saying, 'I Am who I Am. You must say to the Israelites: "I Am has sent me to you. The Lord, the God of your fathers, the God of Abraham, the God of Isaac, and the God of Jacob, has sent me to you." I Am is my name for all time; and from now on, all people will call on me by this name.

'Go and collect the elders of Israel together and tell them,

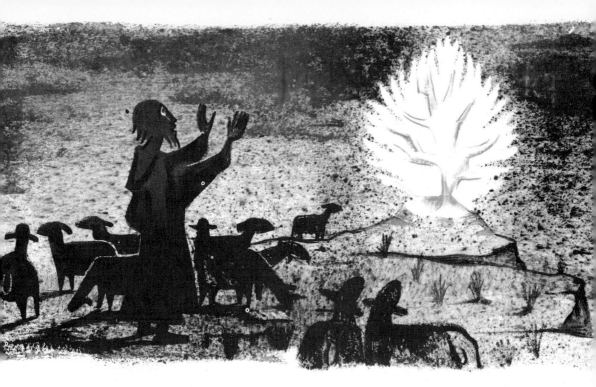

"The Lord, the God of your fathers, the God of Abraham, of Isaac, and of Jacob, has appeared to me and has said to me: I have visited you and seen all that the Egyptians are doing to you. And so I have decided to bring you out of Egypt where you are in slavery, into the land of the Canaanites and other tribes, where there is plenty of milk and honey for everyone." The Israelites will listen to you, and then you are to go with the elders of Israel to Pharaoh and say, "The Lord, the God of the Hebrews, is coming to meet us. So please allow us to make a three days' journey into the desert to offer sacrifice to the Lord our God." I know' said God 'that Pharaoh will not let you go unless he is forced by a mighty power, so I shall show my power by striking the Egyptians with all the troubles I intend to cause them. After this he will let you go.'

So Moses put his wife and his son on a donkey and started back towards Egypt. He carried the staff of God with him.

Now God also spoke to Aaron and said, 'Go into the desert to meet Moses.' And so Aaron went, and met Moses

near the mountain of God and greeted him. Then Moses told Aaron all about the task God had given him to do and all the signs God had ordered him to perform. Moses and Aaron then went and collected all the elders of the Israelites together, and Aaron told them everything that the Lord had said to Moses; and in the sight of the people Aaron performed the signs. The Israelites believed what Aaron told them and they were happy that the Lord had visited them and seen their misery. They bowed down and worshipped the Lord.

MOSES AND PHARAOH

Moses went to see Pharaoh, just as God had told him to, and he took Aaron with him. He told Pharaoh, 'The Lord, the God of Israel, has said, "Let my people go into the desert, so that they may hold a festival in honour of me."' Pharaoh replied, 'Who is the Lord? Why should I listen to him and let Israel go? I know nothing of the Lord, and I will not let Israel go.' Moses and Aaron said to him, 'The God of the Hebrews has come specially to meet us. Please allow us to make a three days' journey into the desert to offer sacrifice to the Lord our God, or he will punish us with a plague or with the sword.' The king of Egypt answered them, 'Moses and Aaron, what do you mean by taking your people away from their work? Go back and get on with it. You know how enormously the numbers of these common labourers have grown, are you wanting to stop them all working?'

On the very same day, Pharaoh gave this command to the Egyptian slave-drivers and overseers: 'Up to now, you have

given the Israelites straw for brickmaking. Do not give them any more straw; let them go and collect it for themselves. All the same, you are still to get from them the same number of bricks as before, not even a little bit less. They are lazy, and that is why they are demanding, "Let us go and offer sacrifice to our God." Make them work harder than ever, so that they have no time to stop and listen to clever speeches.'

The slave-drivers went out with the overseers to tell this to the people. They said, 'Pharaoh has given orders that you will not be given straw. You are to go and collect straw for yourselves wherever you can find it. But you must make exactly the same number of bricks as before.' So the people scattered all over Egypt to gather stubble for making chopped straw. The slave-drivers chased them without stopping and kept on repeating, 'Every day you must make the proper number of bricks, just as you did before.' When the number of bricks was too low, the slave-drivers beat the Israelite foremen and asked them, 'Why have you not produced your full amount of bricks as before, either yesterday or today?'

The foremen of the Israelites went to Pharaoh and complained. They said to him, 'Why do you treat us like this? We are given no straw, and still your overseers tell us to make bricks and now we have been beaten for this!' Pharaoh answered, 'You are lazy, lazy! That is why you ask that the Israelites may go and offer sacrifice to the Lord. Get back to work at once. You shall certainly not be given any straw, but you must still deliver the number of bricks I have ordered from you.' When the Israelite foremen were told that the daily number of bricks was to be the same as ever, they saw they were in a very difficult situation. As they left, they met Moses and Aaron who were waiting for them. They said, 'May the Lord see what you've done and punish you as you deserve! You have made us hated by Pharaoh and his offi-

cials; you have given them reasons for killing us all.'

Once more Moses turned to the Lord and said to him, 'Lord, why do you treat the Israelites so harshly? Why did you give me this task? Ever since I went to Pharaoh and spoke to him in your name, he has ill-treated our nation, and you have done nothing to deliver your people, the Israelites.'

THE PLAGUES

At this time, Moses was eighty years old, and Aaron, his brother, was eighty-three. And the Lord said to Moses, 'I will make you like a god in Pharaoh's eyes, and your brother Aaron is to be your prophet. You yourself must tell Aaron all my commands, and Aaron is to tell them to Pharaoh so that he will let the Israelites leave Egypt. I myself will make Pharaoh obstinate, so that he will not listen to you. Then I will do many signs and wonders in the land of Egypt to show my power over the Egyptians and set my people, Israel, free and lead them out of the land of Egypt. And all the Egyptians shall learn from this that I am the Lord.' Moses and Aaron did as the Lord said.

Then the Lord said to Moses and Aaron, 'Go and ask Pharaoh and if he says to you, "Produce some marvel", you must say to Aaron, "Take your staff and throw it down in front of Pharaoh, and make it turn into a snake." ' So Moses and Aaron obediently went to Pharaoh, and they did as the Lord had commanded. Aaron threw down his staff in front of Pharaoh, and it turned into a snake. Then Pharaoh called for his wise men and magicians, and the magicians did the

same with their witchcraft; each threw down his staff and each staff became a snake. But Aaron's snake swallowed up the snakes of the magicians. Pharaoh remained obstinate and he would not listen to Moses and Aaron.

Then the Lord said to Moses, 'In the morning go and wait on the bank of the Nile till Pharaoh comes, then say to him, "The Lord has sent me to tell you: Let my people go to worship me in the desert. So far you have not listened to my message. But you shall learn that I am the Lord by this: all the river water shall be changed into blood, even down to the contents of every tub or jar." ' So Moses and Aaron did as the Lord told them. In the presence of Pharaoh and all his court, Aaron raised his staff and struck the waters of the Nile, and all the water in the river and in the whole of Egypt changed to blood. The fish in the river died, and the river smelt so foul that the Egyptians could not drink from it. But the magicians of Egypt used their witchcraft to do the same, so Pharaoh was not impressed; he remained obstinate and would not listen to Moses and Aaron. Nevertheless, for the next seven days, all Egypt was digging holes along the river banks in search of water to drink.

Then the Lord said to Moses, 'Go to Pharaoh and tell him, "The Lord says: If you refuse to let my people go to worship me, I will plague the whole of your country with frogs. The river will swarm with them; they will come into your palace, into your bedroom, on to your bed, into the houses of all your people, into your ovens, everywhere. They will even climb all over you, and over all your people." ' But Pharaoh refused. So at Moses' command, Aaron stretched out his hand over the waters of Egypt, and the frogs came up and covered the whole country. But once again the magicians were able to do the same with their witchcraft.

This time Pharaoh summoned Moses and Aaron and said,

'Beg the Lord to get rid of the frogs, and I promise to let the people go. So Moses pleaded with the Lord about the frogs, and the next day all the frogs died. The Egyptians piled them up in heaps and the whole country stank of rotting dead frogs. But as soon as the plague was ended, Pharaoh became as obstinate as ever.

So the Lord sent many other plagues on the Egyptians through Moses and Aaron. First he turned the dust into clouds of mosquitoes which attacked men and beasts. From this time onwards the magicians were not able to do the same things themselves and they said to Pharaoh, 'God really must be behind all this.' Then came great swarms of gad-flies, then a disease which killed off all the Egyptians' animals, then soot which caused boils and sores all over the Egyptians' bodies, then hailstorms which killed nearly all the crops and trees, and locusts which covered the whole ground and ate up any green plants and leaves that remained, and then for three days a complete darkness so thick that it could be felt. Sometimes Pharaoh agreed to a part of what Moses asked: he said that the Israelites could worship the Lord inside Egypt, or that they could only go a little way into the desert and not three days' journey, or that the men could go but not the women and children. But each time when it was over, Pharaoh broke his word and refused to let any Israelites go at all. And each time the Lord protected the Israelites from the plagues.

After the three days of darkness Pharaoh summoned Moses and said, 'You can go and worship the Lord and take your children with you, but your flocks and herds must remain here.' Moses replied, 'No! Our livestock, too, must go with us; not one head of cattle must be left behind: it is from our own livestock that we provide sacrifices in our worship of the Lord our God; until we reach the place, we do not know

what kind of sacrifice we shall have to offer to the Lord.'

But Pharaoh grew obstinate yet once again; he refused to let the Israelites go, and he said to Moses, 'Get out of my sight! See that you never appear before me again, for if ever you do, you shall die!' Moses retorted, 'You yourself have said the very thing: never again shall I appear before you! Here is what the Lord says to you, "Towards midnight I, the Lord, shall pass through Egypt. All the first-born in Egypt shall die: from the first-born of Pharaoh, the heir to his throne, down to the first-born of the maidservant at the mill, and all the first-born of the cattle. And throughout Egypt there will be such a wailing as never was heard before, nor will be heard again. But all the Israelites and their animals shall be safe, not even a dog shall bark at them, and so you will learn that the Lord sees the difference between Egypt and Israel." Then all the people of your court will come down to me and bow low before me and say, "Go away, you and all the people who follow you!" After this, I shall go.' And, hot with anger, Moses left the room. But Pharaoh still refused to let the Israelites leave Egypt.

THE ISRAELITES LEAVE EGYPT FOR EVER

After Moses had left Pharaoh's palace for the last time, the Lord said to Moses and Aaron, 'Tell all Israel this: "On the tenth day of this month and every year after, each family is to take one male sheep or goat without any fault. On the fourteenth day of the month all Israel is to slaughter these animals, and blood from them must be smeared over the doorframe of every house where an animal is eaten. That

85

night, the whole animal is to be roasted over the fire; it must be eaten with unleavened bread and bitter herbs, and not raw or boiled. You are to burn any parts left over. You are to eat it hastily, with a girdle round your waist, sandals on your feet, and a staff in your hand—all ready for a journey. It is to be a passover feast in honour of the Lord, because that night I will go through Egypt and strike down all the first-born, both man and beast. I am the Lord and I shall deal out punishment to all the gods of Egypt. But when I see the blood on your doorframes, I will pass you over and you shall escape my power of destruction.

'"You are to make this day a day of festival, for ever, and every year you must celebrate it as a feast in honour of the Lord, when Israel will remember how the Lord brought them out of Egypt this day. On this fourteenth day of this first month of your new year, you are to get rid of all leaven from your houses, and you are to hold a sacred gathering on this day and again seven days later; on these two days no work is to be done, and you are allowed only to prepare your food. From the evening of this fourteenth day for seven days until the evening of the twenty-first day, you are to eat unleavened bread. This feast of Unleavened Bread cannot ever be changed; it must be kept by everyone, whether they are strangers or native-born, and wherever they live."'

Moses summoned all the elders of Israel and told them what the Lord had said. He also said to them, 'You must keep these rules for all time, you and your children. And you must explain to your children why this Passover festival is kept.' And the people of Israel bowed down and worshipped. Then they went off and did as the Lord had ordered.

At midnight the Lord struck down all the first-born in Egypt, from the first-born of Pharaoh, heir to his throne, down to the first-born of the prisoner in his cell, and the first-

born of all the cattle. All the Egyptians got up in the night, shouting and wailing, for someone had been struck dead in every house in the land. And during the night Pharaoh summoned Moses and Aaron and said, 'Rouse yourselves and the whole of Israel, and get away from my people. Go quickly with your flocks and herds and offer worship to the Lord as you have asked. And ask a blessing on me too.' Then the Israelites asked the Egyptians for silver ornaments and gold, and for clothing, just as Moses had told them to. The Egyptians were in such a hurry to make them go, that they gave them whatever they asked and lost much of their possessions.

Then the Israelites left Egypt to go to Canaan, with all their sheep and cattle in immense droves. The men alone numbered about six hundred thousand, not counting their families. They had been driven out of Egypt very suddenly, with no time to collect food for the journey, and so for the first few days after leaving they baked cakes with the unleavened dough which they had brought from Egypt.

The Lord went in front of them to guide them, by day as a pillar of cloud and by night as a pillar of fire to give them light. And the cloud and the fire never failed them. So they were able to continue their march either by day or by night.

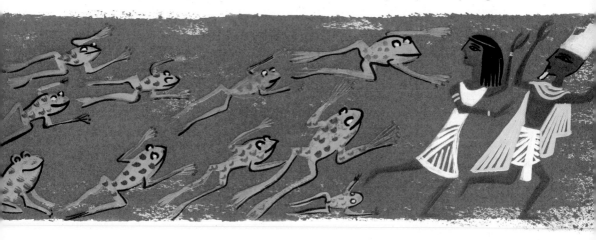

CROSSING THE RED SEA ON FOOT

Now on the journey from Egypt to Canaan, God did not send the Israelites through the land of the Philistines, although that was the shortest way, because he thought that if they had to fight off the Philistines they might lose heart and turn back to Egypt. Instead, God led them by a round-about way through the desert to the Red Sea. So when the Israelites had left Succoth and arrived at Etham on the edge of the desert, the Lord spoke to Moses and said, 'Tell the people of Israel to turn back and pitch camp between Migdol and the sea, in front of Pi-hahiroth and facing Baal-zephon. If you pitch your camp opposite this place and near the sea, Pharaoh king of Egypt will say to himself, "Look how these Israelites wander this way and that, all over the country; they are lost in the desert." This will make Pharaoh's heart stubborn and he will set out in pursuit of you. But there will be glory for me at the expense of Pharaoh and all his army, and the Egyptians will learn that I am the Lord.'

When Pharaoh was told that the Israelites had really gone away, he and his officials changed their minds. 'Why on earth' they said 'did we ever allow these people to leave the work they do for us?' Pharaoh then had his chariot harnessed; he gathered his troops together, and collected all the chariots in Egypt, each manned by a picked team. He became determined to pursue the Israelites, to put an end to their triumphant escape and bring them back to slavery in Egypt. So Pharaoh and the whole Egyptian army, with all their horses and their chariots, gave chase and caught up with the Israelites encamped beside the Red Sea near Pi-hahiroth, facing Baal-zephon. When Pharaoh got near, the Israelites looked up—and there were the Egyptians in

pursuit of them. Pharaoh and his whole army were actually pitching camp some distance off! The Israelites were terrified and prayed to the Lord at the tops of their voices. Then they turned on Moses and said, 'Were there no graves for us in Egypt, so that you had to lead us out into the desert to die? What good have you done us, bringing us out of Egypt? Did we not warn you of this in Egypt? Leave us alone, we said, we would rather work for the Egyptians! Better to work for the Egyptians than die in the desert!' Moses answered the people, 'Have no fear! Stand firm, and you will see what the Lord will do to save you this very day: the Egyptians you see today, you will never see again. The Lord will do the fighting for you: you have only to leave everything to him.'

Then the Lord said to Moses, 'Why do you cry out to me so? Tell the Israelites to march on. As for you, raise your staff and stretch out your hand over the sea and it will divide in two so that the Israelites can walk through the middle on dry ground. As for me, I will let the heart of the Egyptians become so obstinate that they will follow the Israelites into the sea. So there will be glory for me at the expense of Pharaoh and all his army, his chariots, and his horsemen. And when I have won this glory, the Egyptians will learn that I am the Lord.'

Then the angel of the Lord, the pillar of cloud which went in front of the army of Israel, changed position; it moved behind the army and remained there, between the camp of the Egyptians and the camp of Israel, so that the two armies could not see each other or move any closer. As night fell, Moses stretched out his hand over the sea, and the Lord drove back the sea with a strong easterly wind all night, so that the waters divided and the sea became dry land. The Israelites started to march right on to the seabed on dry ground, between walls of water to right and to left of them.

The Egyptians realised what was happening; they gave chase and marched right on to the seabed after them—all Pharaoh's horses, his chariots, and his horsemen.

Now the Lord was watching the Egyptians from the pillar of fire and cloud, and in the last hours of darkness he threw their army into confusion. He so clogged their chariot wheels that they could scarcely move forwards. Then the Egyptians cried, 'Let us run away from the Israelites; the Lord is fighting for them and against us!' At this, the Lord said to Moses, 'Stretch out your hand over the sea, so that the waters may flow back again on the Egyptians and their

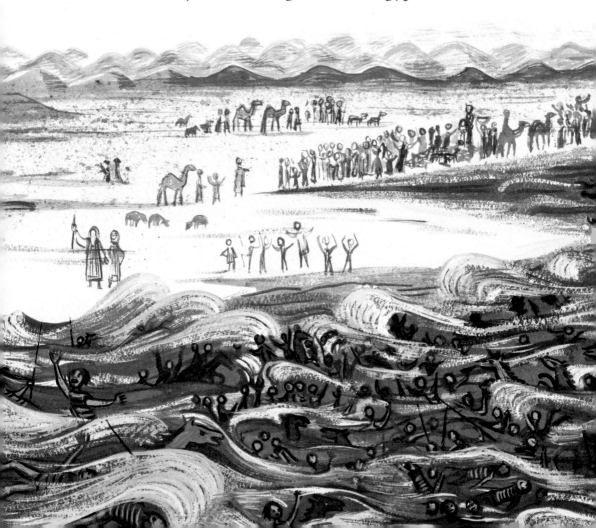

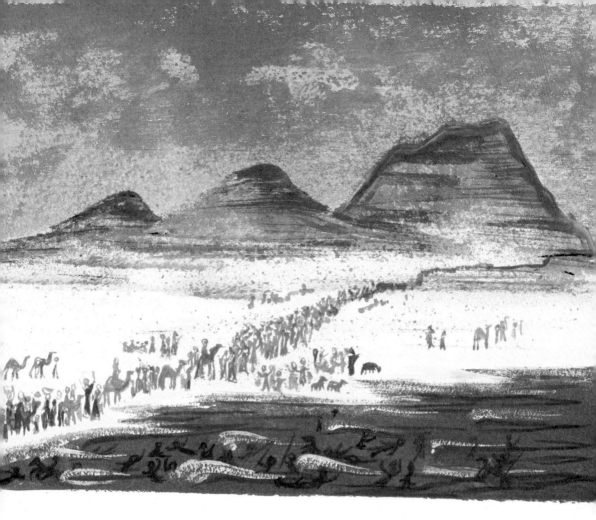

chariots and their horsemen.' Moses stretched out his hand over the sea and, as day broke, the sea returned to its usual place. The fleeing Egyptians were caught in the very middle of the sea, and the returning waters poured over the chariots and the horsemen of Pharaoh's whole army. Not a single one of them was left alive.

In this way the Lord overthrew the Egyptians and rescued Israel from them. That day, looking back across the sea from the far side, Israel saw the Egyptians lying dead on the shore. Israel witnessed this great act of the Lord against the Egyptians, and the nation worshipped the Lord; they put their faith in him and in Moses, his servant.

THE LONG DESERT JOURNEY BEGINS

After the Red Sea had divided and the Israelites had crossed it on dry land and escaped from the Egyptian army, Moses and the Israelites sang a song in honour of the Lord: 'The Lord is my strength and protects me. He is my God, I praise him. The Lord is a warrior, the Lord is his name. He has hurled the chariots and the army of Pharaoh into the sea and the best of his horsemen lie drowned.' Miriam the prophetess, who was Aaron's sister, took up a timbrel and all the women followed her with timbrels, dancing. And Miriam led them in the refrain: 'Sing of the Lord: he has covered himself in glory, he has thrown horse and rider into the sea.'

Moses made the Israelites move from their camp at the Red Sea, and they made for the desert of Shur where they travelled for three days without finding water. When they did find water, it was so bitter they could not drink it; this is why they named the place Marah. The people grumbled at Moses. 'What are we to drink?' they said. So Moses prayed to the Lord and the Lord showed him some wood lying on the ground; Moses threw this wood into the water, and it made the water sweet enough to drink. It was there that the Lord gave the Israelites rules and instructions to obey, and there he tested them.

Then the Lord spoke through Moses and said, 'If you listen carefully to the voice of the Lord your God and do what he says is right, if you pay attention to his commandments and keep his laws, I, the Lord, will not inflict on you the evils I inflicted on the Egyptians, for it is I, the Lord, who give you the healing you need.'

Then they came to Elim where there were twelve springs of water and seventy palm trees; and they pitched their camp there beside the water.

THE BREAD FROM THE SKY

From Elim the Israelites marched on and on till they reached a part of the desert between Elim and Sinai. Then all the people grumbled against Moses and Aaron, saying, 'Why did we not stay and die in Egypt? There at least we had meat and could eat bread to our heart's content! As it is, you have brought us to this desert and we shall starve to death!'

Then the Lord said to Moses, 'I have heard the complaints of Israel. Tell them, "In the evenings you shall eat meat, and in the mornings I will rain down on you as much bread as you could wish. Then you will learn that I, the Lord, am your God." Each day they are to go out and gather only enough for that day; this will test their obedience. On the sixth day they will find they have twice as much as usual.'

Moses and Aaron said to the Israelites, 'We are only the servants of the Lord. You are really complaining against him—and he has heard your complaints. The Lord says that in the evenings he will give you meat to eat, so that you may learn that it was he who brought you out of Egypt; and in the mornings he will give you all the bread you want, to show you his glory.' Then at Moses' command Aaron said to all Israel, 'You are in the presence of the Lord now!' And as Aaron spoke, all Israel looked out over the desert, and there was the glory of the Lord shining in the form of a cloud.

And it happened just as Moses had said: in the evening quails flew into the camp and covered it completely. In the morning there was dew all round the camp, and when the dew disappeared the ground was covered all over with a fine, powdery stuff like hoarfrost. The Israelites could not understand what it was. 'That' said Moses 'is the bread the Lord gives you to eat. Everyone must gather enough for his needs, one measure for each member of each family; but no

93

one is to keep any for the next day.' It was white and tasted like wafers made with honey. They called it 'manna'. When they measured what they had collected, each man found he had collected what he needed. This happened every morning. Afterwards, when the sun grew hot, the manna melted away. But there were some people who did keep part of the manna for the next day, and it bred maggots and smelt foul. Moses was angry with them.

On the sixth day they were all surprised to find that they had collected twice as much food as usual. So all the leaders came to tell Moses about it and he said, 'Here is the Lord's command: Tomorrow, the seventh day, is to be a day of complete rest, a sabbath day sacred to the Lord. Today, bake or boil whatever you want to; then put aside for tomorrow all that is left.' So they did this. On the next day, the seventh, the manna did not smell foul, and there were no maggots in it. Moses said, 'Eat it today, for today you will not find any on the ground.' Some people still went out to collect manna, but they found none. Then the Lord said to Moses, 'How much longer will you refuse to keep my laws? Listen! I arranged this sabbath day specially for you. That is why I gave you two days' food on the sixth day. On the seventh day everyone must stay at home and must not go out to work.' So on this day no one did any work at all.

Moses also said, 'This is the Lord's command: Everyone is to fill a jar with manna and keep it for their descendants, to let them see the food that the Lord gave you in the desert.' Then on Moses' order, Aaron put a jar full of manna in front of the Lord's place, to be kept there for Israel's descendants.

The Israelites were to live on manna for forty years more, until at last they got out of the desert and into a country with people in it, on the borders of the land of Canaan.

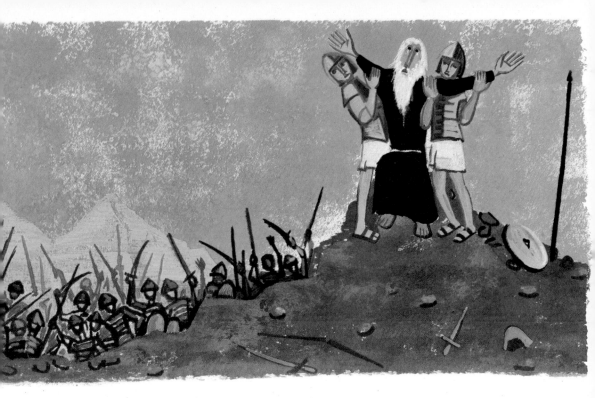

VICTORY OVER THE AMALEKITES

At the Lord's command, all Israel left the desert camp between Elim and Sinai. They came to a place called Rephidim and camped there, although there was no water to drink.

The Amalekites came to attack them. Moses said to Joshua, 'Choose your men, and march out tomorrow morning to fight. I will stand on the hilltop, with God's special staff in my hand.' Next morning, Joshua marched out to engage Amalek, while Moses and Aaron and Hur went to the top of the hill. Everyone noticed that as long as Moses kept his arms raised, Israel got the better of the Amalekites; and when Moses let his arms fall, Amalek gained the advantage. Moses' arms grew very tired, so Aaron and Hur fetched a stone for him to sit on and they held up his arms, one on one side, one on the other. In this way, Moses' arms were firmly held up till sunset, and by that time Joshua and his fighters were able to wipe out Amalek and all his tribesmen.

THE TEN COMMANDMENTS

Three months after the Israelites left Egypt, they reached the desert of Sinai and pitched camp facing the Sinai mountain.

Then Moses climbed up the mountain to meet God, and the Lord called to him from the mountain and said, 'Say this to the Israelites, "You yourselves have seen what I did with the Egyptians, how I brought you safely here to meet me. From this you know that now, if you obey me and keep the pact I made with you, you shall be my special nation among all the others, because I can do what I like with the whole earth. I will be your king and every one of you shall be a person specially set aside to serve me."' So Moses came down and told the elders of Israel all that the Lord had said. Then all the people answered, 'We will do what the Lord has said.'

Moses climbed the mountain again to give the people's answer, and the Lord said, 'I am coming to you in a thick cloud so that the people may hear when I speak to you and may trust you always. Tell them to spend today and tomorrow washing their clothes and getting ready for the third day when I will be present on Mount Sinai. The foot of the mountain is to be marked out and you are to tell the people, "Take care not to go up the mountain or to touch the foot of it; any person or animal who does, is to be stoned to death or shot; no one must touch them." They are to go up the mountain only when the ram's horn sounds a long blast.' So Moses came down and the people did as the Lord had commanded.

On the third day, just as dawn was breaking, lightning flashed over the mountain and there was a roar of thunder and a noise like a gigantic trumpet. A thick cloud rolled down over the mountain, and in the camp everyone trembled with fear. Moses knew that the Lord had come to them in the form of fire, and he led Israel out of the camp to meet God.

As they stood at the bottom of the mountain, it was all covered in smoke which shot up into the air as from a furnace. The whole mountain shook violently. The trumpet sound grew louder and louder and louder still. Moses spoke to God and God answered him from the top of the mountain with roars of thunder; and he called Moses to go up and said, 'Go and warn the people not to come beyond the limits marked out, to try to see me, or many will die. Even the priests must make themselves clean before they come near the Lord, or the Lord's power will break out against them.' Moses replied, 'But you have already warned us about that.' So the Lord said, 'Go down and fetch Aaron.'

Then God spoke these words: 'I am the Lord your God who brought you out of Egypt and out of slavery.

'You are to have no gods except me.

'You are not to make yourself a model of anything at all in order to bow down before it or worship it.

'You are not to say my name, except carefully and respectfully.

'Remember, every seventh day is a holy day for the Lord your God, and no one is to do any work on that day.

'Everyone is to respect his father and his mother.

'You are not to kill.

'You are not to take another man's wife or another woman's husband.

'You are not to steal.

'You are not to say anything untrue against another person.

'It is wrong to want to get hold of anything that belongs to someone else.'

Moses then went near to the dark cloud where God was. But all the rest of the people shook with fear at the rumbling of the thunder, the flashes of lightning, the trumpeting sound, and the smoking mountain; and they kept their distance.

THE GOLDEN CALF

After the Lord had given the people of Israel the ten commandments, he called Moses to go up onto Mount Sinai again and gave him many more rules and plans for the people. Last of all the Lord gave Moses two stone tablets on which was written God's Law for Israel. The writing was on the front and the back of both tablets and was made on them by the finger of God. The tablets were the work of God.

Moses had stayed up on the mountain talking with God for forty days and forty nights. This was so long that the Israelites began to think he had disappeared for good. So they gathered round Aaron and said to him, 'Come, make us a god to go at the head of us and lead us; we do not know what has become of this Moses, the man who brought us out from Egypt.' Aaron answered them, 'Bring me all the gold rings you have.' So they all took the gold rings from their ears and Aaron melted the metal down in a mould and cast a model of a calf. Then the people began to shout, 'Israel, here is your God who brought you out of Egypt!' When Aaron saw this, he built an altar in front of the model and said, 'Tomorrow will be a festival in honour of the Lord.'

And so, early the next day the Israelites offered sacrifices to the golden calf on the new altar. Then all the people sat down together to eat and drink at a special feast. After that, they began to make merry with singing and music and dancing and all kinds of amusements.

Then the Lord said to Moses on the mountain, 'Go down now, because your people have turned against me. They have been quick to leave the way I marked out for them; they have made themselves a metal calf and have worshipped it and offered sacrifices to it. They have said of it, "This is your God, Israel, who brought you out of Egypt!" I can see how

wilful these people are! Leave me, now; my anger shall blaze out against them and destroy them. But I will still make you yourself into a great nation.'

But Moses pleaded with the Lord and said, 'Lord, why should your anger blaze out against this people of yours whom you brought out of Egypt? Why give the Egyptians the chance to say, "Aha, it was in treachery that the Lord led them away, only to do them to death in the mountains and so wipe them off the face of the earth"? Let go of your burning anger, change your mind and do not bring this disaster on your people. Remember the promise you made to Abraham, Isaac and Jacob: I will make your descendants as many as the stars of heaven, and I will give them all this land as I promised to you, and it shall be theirs for ever.' So the Lord gave up his anger and Moses then made his way back down the mountain carrying the two stone tablets of the Law.

Joshua heard the noise of the people shouting, so he went to meet Moses and said, 'It sounds just as if there is a battle going on in the camp.' Moses answered, 'This sound is no song of victory, nor is it a wailing for a defeat. It is the sound of chanting and merrymaking.'

As Moses approached the camp and saw the calf and the people dancing, his anger blazed. He threw down the stone tablets and broke them at the foot of the mountain. He seized the calf and burned it, grinding it into powder which he scattered on the water; then he made the Israelites drink the water. Moses said to Aaron, 'What has this people done to you, for you to bring such a great sin on them?' Aaron answered, 'Do not be so furiously angry. You yourself know how easily this people gets into evil ways. They said to me, "Make us a god to go at our head and lead us; we do not know what has become of Moses." So I said to them, "Who

has gold?", and they took off their gold ornaments and brought them to me. I simply threw the gold into the fire and out came this calf.'

When Moses saw that the people were quite out of control, he stood at the camp gate and shouted, 'Whoever is true to the Lord, gather round me.' All the tribe of Levi gathered round, and he said, 'This is the message of the Lord: put on your swords and quarter the camp from gate to gate and kill a brother, a friend or a neighbour.' The Levites obeyed, and many thousands were killed that day as a punishment for worshipping the golden calf.

Then Moses went up the mountain again to ask the Lord to forgive the people for turning against him. The Lord said, 'Leave this place with all the people and go on towards

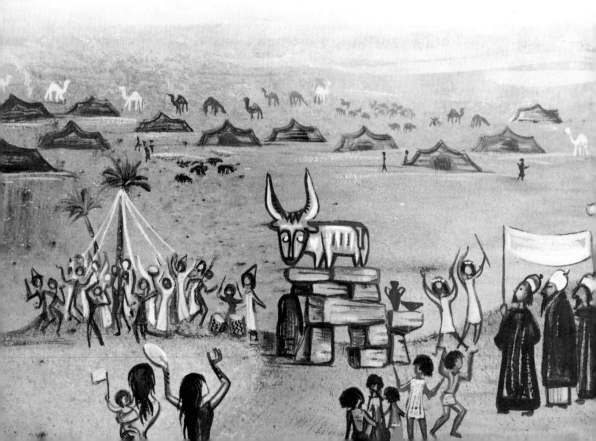

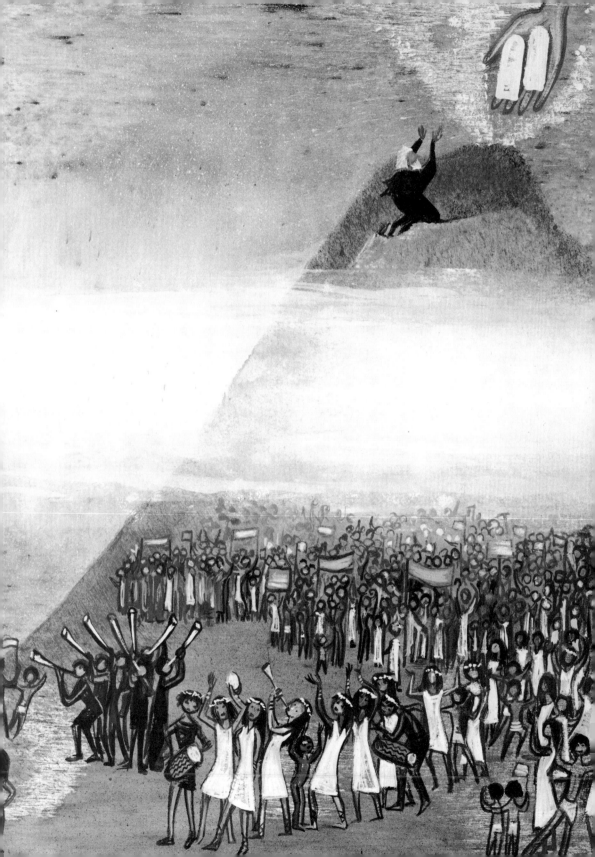

the land I said I would give you. But first cut two more tablets of stone like the first ones and come up to me on the mountain, and I will write on them the same words that were on the first tablets.' Moses did this. When he finally came down from the mountain and reached the camp, Aaron and all the people saw that his whole face shone with radiance; it shone so much that no one dared go near him.

THE SPIES SENT INTO CANAAN

The Lord spoke to Moses and said, 'Send out the leader from each tribe to go and find out something about this land of Canaan which I am giving to the Israelites.'

Moses sent them to spy out the land of Canaan, saying, 'Go up into the Negeb, then into the highlands. See what sort of country it is, good or poor, fertile or barren, wooded or open; and what sort of people there are, strong or weak, few or many; what sort of towns they have, open or fortified. Be bold, and bring back some of the produce of the country.'

The leaders went off to spy out the land, from the desert of Zin to Rehob, the Pass of Hamath; and through the Negeb as far as Hebron, where the Anakim tribe lived. It was the season for early grapes and they came to a vine-growing valley. There they cut off a branch with a cluster of grapes, which two of them carried away on a pole, as well as pomegranates and figs. This place was later called the Valley of Eshcol, after the cluster of grapes.

At the end of forty days, the spies came back and made contact with Israel in the desert of Paran, at Kadesh. They showed them the produce of the country and reported,

'There is certainly plenty of milk and honey. But the inhabitants are a powerful people; the towns are fortified and very big; yes, and we saw the descendants of Anak there. The Amalekites hold the Negeb area, the Hittites, Amorites and Jebusites hold the highlands, and the Canaanites hold the sea coast and the banks of the river Jordan.'

Caleb, one of the spies, made a big speech to the people gathered round Moses, and said, 'We must march in and conquer this land: we are well able to do it.' But the men who had gone with him answered, 'We are not able to march against this people; they are stronger than we are.' And they began to point out all the difficulties, saying, 'The country we went to spy on is a country that devours its inhabitants. Every man we saw there was of enormous size. Yes, and we even saw giants there; beside them we felt like grasshoppers, and so we seemed to them.'

At this, the whole people of Israel raised their voices in protest and cried aloud, wailing all that night. Then all the Israelites grumbled against Moses and Aaron, and the whole nation said, 'If only we had died in the land of Egypt, or at least in this desert! Why does the Lord bring us to this land, only to have us die by the sword, and our wives and children taken captive? Should we not do better to go back to Egypt?'

Then the Lord spoke to Moses and Aaron and said, 'Tell the people of Israel this: "I swear that you shall not enter the land where I promised most solemnly to settle you. It is Caleb and Joshua and your young children that you said would be taken captive, it is these I shall bring in to know the land you have been too proud to accept. As for you, your dead bodies will fall in this desert, and your sons will be wanderers in the desert for forty years; they will pay the price of your lack of faith, until the last of you lies dead in the desert."'

MOSES WILL NEVER REACH CANAAN

At Kadesh there was no water for the people, and they were all united against Moses and Aaron. The people held a meeting and challenged Moses, saying, 'We would rather have died as our brothers died who rebelled against the Lord! We are the Lord's own people. Why did you bring us into this desert, only to let us die here, both we and our cattle? Why did you lead us out of Egypt, only to bring us to this wretched place? It is no good for sowing seed, it has no figs, no vines, no pomegranates, and not even water to drink!'

Moses and Aaron left the gathering and went to the door of the Tent of Meeting. They threw themselves face downward on the ground, and the glory of the Lord came and appeared to them. The Lord spoke to Moses and said, 'Take this branch and call all the people together, you and your brother Aaron. Then, in full view of them, order this rock to give water. You will make water flow out of the rock, and so you will provide drink for the people and their cattle.'

Moses took up the branch from in front of the Lord's place, as he had been told. Then Moses and Aaron called the people together in front of the rock and addressed them: 'Listen now, you rebels. Shall we make water gush from this rock for you?' And Moses raised his hand and struck the rock twice with the branch. A great stream of water gushed out, and all the people drank and their cattle too. They called this place the waters of Meribah, for here the people of Israel challenged the Lord and the Lord made his holiness plain for all to see.

But the Lord said to Moses and Aaron, 'In the past you failed to trust that I could make my holiness plain to the eyes of the people of Israel. For this reason you shall not lead this people into the land I am giving them.'

THE DEATH OF MOSES

After Moses had told Israel that Joshua would lead them into Canaan, the Lord said to Moses, 'The time is near when you must die. Summon Joshua and take your usual places at the Tent of Meeting, so that I may give Joshua his orders.'

Later that day the Lord said to Moses, 'Climb Mount Nebo, in the land of Moab opposite Jericho, and look out over the land of Canaan which I am giving to Israel as their own. When you have climbed the mountain you will die there, just as your brother Aaron died on Mount Hor. You may see this land only from far off and you cannot enter it, because you broke faith with me that time at Meribath-kadesh in the desert of Zin and because you did not show my holiness among the people of Israel.'

So Moses climbed up Mount Nebo opposite Jericho. There, the Lord showed him the whole land of Canaan: Gilead as far as Dan, all Naphtali, the land of Ephraim and Manasseh, all the land of Judah as far as the Western Sea, the Negeb, and the stretch of the Valley of Jericho, the city of palm trees, as far as Zoar. The Lord said, 'This is the land I promised to Abraham, Isaac and Jacob, and their descendants. I have let you see it, but you shall not cross into it.' And there, still in the land of Moab on Mount Nebo, Moses died, just as the Lord foretold. He was buried in the valley below, opposite Beth-peor; but to this day no one has ever found his grave. Even though Moses was a hundred and twenty years old when he died, his sight was still good and he was full of vigour. Israel mourned him for thirty days in the plains of Moab. Then Joshua son of Nun was filled with the spirit of wisdom, for Moses had laid his hands on him; and the people of Israel obeyed Joshua, carrying out the order that the Lord had given to Moses.

Since then, never has there been such a prophet in Israel as Moses, the man whom the Lord knew face to face. All Israel will remember the power and the dignity of Moses.

THE INVASION OF CANAAN

When Jabin, king of Hazor, heard the Israelites were coming, he sent word to all the nearby kings, They all met together by the waters of Merom with their soldiers and horses and chariots, to fight against Israel. The Lord said to Joshua, 'Have no fear; tomorrow Israel shall completely slaughter them.' Joshua did succeed in surprising and defeating them. Then he captured Hazor itself; every living creature there was killed and the city burned. For a long time Joshua was at war with all the other cities, except Gibeon; but he conquered them one by one. Finally he wiped out the Anakim tribe everywhere except in Gaza, Gath and Ashdod. So, just as the Lord had told Moses, Joshua became master of the whole country, and he divided it among the tribes of Israel. Then the whole country had rest from war.

SAMUEL AND ELI

Elkanah had two wives, Peninnah and Hannah. Peninnah had children but Hannah had none. Because of this, Peninnah would mock Hannah every year when the family went to the special sacrifices in the Temple at Shiloh. So Hannah went to the Temple and prayed for a son. She promised to offer the boy for special service to the Lord in the Temple. When Eli the priest saw her staying there a long time, moving her lips but making no sound, he accused her of being drunk. 'No, I am not drunk,' Hannah replied 'but in great trouble and I am asking the Lord to help me.' 'May God grant what you have asked.' said Eli 'Go in peace.' In time Hannah did have a son, called Samuel. When he was old enough, she took him to the Temple and left him there with Eli for special service of the Lord.

Now Eli had two sons, Hophni and Phinehas, who were scoundrels. They cared nothing for the Lord. Whenever a man offered a sacrifice of meat, they would threaten him and force him to give them some before it was cooked. This was very wrong. Eli heard what his sons were doing and he warned them; but they did not listen to their father's words. Then a holy man came to Eli and said, 'The Lord says, "Why do you respect your sons more than me, by letting them grow fat on the best part of all the offerings? I will break your strength. What happens to your two sons shall be a warning for you: in one day both shall die. I insist on having a faithful priest who will do whatever I plan and whatever I desire."'

Meanwhile the boy Samuel went on growing up, and more and more the Lord and all the people thought well of him.

GOD SPEAKS TO SAMUEL

In time, the boy Samuel became a helper for Eli in serving the Lord. In those days the Lord hardly ever spoke to his people, and visions were rare. One evening, Eli was lying down in his room, for his eyes were beginning to give trouble and he could no longer see properly. The lamp of God had not yet gone out, and Samuel was lying down in the holy place where the ark of God was kept, when the Lord called out, 'Samuel! Samuel!' The boy shouted, 'Here I am', and ran to Eli and said, 'Here I am. You called me?' Eli said, 'I did not call. Go and lie down.' So Samuel went and lay down. Once again the Lord called out, 'Samuel! Samuel!' The boy got up and went to Eli again and said, 'Here I am. You called me?' Eli replied, 'I did not call you, my son; go and lie down.' Samuel did not yet know anything about the Lord, and the Lord's message had not yet been made clear to him. Once again the Lord called, a third time. Samuel got up and went to Eli and said, 'Here I am, for you did call me!' Then Eli understood that it was the Lord who was calling the boy, and he said to Samuel, 'Go and lie down, and if someone calls, say this, "Speak, Lord, your servant is listening."' So Samuel went and lay down.

Then the Lord came and actually stood by him, calling as he had done before, 'Samuel! Samuel!' Samuel answered, 'Speak, Lord, your servant is listening.' Then the Lord said to Samuel, 'I am about to do something in Israel which will stagger everyone when they hear about it. On that day, I will carry out against Eli everything I have spoken about his family, from beginning to end. You are to tell him that I condemn his family for ever because he has known that his sons have been cursing God, yet he has done nothing about it. Therefore I promise that no sacrifice or any offering shall

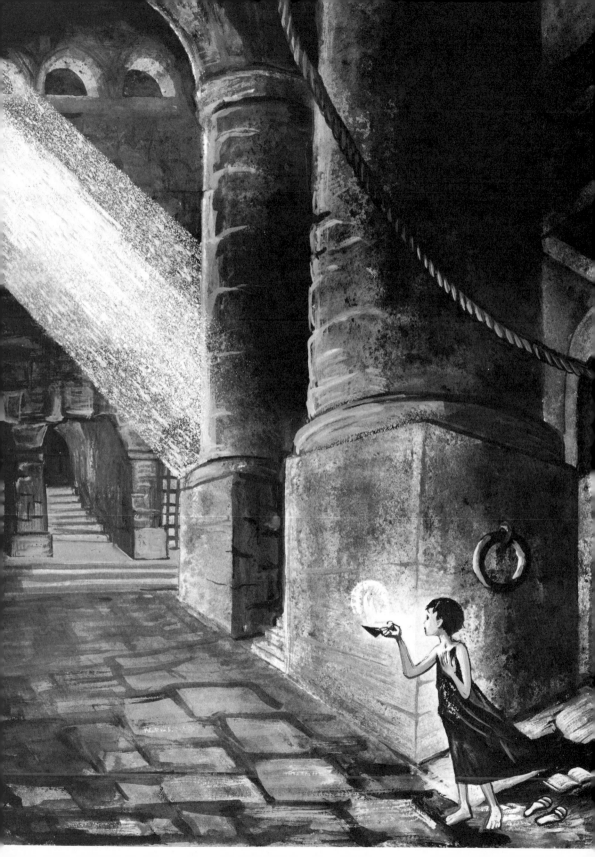

ever wipe out the guilt of the family of Eli.'

At this news, Samuel lay very still and did not sleep a wink. When morning came and he started on his job of opening up the Temple doors, he was afraid to tell the vision to Eli. But the priest called him and said, 'What message did the Lord give you? Do not hide it from me. May God's anger strike you, if you keep back anything of what he said to you.' Samuel then told him everything, keeping nothing back from him. Eli said, 'He is the Lord; let him do what he thinks good.'

Samuel grew up into a man and the Lord was with him and continued to appear in Shiloh. People paid a lot of attention to whatever Samuel said, and all Israel, right from Dan as far as Beersheba, came to realise that Samuel was truly a prophet of the Lord. By then Eli was very old indeed and his sons still continued their wicked behaviour.

THE DEATH OF ELI

Once, when the Israelites were encamped near Ebenezer, the Philistines began to gather at Aphek to fight them. The battle was a hard one; Israel was defeated and about four thousand of their army were killed. When the remaining troops returned, the elders of Israel said, 'Why has the Lord allowed us to be defeated today? Let us fetch the ark of our God from Shiloh so that we may have it with us and be rescued from our enemies.' So the two sons of Eli, Hophni and Phinehas, went to Shiloh with an escort of troops to fetch the ark. When the ark arrived, the whole of Israel cheered so loudly that the ground shook. The Philistines heard the noise and

said to themselves, 'What on earth can this mean?' When they realised that the ark had come into the Israelite camp, they were afraid and cried out, 'God has come to the Israelite camp. Who will save us now from the power of this mighty God who struck down Egypt with every kind of plague?' But they plucked up courage and said, 'Philistines, let us be men, or we will become slaves to the Hebrews just as they were slaves to us. Be men and fight!' So they joined battle and Israel was routed again with great slaughter. The two sons of Eli were killed and the ark itself was captured.

One man ran all the way from the battle and reached Shiloh that same day, with his clothes torn and dust on his head. When he arrived, Eli was sitting beside the town gate watching the road, for he was very worried about the ark. The news the man brought set the whole town in an uproar. Eli heard the shouting and asked, 'What is this great noise all about?' The man said to Eli, 'I have escaped from the battle today. Israel's army has been utterly routed by the Philistines. Your two sons are dead and the ark of God has been captured.' When he heard about the ark, Eli fell backwards off his seat and broke his neck, for he was old and heavy. So he died, and his rule of forty years over Israel was ended.

VICTORY OVER THE PHILISTINES

The Philistines kept the ark of the Lord in their country for seven months. But it brought disaster to every town where it was put. So they called for their priests and diviners and asked, 'What shall we do with the ark of the Lord? Tell us

how to send it back to where it belongs.' They replied, 'You must not send it away empty, but with an offering. You must make golden models of the boils and the rats that ravage you, and put them in a box beside the ark on a new cart drawn by two cows. Then let the cows go their own way. If they go up the road to Beth-shemesh, then it was the Lord who caused our troubles; but if not, then we will know that all this happened to us by chance.'

The people did this, and the cows pulling the cart made straight for Beth-shemesh with the Philistine chiefs following behind to watch. Now the people of Beth-shemesh were out harvesting wheat, so they saw the ark coming. They went joyfully to meet it and at once sent messengers to the people of Kiriath-jearim on the hill, saying, 'The Philistines have sent back the ark of the Lord; come down and take it up to safety in your town.'

Twenty years passed, and the whole of Israel longed for the Lord to be with them again. So Samuel said to them, 'If you really want to go back to the Lord, put aside your foreign gods and serve only him.' The Israelites agreed, and Samuel told them all to gather at Mizpah where he would plead with the Lord for them. But the Philistines got to know about this. So they marched against the Israelites, and even as Samuel was offering a sacrifice to the Lord, they came up to give battle. But the Lord thundered with a great noise and terrified the Philistines; so they were routed and driven away by Israel at last.

Samuel built an altar in honour of the Lord at Ramah, his home town. For as long as he lived he was judge over Israel. The Philistines were so afraid of him that they no longer invaded Israel and there was peace.

SAUL AND SAMUEL

When Samuel grew old, he made his two sons, Joel and Abijah, judges over Israel. But his sons did not follow his example; they were greedy for money, they took bribes and they judged unjustly. So all the elders of Israel gathered at Samuel's home in Ramah to complain. They said, 'You are old, and your sons are no good. Give us a king, like other nations.' Samuel thought that a king was not at all a good idea, so he prayed to God. But the Lord said, 'It is not really you the people hate, it is me. Ever since I brought them out of Egypt they have served other gods and turned against me —now they are turning against you too. So obey their voice; only, you must warn them about the power a king would have over them.' Samuel warned the people, but they cried, 'No! We want a king to rule us and lead us in battle.'

Now there was a man called Kish and he had a very handsome son named Saul who was head and shoulders taller than anyone else. Some of Kish's donkeys had strayed, so Saul went to find them. When he got as far as the land of Zuph, he said to his servant, 'Let us go back before my father gets worried.' The servant suggested they should ask help from a prophet in the nearby town. As they went up the slope to the town, they met some girls going out to draw water. The girls told them, 'Yes, there is a sacrifice today and the prophet has just arrived. You will meet him as soon as you enter the town.'

Now the Lord had given Samuel a vision the day before, saying, 'Tomorrow I will send you a man from the land of Benjamin; you are to anoint him king over Israel.' When Samuel saw Saul, the Lord told him, 'That is the man; he shall rule my people.' Saul met Samuel in the gateway and said, 'Where is the prophet's house?' Samuel replied, 'I

am the prophet. Do not worry about the donkeys; they have been found. In any case, all the wealth of Israel is to belong to you.' Saul was quite mystified and said, 'But I am from the tribe of Benjamin, the smallest in Israel. And my family is the least of all in the tribe. Why do you say such things to me?'

Samuel then took Saul to his house to eat, and bedding was spread out on the house-top for him to sleep on. At day-break Samuel called to Saul, 'Get up; I must leave.' They walked to the end of the town, where Samuel said, 'Stand still for a moment.' He took a little bottle of oil, poured it on Saul's head and kissed him, saying, 'Now the Lord has anointed you king over Israel. You are to rule the Lord's people and save them from their enemies. This oil is the sign.'

THE ANOINTING OF THE BOY DAVID

Saul proved to be a bad king of Israel, so the Lord turned against him. The Lord said to Samuel, 'You know I no longer accept Saul as king of Israel. How much longer will you go on grieving over this? Take a supply of the special oil with you and go. I am sending you to Jesse of Bethlehem, for I have chosen one of his sons to be king.' Samuel replied, 'How can I go? When Saul hears of it he will kill me.' Then the Lord said to Samuel, 'Take a young cow with you and say, "I have come to sacrifice to the Lord." Invite Jesse to come to the sacrifice, and then I myself will tell you what to do.'

So Samuel did what the Lord ordered and went to Bethlehem. The elders of the town came out trembling to meet him and asked, 'Have you come with a friendly purpose towards us?' 'Yes,' Samuel replied 'I have come to sacrifice

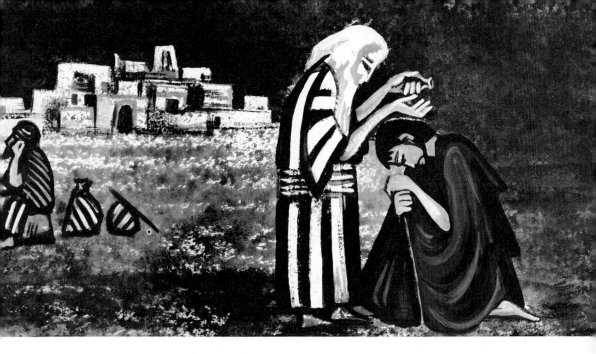

to the Lord. Make yourselves clean in the eyes of the Lord and come with me.' Samuel also invited Jesse and his sons.

When they arrived, Samuel caught sight of Eliab and thought, 'Surely the Lord's chosen man stands there before him.' But the Lord said to Samuel, 'Take no notice of his appearance or his height for I do not accept Eliab. God does not see as man sees; man looks at appearances but the Lord looks at the heart.' Jesse then called in his son Abinadab and presented him to Samuel, and Samuel said, 'The Lord has not chosen this one either.' Jesse then presented Shammah, but Samuel said, 'The Lord has not chosen this man either.' Jesse presented each of his seven sons to Samuel, but each time Samuel said to Jesse, 'The Lord has not chosen this one.' Then Samuel asked Jesse, 'Are these all the sons you have?' Jesse answered, 'There is still one left, the youngest; he is out looking after the sheep.' Then Samuel said to Jesse, 'Send for him; we will not sit down to eat until he comes.' Jesse sent for the boy whose name was David. His face had a fresh colour and he had fine eyes and a pleasant manner. The Lord said, 'Come, anoint this one, for he is the one I have chosen.'

At this, Samuel took his horn of oil and poured it over David where he stood with all his brothers. Then the spirit of the Lord came to David and stayed with him from that day on. As for Samuel, he rose and went back to his home in Ramah.

DAVID'S FIGHT WITH GOLIATH

Not so very long after David had been anointed by Samuel, the Philistines collected their troops together at Socoh, for war against Israel. They pitched camp between Socoh and Azekah. Saul and the Israelites pitched their camp in the Valley of the Terebinth. Then each army drew up its line of battle: the Philistines on the hills on one side of the valley and the Israelites on the hills the other side.

One of the Philistine shock-troopers stepped out from the ranks. His name was Goliath, from Gath; and he was nearly ten feet tall. On his head was a bronze helmet, and over his chest was a plate of bronze armour, made like fish-scales, which weighed over a hundredweight. He had bronze armour on his legs and a bronze javelin across his shoulders. His spear was as thick as a doorpost, and its iron head alone weighed about forty pounds. His shield was carried in front of him by a special bearer.

Goliath stood in front of Israel's army and shouted, 'Why bother to come out and get ready for battle? I am a Philistine and you are only the slaves of Saul. Choose one man to come down and fight me. If he wins and kills me, we will be your slaves; but if I beat him and kill him, you shall become our slaves. I challenge Israel today: send me a man and we will fight in single combat.' This happened every morning and

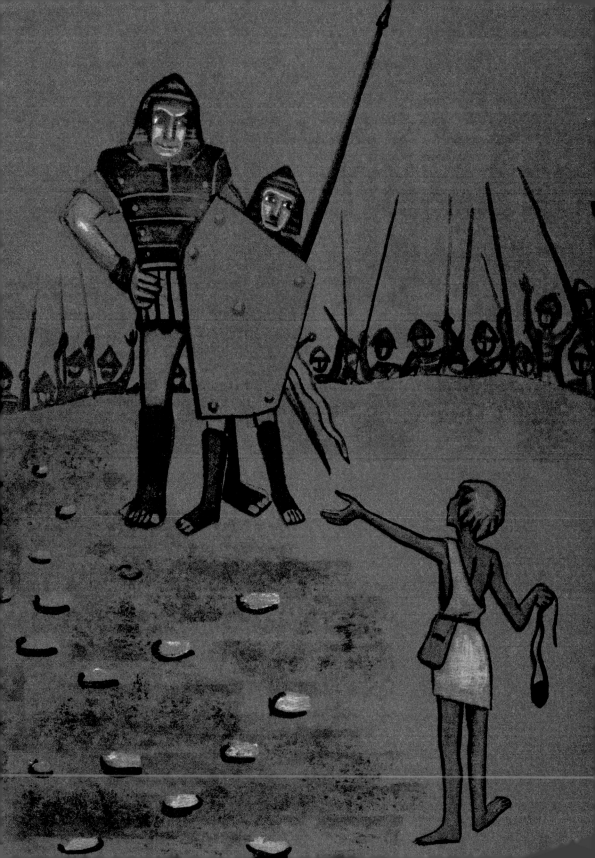

evening for forty days, and each day the Philistine army advanced a little bit nearer. Each time Saul and the Israelites heard the challenge, they were dismayed and terrified.

Now there was an old man called Jesse, of Bethlehem in Judah, who had eight sons. The three eldest were with Saul's army; their names were: the first-born Eliab, the second Abinadab and the third Shammah. Jesse's youngest son was called David. He spent some of his time serving Saul and at other times he looked after his father's sheep. One day Jesse said to David, 'Take this bag of roasted grain and these ten loaves to your brothers in the camp, and hurry! And take these ten cheeses to their commander. Ask him how your brothers are and bring me some message from them.'

David rose early the next morning and, leaving the sheep with someone to guard them, he went off with his load as Jesse had ordered. He came to the camp just as the troops, shouting their war cry, were leaving to take up battle stations facing the Philistines. David left the bundle in charge of the baggage guard, ran to the battle line and went to ask his brothers how they were.

While he was talking to them, Goliath came out from the Philistine ranks to give his usual daily challenge. As soon as the Israelites saw him coming, they were all terrified and ran away. They said to David, 'Do you see this man coming up now? He is coming to challenge Israel. If any man kills Goliath, the king will pour riches on him and will give him his daughter in marriage and grant his father's family the freedom of Israel.' Then David heard Goliath's challenge.

David wanted the men who were standing near him to repeat what they had just said, so he asked them, 'Will all that really be the reward of the man who kills this Philistine and removes the disgrace from Israel? Who does this pagan Philistine think he is, to insult the armies of the living God?'

The men repeated exactly what they had said before. Now Eliab, his elder brother, heard what David was saying to the men and he got angry with David. 'Why have you come down here?' he said. 'Whom have you left in charge of those sheep out in the desert? I know your insolence and your wicked heart; you have come just to watch the battle.' David retorted, 'What have I done wrong? Can't I even speak to people?' He turned away from Eliab to ask the same question of yet another man; and he got the same answer.

Some of the men took note of David's words and reported them to Saul, who sent for him. David said to Saul, 'No one ought to lose heart because of this Philistine; I am your servant and I will go and fight him myself. But Saul replied, 'You certainly cannot go and fight the Philistine; you are only a boy and he has been a warrior ever since his youth.'

But David said, 'I am your servant and I used to look after the sheep for my father. Whenever a lion or a bear came out and took a sheep from the flock, I used to follow it up and strike it down and rescue the sheep from its mouth. If it turned on me, I seized it by the hair round the jaw and struck it down and killed it. I have killed both lion and bear, and this pagan Philistine shall be like one of them, for he has dared to insult the armies of the living God. The Lord who rescued me from the claws of lion and bear will rescue me from the power of this Philistine.' Then Saul said to David, 'Go, and the Lord be with you!' He gave his own armour for David to wear, and a bronze helmet and a breastplate. He buckled his own sword over the armour. But David was not used to the weight of all these things and he could not move an inch. 'I cannot walk with these;' he said to Saul 'I am not used to them.' So they took them off again.

David took his staff in his hand, picked five smooth stones from the river bed and put them in his shepherd's bag. Then

with his sling in his hand, he went to meet Goliath. The Philistine, with his shield-bearer moving ahead of him, came nearer and nearer to David. Then he looked at David, and what he saw filled him with scorn, because David was only a youth, a nice-looking boy with a ruddy face. The Philistine said to him, 'Am I a dog that you come against me with sticks?' And he cursed David by his gods. The Philistine then said to David, 'If you come any closer, I will see that your flesh is given to the birds of the air and the beasts of the field.' But David answered the Philistine, 'You come against me with sword and spear and javelin, but I come against you in the name of the God of the armies of Israel, the Lord, whom you have dared to insult. The Lord will enable me to get the better of you. Today I shall kill you, cut off your head, and give your dead body and the bodies of the Philistine army to the birds of the air and the wild beasts of the earth. In this way all the earth shall know that there is a God in Israel, and all these people here shall know that it is not by sword or by spear that the Lord gives victory, for our God is lord of the battle and he will deliver you into our power.'

Just as the Philistine army started forward to slaughter David, David left the Israelite line of battle and ran closer to Goliath. Putting his hand in his bag, he took out a stone and slung it, striking the Philistine on the forehad. The stone went right into Goliath's forehead and he fell to the ground face downwards. Then David ran and stood over Goliath; he seized Goliath's sword and drew it from the scabbard, ran him through with it and cut off his head. So, with no sword and only a sling and a stone, David triumphed over Goliath the Philistine and struck him down and killed him.

The Philistines saw that their champion was dead and took to flight. The men of Israel and of Judah rushed forward, shouting their war cry, and pursued the enemy, leaving

wounded Philistines lying all along the road from Shaaraim towards Gath and Ekron. After finishing their pursuit of every last Philistine, the Israelites returned and plundered their camp. As for David, he brought Goliath's head to Jerusalem, and he kept Goliath's armour in his own tent.

DAVID AND JONATHAN

After David had killed Goliath, Abner brought him before King Saul, still carrying Goliath's head. There he met Saul's son Jonathan and they became very close friends. David was successful on many missions and was soon given men to command. On one occasion some women came out to greet the king with a song: 'Saul has killed his thousands, and David his tens of thousands.' This made Saul very angry, for he saw that the Lord was with David and that he was the popular hero and leader of all Israel. He came to fear and hate David more and more and planned to kill him. So Jonathan warned David, 'Hide yourself tomorrow morning. I will go out with my father in the fields and find out what I can and let you know.' Next day he spoke to Saul in praise of David, and Saul promised: 'As the Lord lives, I will not kill him.' But soon afterwards Saul was listening to David playing the harp, and in a sudden fit of wild jealousy he tried to pin David to the wall with his spear. David avoided the spear and fled to his house.

Now Saul's daughter Michal fell in love with David and wanted to marry him. To his surprise and delight, Saul agreed—if David killed a hundred Philistines. Saul hoped he would be killed. But David set out at once with his men; they killed two hundred Philistines and brought back a part

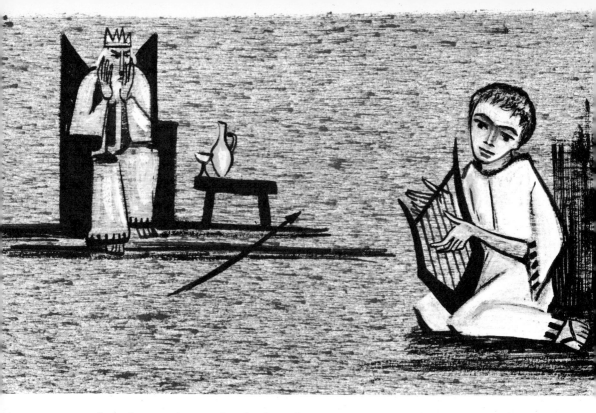

of each to show Saul. So the marriage took place. Saul
decided to have David killed the next morning, and that very
night he sent agents to watch the house. But David's wife
had courage. She helped him to escape through the window.
Then she made a dummy and put it in the bed. The agents
demanded to enter, but she said, 'He is ill.' Saul ordered
them to bring David on his bed. So they went in and found
only the dummy. Saul had furious words with Michal for
her trick but she answered him with a lie, saying, 'David said
to me, "Let me go or I will kill you." '

David fled to Samuel and told him all that Saul had done.
Then Saul's agents arrived. When they saw Samuel and all
his fellow prophets, the spirit of God overcame them and
they fell into a trance. Two more groups of agents were
sent and the same happened. Finally Saul went himself, and
he was overcome too—in fact he took off all his clothes and
lay on the ground naked all that day and night. Everyone
in Israel thought it a huge joke and asked, 'Is Saul one of

those prophets, too?'

Again David fled and went to ask Jonathan, 'Why does your father want to kill me?' Jonathan found it hard to believe that his father's heart was so evil, because he knew that in the past the Lord had been with his father. So he replied, 'He will not really kill you.' But David said, 'As the Lord lives, there is only a step between me and death.' 'What do you want me to do?' said Jonathan. David said, 'Look, tomorrow is New Moon and I have to sit at the king's table; but you must let me go and hide in the fields till evening and make an excuse for my absence. If he says, "Very well", I am safe; but if he is angry, you may be sure he intends evil. How will you let me know?' Jonathan said, 'The next day you must go and hide in the fields by that big heap of stones over there. I shall go shooting and pretend to use the stones as a target. My servant will go to find the arrow. If I say to him, "The arrow is this side of you", you have nothing to fear. But if I say, "The arrow is ahead of you", you must escape at once.'

At the New Moon feast, Saul noticed David's absence. He flew into a rage and insulted David and accused Jonathan of being in league with him. Jonathan spoke in defence of David and left the table in a fury, for he saw that Saul had already made up his mind that David must die. In the fields next day all went exactly as planned, and Jonathan sent his servant back to the town with his weapons. David then rose from behind the stones, fell to the ground and bowed down three times to honour his friend's loyalty. They embraced and wept because they would be separated for a long time. Jonathan said to David, 'Go in peace. And may the Lord be witness to the oath which both of us have sworn in his name, that you and I and your descendants and mine will never be enemies.'

DAVID SPARES SAUL'S LIFE

Saul never stopped hunting down David, and he had spies
and informers everywhere. Some men from the desert of
Ziph came to tell Saul that David was hiding on the edge of
the desert. So Saul set off with three thousand men to search
for him. David knew Saul would pursue him, and his own
spies reported where Saul had encamped with his troops.

'Who will come down with me into the camp of Saul?'
asked David. Abishai answered, 'I will.' So in the dark they
made their way towards Saul's army. They entered the camp
and found Saul lying asleep, his spear stuck in the ground
beside his head. Abner and the troops lay all round him.

Then Abishai said to David, 'Today God has put your
enemy in your power; so let me pin him to the ground—
just one stroke, with his own spear!' David answered, 'Do not
kill him. The Lord will strike him down when his time
comes. Take the spear and the pitcher of water beside his
head and let us go.' No one saw, no one knew, no one woke
up. On the top of the mountain some distance off, David
halted and called out to Abner. 'Who is that calling?' shouted
Abner. David answered: 'Why did you not guard your king?
Some stranger came to kill him. Look where the king's
spear is now, and his pitcher of water.' Then Saul recognised
David's voice and said, 'Is that your voice, David?' David
answered, 'It is, my lord king. What have I done? What evil
am I guilty of?' Saul replied, 'I have done wrong. Come
back, David; I will never harm you again since you have
respected my life today.' David answered, 'The king's spear
is here. Send a soldier to fetch it. Today the Lord put you
in my power, but I would not harm the Lord's anointed
king. Just as I valued your life highly today, so will the Lord
value my life highly and he will deliver me from all

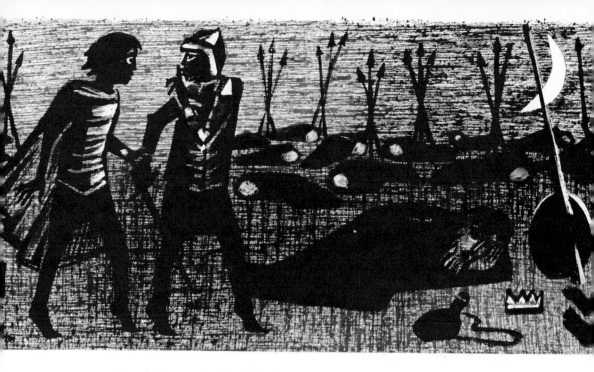

troubles.' Then Saul said, 'May you be blessed, David! You will do great things.' Then David went on his way and Saul returned home. This was not the only time that David spared Saul's life when he could easily have killed him.

DAVID, KING OF JUDAH AND ISRAEL

The Philistines made war on Israel again and the Israelites were defeated in a fierce battle on Mount Gilboa. Three of Saul's sons were killed: Jonathan, Abinadab and Malchishua. Saul himself was taken by surprise and wounded. He said to his armour-bearer, 'Draw your sword and kill me.' But the armour-bearer was afraid and would not do it. So Saul took his own sword and fell on it and died.

The next day the Philistines came and cut off Saul's head and carried it round on show. They fixed the bodies of Saul and his sons to the town wall of Beth-shan. But when the

people of Jabesh-gilead heard this, their warriors set out through the night to take the bodies off the wall: they burnt them and buried the remains under the tamarisk tree in Jabesh.

Meanwhile, David was resting in Ziglag after routing the Amalekites. When he heard the bad news, he wept and tore his clothes, and he sang a sad song for the loss of his special friend Jonathan and for Saul. Then David prayed to the Lord to find out where to go next. The Lord told him, 'Go to Hebron in Judah.' So David went to live there, and the men of the tribe of Judah came and anointed him as their king.

Now Abner, Saul's general, escaped alive from Mount Gilboa and made Saul's son Ishbaal king over all Israel, except Judah. Led by Abner, Ishbaal's followers marched out to Gibeon, and David's followers marched out under Joab to meet them there. A very fierce battle took place and Abner and his men were beaten and pursued by David's followers. Then Abner realised how foolish it was for the tribes of Israel to go on fighting among themselves, and he called out to Joab, 'Is the sword to go on eating up Israel for ever? Do you not know that this will end in disaster?' Joab agreed; so he halted all David's troops and they fought no more.

All Israel then came to David at Hebron. 'Look,' they said to him 'when Saul was king it was always you who led Israel. It was to you that the Lord said, "You are to be the leader of Israel." ' So David was made king of all Israel.

David then marched on Jerusalem. The Jebusites living there boasted, 'You will never get in here. Why, it only needs a few blind and lame men to keep you out!' But David did capture the fortress, and he built a wall round it and named it the Citadel of David. David grew greater and greater. The Lord God was with him, and here at Jerusalem many sons and daughters were born to him. Among them was Solomon, the most famous of all.

DAVID AND BATHSHEBA

Towards the end of one year, the best time for campaigning, David sent Joab, his general, with the king's guards and the whole army to fight the Ammonites. Early one evening while the army was away, David was strolling on the palace roof, when down below he noticed a woman bathing. She was very beautiful. David found out that she was Bathsheba, the wife of Uriah, one of his soldiers. He sent for her and took her as if she was his own wife.

Some while later on, Bathsheba told David she was going to have a baby. So David sent Joab an order to send Uriah back to Jerusalem. When Uriah arrived, David said to him, 'Go home and enjoy yourself.' Uriah left the palace, but he would not go home, because he felt it was unfair to do this when all his fellow soldiers were living in tents near the fighting. For three days David tried to get Uriah to go home, but he still refused. So David sent Uriah back to Joab with a letter which said, 'Station Uriah in the thick of the fight and then fall back behind him so that he will get killed'. Joab did this and Uriah was killed by the enemy, along with some of David's bodyguard. Then Joab sent David a full account of the battle, and told the messenger, 'If the king is angry about our losses, you are to say, "Uriah was killed too." '

When the messenger arrived he told David all the news. David was angry with Joab and said, 'Why did you go so near the ramparts? Do you not remember how at Thebez a woman dropped a millstone on Abimelech from the ramparts and killed him?' The man explained why, and added, 'Uriah was killed too.' Then David said, 'Tell Joab, "Do not worry about this setback. Storm the town with more men and overthrow it." ' When Uriah's wife heard the news, she mourned for her husband. But when her mourning was over,

David sent for her and she became his wife and bore him a son.

But what David had done angered the Lord. So the Lord sent Nathan the prophet to tell David this story: 'Two men lived in the same town, one rich, the other poor. The rich man had large flocks and herds. The poor man had nothing but one small ewe lamb which he had bought, but he loved and cared for it as for one of his children. When a traveller came to stay with the rich man, he refused to kill one of his own flock to give his guest a meal and he took the poor man's lamb instead.' David's anger flared up at this story. 'By the Lord,' he said, 'such a man deserves to die!' Then Nathan said, 'You are that man. The Lord says, "I made you king over all Israel; I gave you everything in plenty, and I would do as much again for you. Why have you gone against me and done evil? You have stolen Uriah's wife, and it is you who really killed him. In full view of all Israel I will stir up evil for you out of your own family."'

David said to Nathan, 'I have done wrong against the Lord.' Nathan replied, 'The Lord forgives your sin; you yourself are not to die. But the child that is born to you is to die.' So David went and comforted his wife Bathsheba.

Later on, Bathsheba bore David another son whom she named Solomon. The Lord loved him and made this known through the prophet Nathan.

ABSALOM REVOLTS AGAINST KING DAVID

Absalom, a son of King David was the most handsome man in Israel. But he was busily plotting against his father. For years he stood at the city gate early each morning and talked to passers-by, secretly turning them against David. Then

Absalom asked his father, 'May I go to Hebron to keep my vow?' 'Go in peace' said David. So he set off, but he also told all his supporters, 'At the trumpet signal you are to say, "Absalom is our King!"' In Hebron, still more people joined Absalom's plot, until at last someone told David about it. So David said to all his officers, 'We must get out of Jerusalem at once to avoid a surprise attack.' All the king's soldiers marched past him to the Kidron stream; everyone else went on out into the desert. Zadok the priest was there too, with the ark of God. David said to him, 'Take the ark quietly back to the city, with Abiathar, and send me news in the desert.' David was on his way up onto the Mount of Olives near the city, when he heard that Ahithophel, his counsellor, also supported Absalom. As he reached the top his friend Hushai came up, and David said to him, 'Go back to the city secretly as my agent. Say that you now support Absalom and tell Zadok and Abiathar anything you hear about the plans made by Ahithophel and Absalom.' Hushai set off quickly and got into the city again just as Absalom was arriving there.

THE DEATH OF DAVID'S SON, ABSALOM

At the Kidron stream just outside Jerusalem, King David waited for an attack by his rebel son Absalom. He divided his army into three groups, one under Joab, another under Joab's brother Abishai, and the third under Ittai. Then David said to his troops, 'I too will march with you in person.' But they replied, 'You must not go. You are more important than ten thousand of us.' David said, 'I will do as you think best.' Then he stood and watched his troops march away in

their hundreds and thousands. He gave a special order to his commanders, Joab, Abishai and Ittai: 'For my sake, treat young Absalom gently.' And all the troops heard that the king had given this order. Then they marched out against the rebel army of Israel. Battle was joined in the Forest of Ephraim, and there Israel's army was beaten by David's followers. It was a great defeat, with twenty thousand killed and wounded. The fighting spread throughout the region and the forest claimed more victims that day than the sword.

Absalom himself was riding a mule and in the confusion he ran into some of David's followers. As he fled from them, his mule passed under the thick branches of a great oak tree. Suddenly Absalom's head caught fast in the branches. But his mule went galloping on, so he was left hanging by the neck between earth and sky. One man saw this happen and told Joab. Joab said to the man, 'If you saw him, why did you not strike him to the ground then and there? I would have given you a reward of ten silver shekels on the spot, and a

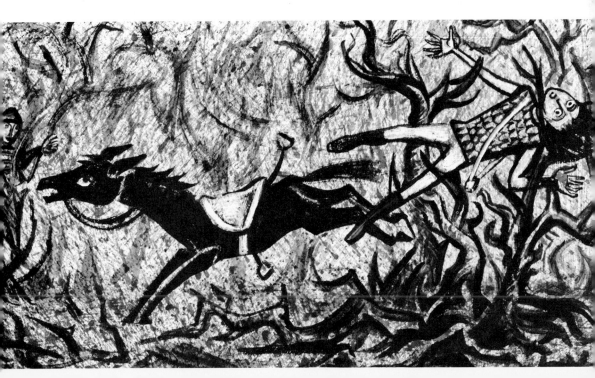

belt too.' But the man answered, 'Even if you were to give me a thousand silver shekels, I would not harm the king's son. We heard the king give you and Abishai and Ittai the order to spare young Absalom. Nothing is hidden from the king; if I had acted treacherously and so put my life in danger, you yourself would have stood by and given me no help.' Then Joab said, 'I cannot waste my time arguing with you.' And he took three lances and went off and drove them into Absalom's heart while he was still hanging there alive in the oak tree. Ten of Joab's armour-bearers stepped forward, cut Absalom down and finished him off.

Then Joab had the trumpet sounded to stop his troops pursuing Israel. They took Absalom, flung him into a deep pit in the forest and made a great pile of stones over him. Meanwhile, all the Israelites had fled, each man to his tent.

On hearing the news, King David shuddered. In spite of everything, he could never stop loving his son Absalom. He went up to the room over the city gate and burst out weeping, saying over and over again, 'My son Absalom! My son! My son Absalom! If only I could have died instead of you! Absalom, my son, my son!'

SOLOMON BECOMES KING OF ISRAEL

When King David was very old, another of his sons, Adonijah, plotted to become king on his father's death and gained a lot of supporters. Adonijah was very handsome and very proud, and his father had never once tried to stop him having his own way. He loved to show off with his chariot and fifty runners. One day he arranged to be proclaimed

king by his royal brothers at a great banquet to which he invited them all except Solomon, and all the king's officials except the prophet Nathan, Benaiah, and the king's champions.

Nathan said to Solomon's mother, Bathsheba, 'Did you hear that Adonijah has made kimself king? If you want to save the lives of yourself and Solomon, go straight to King David and say, "Did you not promise that your son Solomon is to be king after you? How is it, then, that Adonijah is king?" I will come in after you and say the same thing.' So Bathsheba did this. When the prophet Nathan arrived, he gave the same news and asked the king, 'Is this done with the king's approval? Or have you not told your loyal subjects who is to succeed you?' David sent for Zadock the priest and Benaiah, and ordered them, together with Nathan, 'Take the royal guard, mount Solomon on my own mule and escort him down to Gihon. There Zadok and Nathan are to anoint him king of Israel. Then sound the trumpet and shout, "Long live King Solomon!" Then he is to come and take his seat on my throne and be king in place of me, for he is the man I have appointed as ruler of Israel and of Judah.' This was done, and the people all rejoiced and followed after Solomon, playing pipes and shouting loud enough to split the earth.

Adonijah and his guests had by then finished eating. They heard the noise and then the news that David had made Solomon king. At this, all the guests took fright and disappeared. Adonijah also was in terror of Solomon and fled to try to save himself by clinging to the horns of the altar of the Lord. When Solomon heard this he said, 'If he behaves honourably, not one hair of his shall be touched; but if he bears ill will, he shall die.' Solomon then sent for Adonijah, and Adonijah did homage to him. Solomon said to him, 'Go to your house.'

SOLOMON'S PRAYER

After Solomon had become king of Israel, he allied himself with Pharaoh king of Egypt by marrying Pharaoh's daughter. He brought her to live in the Citadel of David until he could finish building his palace and the wall round Jerusalem. The people of Israel were still sacrificing on the high places, because at that time the Temple was not yet finished and so there was no place where the Lord could be with his people. Solomon loved the Lord: he followed the customs of David his father, except that he offered sacrifice on the high places.

One time the king went to Gibeon to sacrifice there, since that was the greatest of the high places, and he offered a thousand sacrifices. There at Gibeon the Lord appeared to Solomon in a dream during the night and said, 'Ask what you would like me to give you.' Solomon replied, 'You showed great kindness to your servant my father, David, during his life; and you go on being kind to him by allowing me, his son, to sit on his throne today. But I am a very young man, unskilled as a leader. Here I am in the midst of this people of yours that you have chosen, a people so many that its number cannot be known. Make me able to see the difference between good and evil, otherwise I cannot govern this people of yours that is so great.' The Lord was pleased that Solomon asked for this and he said, 'Since you have not asked for long life or riches for yourself or for the death of your enemies, but have asked to be able to tell good from evil, here and now I do what you ask. I make you wiser and more shrewd than anyone has been before you or anyone will be after you. I shall give you also what you have not asked: such riches and glory as no other king ever had. And I will give you a long life, if you follow my ways and keep my laws and commandments as your father David did.'

Then Solomon awoke; it was a dream. He returned to Jerusalem and stood before the ark of the Lord; he offered all kinds of sacrifices, and to thank the Lord he gave a great banquet for all his servants.

SOLOMON BUILDS THE TEMPLE

In the fourth year of his reign King Solomon began to build the Temple of the Lord in Jerusalem. During the building the Lord said to Solomon, 'If you faithfully follow my commandments, I will make my home among the people of Israel, as I promised to your father David, and I will never desert Israel my people.' The Temple was ninety feet long, thirty feet wide and thirty seven and a half feet high. The windows had frames with criss-crossed wood in them. All the walls were built with stone already made to fit exactly at the quarry. Then the stone walls were covered over with cedar wood, inside and out, so that no stone showed; the wood was carved with angels, palm trees and rose flowers, both inside and outside. The floor and the doors were made of juniper wood, and the entrance was at the right-hand corner. Inside the Temple Solomon made a Debir, the holiest place of all, to contain the ark of the Lord. In the Debir were two enormous flying angels made of olive wood plated with gold. The wings of each were fifteen feet across and together they stretched right from wall to wall, meeting in the middle. Finally all the walls of the Temple with their carvings, inside and outside, and even the floor, were plated with gold—gold everywhere, so that the Temple shone with gold.

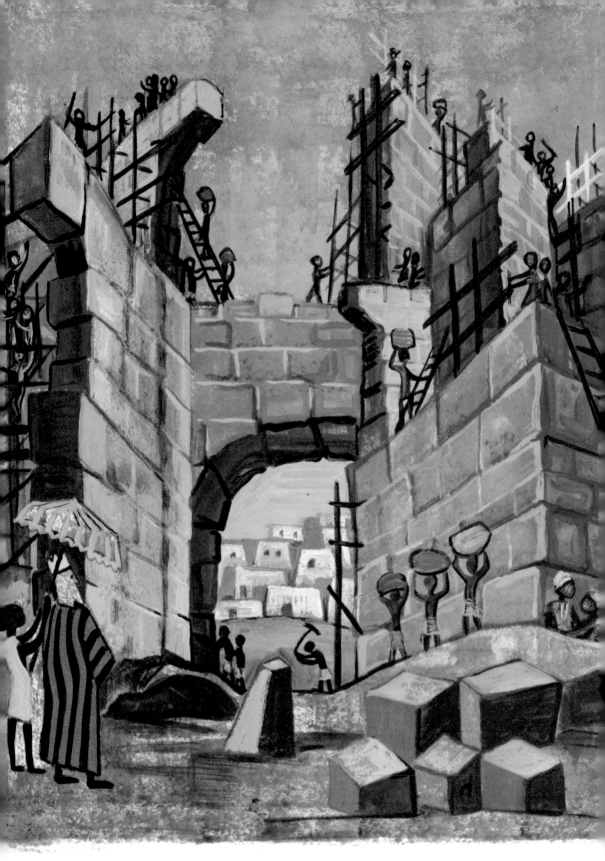

The Temple took seven years to build, and when it was finished, the ark of the Lord was installed. Inside it were the two stone tablets on which the Law was written, placed there by Moses in Sinai four hundred and eighty years before, after the Israelites left Egypt. Solomon and all Israel offered sacrifices before the ark, and the glory of the Lord filled the Temple in the form of a cloud—so thick that the priests were not able to go on with their duties. Solomon blessed all the people of Israel and said, 'Blessed be the Lord God of Israel who has kept his promise to my father David and come to make his home here.' Then he prayed, saying, 'Lord, you have kept your promise. Yet will God really live with men on the earth? Why, even the heavens cannot hold you. How much less this house that I have built! Hear the prayer of your servant and of all Israel, and as you hear, forgive. And if any foreigner, not of Israel, comes to pray to you in this Temple, grant all he asks, so that all the peoples of the earth may come to know and honour you.' Then Solomon blessed all the people once more, and together they again offered sacrifices to the Lord.

ELIJAH FLEES FROM KING AHAB

After Solomon's death, Israel and Judah were again divided and fought against each other. The rulers and the peoples of both kingdoms turned away from the Lord and worshipped Baal and other false gods. Ahab, son of Omri, became king of Israel when his father died. He reigned for twenty-two years and did more evil things against the Lord than all the kings of Israel before him. One of the least of his wicked

acts was to marry Jezebel. She was the daughter of a nearby pagan king and murdered many of the Lord's prophets. Then Ahab began to worship the god Baal. He put an altar to Baal in the temple he built to Baal in Samaria. He also put up a sacred pole and committed many other crimes as well, and the Lord grew very angry with him.

So the Lord sent the prophet Elijah to Israel. And Elijah went to King Ahab and said, 'As the Lord God of Israel lives, there shall be neither dew nor rain in these years except at

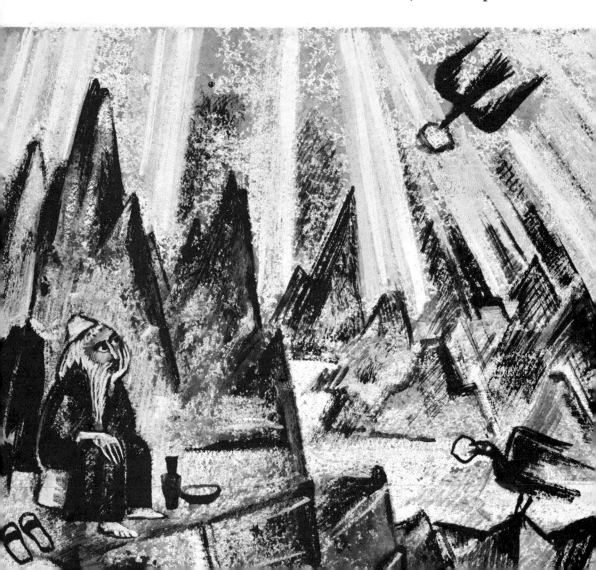

my order.'

This was an extremely rash thing to say to any king of Israel, especially Ahab, and Elijah's life was in great danger. So the Lord said to him, 'Go away from here eastwards, and hide yourself in the valley of the Cherith stream east of the river Jordan. You can drink from the stream, and I have ordered the ravens to bring you food there.' Elijah did as the Lord had said; and the ravens brought him bread in the morning and meat in the evening.

But after a while the stream dried up, for the country had no rain. So the Lord said to him, 'Go and stay in Zarephath, near Sidon. A widow there will give you food.' So off he went. When he reached the city gate, he saw a widow gathering sticks and said to her, 'Please bring me a little water to drink.' But Elijah was very hungry, so as she set off to bring it, he called after her, 'Please, bring me a scrap of bread also.' 'Baked bread?' she replied 'As the Lord lives, I don't have any of that; all I have is a handful of meal in a jar and a little oil in a jug; I am just gathering a stick or two to go and heat that up for myself and my small son; then that's all and we shall die of hunger.' But Elijah said to her, 'Do not worry; go and do as you have said. But first make me a little scone out of it and bring it to me, and then make some for yourself and for your son. For the Lord God of Israel says "Jar of meal shall not be spended, jug of oil shall not be emptied, till the Lord sends rain."'

The woman did as Elijah told her and they all ate the food, and Elijah stayed with them. From then on, they always found that the meal and the oil were never quite used up, just as Elijah had foretold.

Later on, the son of the widow fell sick, so badly that he seemed to stop breathing. And the woman said to Elijah, 'Man of God, have you come here to kill my son because of

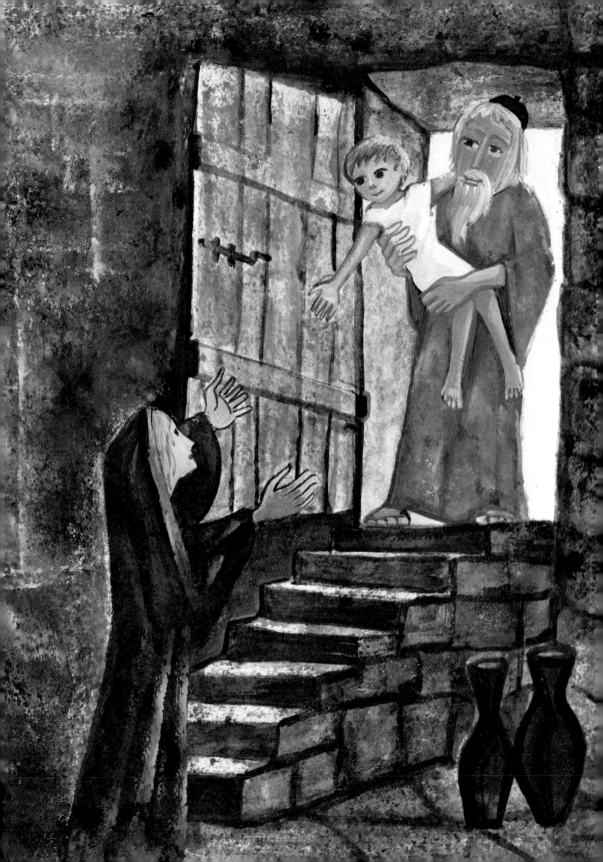

my sins?' 'Give me your son' he said, and took him from her lap, carried him upstairs and laid him on his own bed in the upper room. He stretched himself out over the child three times and cried out, 'Lord my God, I beg you, let the soul of this child return to him again!' The Lord heard Elijah's prayer and the boy returned to life. Then Elijah carried the boy downstairs again to his mother and said, 'Look, your son is alive.' The woman replied, 'Now I know you are a man of God and the word the Lord speaks through you is truth itself.'

THE RETURN OF ELIJAH

When Elijah fled from King Ahab to Zarephath, the king's men searched all the nations for him in vain. After three years the Lord said to Elijah, 'Go back to Ahab in Samaria. I am about to send rain.' So Elijah set off.

Now for lack of rain the famine in Samaria was so bad that Ahab and Obadiah, the master of his palace, set out in different directions to search for grass to keep horses and mules alive. On his way, to his great surprise, Obadiah met Elijah who said, 'Go and tell Ahab that I am here.' Obadiah was terrified and replied, 'My master has searched for you in all the nations. If I tell him and then you disappear, he will kill me. I am already under suspicion because, when Jezebel his wife was murdering the Lord's prophets, I hid a hundred of them in a cave, fifty at a time, and fed them secretly. Go and tell Ahab! Why, he'll kill me!' Elijah said, 'I will go to Ahab myself, today!' So Obadiah did go to tell Ahab the news, and Ahab then went to find Elijah.

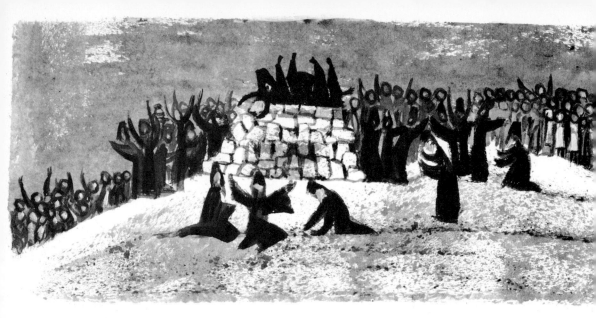

ELIJAH AND THE PRIESTS OF BAAL

When Elijah came out of hiding and met King Ahab, Ahab said, 'So there you are, you enemy of Israel!' 'Not I;' Elijah replied 'I am not the enemy of Israel, you and your family are the enemy because you have turned away from the Lord and gone after the Baal god. I challenge you now: give orders for all Israel to gather round me on Mount Carmel, and also those four hundred prophets of Baal—the ones who eat at your wife Jezebel's table.'

Ahab sent out messengers to call all the people of Israel and all the prophets of Baal to meet on Mount Carmel. When they were all collected on the hillside, Elijah stepped out in front of all the people. He asked them, 'How long do you mean to go on hobbling along from side to side, first on one leg then on the other? If the Lord really is God, then you should follow him; but if Baal is God, then you should follow him.' But the people remained silent and never said a word. However, Elijah would not give up and he said to them, 'I, I alone, am left as a prophet of the Lord, while there are more than four hundred prophets of Baal. So let us have two bulls. Let the prophets of Baal choose one for them-

selves, make it ready and lay it on the firewood as a sacrifice; but they are not to set fire to it. I in my turn will prepare the other bull in the same way, but I will not set fire to mine either. The prophets of Baal are to call on the name of their god, and I shall call on the name of the Lord my God; the god who answers with fire, he really is the true God.' The people all shouted their answer, 'Agreed!'

Then Elijah said to the prophets of Baal, 'Choose one bull and begin, for there are more of you. Call on the name of your god but do not light the fire.' They took the bull, killed it and made it ready. Then from morning to midday they called on the name of Baal. 'O Baal, answer us!' they cried as they performed their strange hobbling dance round the altar they had made. But there was no voice, no answer, only complete silence. When midday came, Elijah mocked them, saying, 'Why don't you call a bit louder? If your Baal is a god, perhaps he is too busy with other things, or perhaps he

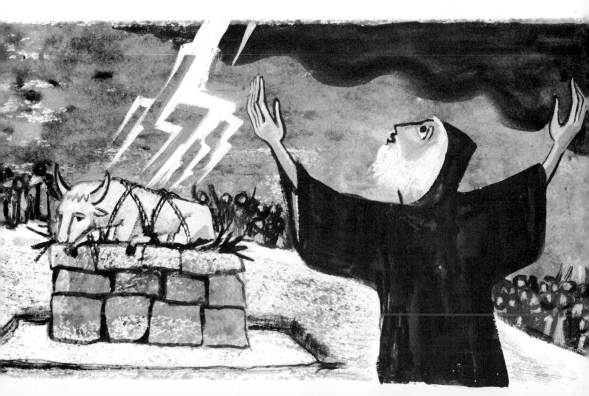

has gone away on a journey? Or perhaps he is asleep and needs waking up?' So they shouted louder and louder and slashed themselves with swords and spears until the blood streamed down their bodies. Midday passed, and they ranted on and on until the time came to present the offering to Baal. But still there was no voice, no answer, no attention given to them, no result at all. They had failed completely.

Then Elijah said to all the people, 'Come closer to me', and all the people came closer to him. He took twelve stones, because this was the number of the tribes of the sons of Jacob to whom the Lord had said, 'Israel shall be your name,' and he rebuilt the broken altar of the Lord. Round the altar he dug a trench large enough to hold two sacks of seed. Then he arranged the wood, and killed the bull, made it ready and laid it on the wood. After doing this he said, 'Fill four jars with water and pour it on the sacrifice and on the wood.' He did this because he wanted to make everything wet, so as to show the power of the fire of the Lord. They poured on the water. He said, 'Do it a second time' and they did it a second time. He said, 'Do it a third time' and they did it a third time. The water flowed all round the altar, and the trench itself was full of water. When the time came to present the offering to the Lord, Elijah the prophet stepped forward and said 'Lord, God of Abraham, Isaac and Israel, let all the people know today that you are God in Israel, and that I am your servant, and that I have done all these things at your command. Answer me, Lord, answer me, so that this people may know that you, the Lord, are God and that you are winning back their loyalty.'

Then the fire of the Lord came and burnt up the sacrifice and the wood, and it dried up the water in the trench. When all the people saw this they fell on their faces. 'The Lord is God,' they cried 'the Lord is God.' At this, Elijah gave the

order, 'Seize the prophets of Baal: do not let one of them escape.' The people seized them, and Elijah took them to the valley of the Kishon stream, and there he had them slaughtered, all four hundred and more, down to the last man.

Elijah said to King Ahab, 'Go back to the city and eat and drink; for I hear the sound of rain coming.' The sky grew dark with cloud and storm, and rain fell in torrents. Ahab mounted his chariot and made for Jezreel. The hand of the Lord was on Elijah and, tucking up his cloak, he ran in front of King Ahab as far as the outskirts of Jezreel.

ELIJAH IS SENT TO MOUNT SINAI

When Ahab told Jezebel all that Elijah had done, and how he had slaughtered all the prophets of Baal, Jezebel was beside herself with rage, and she sent a messenger to Elijah to say, 'May the gods strike me dead or worse, if by this time tomorrow I have not destroyed your life as you destroyed their lives!' Elijah was afraid and fled for his life. He came to Beersheba, a town of Judah, and he left his servant there. He himself went on a further day's journey into the desert and sat under a furze bush and wished he were dead. 'Lord,' he said 'I have had enough. Take my life; I am no better than my ancestors.' Then he lay down and went to sleep.

An angel came and touched him and said, 'Get up and eat.' He looked round, and there at his head was a scone baked on hot stones, and a jar of water. He ate and drank and then lay down again. But the angel of the Lord came back a second time and touched him and said, 'Get up and eat, or the journey will be too long for you.' So he got up and ate and drank. Then, strengthened by the food, he walked for forty

days and forty nights to reach Sinai, the mountain of God.

There he went into the cave in the mountain-side and spent the night in it. Then the Lord spoke to him, saying, 'What are you doing here, Elijah?' He replied, 'I am filled with passionate desire to serve the Lord Sabaoth, because the sons of Israel have turned away from you, broken down your altars and killed your prophets. I am the only one left, and they want to kill me.' The Lord told him, 'Go out and stand on the mountain before the Lord.'

Then the Lord himself passed by. There came a mighty wind, so strong that it tore the mountains and shattered the rocks in the path of the Lord. But the Lord was not in the wind. After the wind came an earthquake. But the Lord was not in the earthquake. After the earthquake came a fire. But the Lord was not in the fire. And after the fire there came the sound of a gentle breeze. And when Elijah heard this, he covered his face with his cloak and went out and stood at the entrance of the cave. Then a voice said to him, 'What are you doing here, Elijah?' He replied, 'I am filled with a passionate desire to serve the Lord Sabaoth, because the people of Israel have turned away from you, broken down your altars and killed your prophets. I am the only one left and they want to kill me.'

The Lord replied, 'Go back by the same way to the desert of Damascus. You are to go and anoint Hazael as king of Aram. You are to anoint Jehu son of Nimshi as king of Israel, and you are to anoint Elisha son of Shaphat, of Abel Meholah, as prophet to succeed you. Anyone who escapes the sword of Hazael will be put to death by Jehu; and anyone who escapes the sword of Jehu will be put to death by Elisha. But I shall spare seven thousand in Israel: all those who have not bowed before Baal, and those who have not kissed the image of him.'

GOD ASKS THE HELP OF ELISHA

On Mount Sinai the Lord spoke to Elijah and said, 'Go, go back the way you came, to the desert of Damascus and call Elisha, the son of Shaphat, who lives in Abel Meholah, to be the prophet who will succeed you.' So Elijah set off. On his way, just as the Lord had said, he came on Elisha, who was ploughing behind a team of twelve pairs of oxen, walking beside the twelfth pair himself. Elijah passed near to him and threw his cloak over him as a sign that Elisha must obey his orders from now on. Elisha at once left his oxen and ran after Elijah. 'Let me kiss my father and mother,' he said 'then I will follow you.' Elijah answered, 'Go, go back; for what have I done to you?' Elisha turned away, took the twelfth pair of oxen and slaughtered them to show that he was leaving his old way of life. He burnt the plough as a fire for cooking the oxen, then gave the food to his men. After this he got up and followed Elijah and became his servant.

AHAB ARRANGES THE DEATH OF NABOTH

When King Ahab returned to his country of Samaria after defeating the Aramaeans, he noticed that close by his own palace was a vineyard belonging to a man called Naboth who lived in Jezreel. Ahab said to Naboth, 'I want your vineyard for my vegetable garden, because it adjoins my palace. I will give you a better vineyard in exchange or, if you prefer, I will pay you in money.' But Naboth answered Ahab, 'The Lord forbid that I should sell you what has always belonged to my family!'

Ahab went home gloomy and out of temper at Naboth's words. He lay down on his bed and turned his face away and refused to eat. His wife Jezebel came to him and asked, 'Why are you so sulky that you will not even eat?' He said, 'I have been speaking to Naboth of Jezreel. I said: Give me your vineyard either for money or, if you prefer, for another vineyard in exchange. But he refused.' Then his wife Jezebel said, 'You make a fine king of Israel, and no mistake! Get up and eat; cheer up, and you will feel better. I will get you Naboth's vineyard myself.'

So Jezebel wrote letters in Ahab's name to the elders and nobles who lived in Jezreel, and sealed them with his seal. In the letters she wrote, 'Proclaim a fast, and put Naboth in the forefront of the people. Then arrange for a couple of ruffians to go to him and accuse him like this, "You have cursed God and the king." Then see that he gets the lawful punishment for this: stone him to death.'

The elders and nobles of Naboth's town did what Jezebel had ordered: they proclaimed a fast and put Naboth in the forefront of the people. Then the two ruffians came and stood in front of him and made their accusation, 'Naboth has cursed God and the king.' The people led him outside the

town and stoned him to death. The elders and nobles then sent word to Jezebel. When Jezebel heard the news, she said to Ahab, 'Get up! Take possession of the vineyard which Naboth would not give you for money, for Naboth is no longer alive, he is dead.' When Ahab heard this news, he got out of bed and went down to take over the vineyard.

Then the Lord spoke to Elijah the prophet and said, 'Get up and go and meet Ahab king of Israel, down in Samaria. You will find him in Naboth's vineyard; he has gone to take possession of it. You are to say to him, "The Lord says this: You have committed murder; now you also grab what is not yours. For this—and the Lord says it—in the place where the dogs licked the blood of Naboth, the dogs will lick your blood too." ' When Elijah arrived, Ahab said to him, 'So you, you my enemy have found me out!' Elijah answered, 'I have found you out. The Lord says this: "For your double dealing, and since you have done what is not pleasing to the Lord, I will now bring disaster on you; I will sweep away your descendants, and wipe out every male belonging to the family of Ahab in Israel, slave or free. I will treat your family as I treated the families of Jeroboam and Baasha, for rousing my anger and leading Israel into sin. The dogs will eat those of Ahab's family who die in the city; the birds of the air will eat those who die in the open country." ' The Lord also spoke these words against Jezebel: 'The dogs will eat Jezebel in the Field of Jezreel.'

And indeed there was never anyone like King Ahab for double dealing and for doing what is not pleasing to the Lord, urged on by Jezebel his wife. He behaved in the most outrageous way; he worshipped idols too, just like the Amorites whom the Lord drove out of their country to give it to the people of Israel.

When King Ahab heard these words, he tore his clothes

and put sackcloth next to his skin, and he stopped eating any food. He even slept in the sackcloth, and he walked with slow dragging steps. Then the Lord spoke to Elijah again, 'Have you seen how King Ahab has humbled himself before me? Because he has humbled himself before me, I will not bring disaster on him himself; but I will bring disaster on his family in the lifetime of his son.'

ELIJAH AND ELISHA

Elijah and his friend Elisha were setting out together from Gilgal, when Elijah said to Elisha, 'Please stay behind, for the Lord is only sending me as far as Bethel.' But Elisha replied, 'No, I will not leave you!' At Bethel all the prophets came out to meet Elisha and said, 'Do you know that the Lord is going to carry away your master, Elijah, today?' 'Yes, I know;' he said 'be quiet.' Exactly the same thing happened all over again when the Lord told Elijah to go on to Jericho and then on to the river Jordan. And so they reached the Jordan together, and fifty of the prophets followed them. Then Elijah took off his cloak, rolled it up and struck the water with it. The water divided and the two of them crossed over with dry feet. Then Elijah said, 'You can ask one thing before I am taken from you.' Elisha answered, 'Let me receive a double share of your spirit.' 'That is difficult;' said Elijah 'it can be so only if you see me as I am taken away.' They walked on, talking as they went, when suddenly a chariot and horses, all of fire, appeared between them, and Elijah vanished to heaven in a whirlwind.

Elisha tore his clothes with sorrow, then he picked up

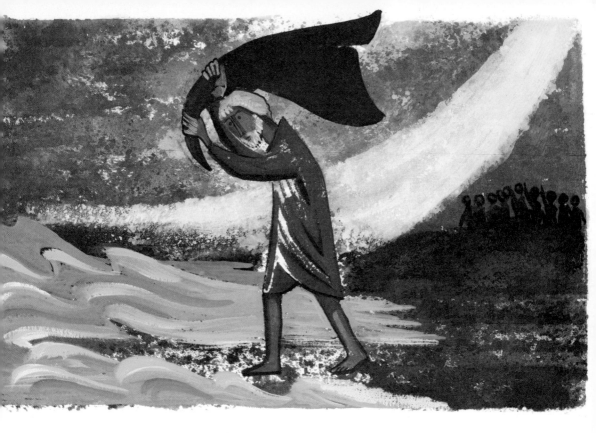

Elijah's cloak, went back to the Jordan, and struck the water
with it, crying, 'Where is the Lord, the God of Elijah?' The
water divided and Elisha crossed over to return to Jericho.
The waiting prophets saw him in the distance, and said, 'The
spirit of Elijah has come to rest on Elisha.' They went to
meet him and bowed to the ground.

The men of Jericho said to Elisha, 'The town is pleasant,
but the water is bad and very unhealthy.' 'Bring me a new
bowl,' he said 'and put some salt in it.' Then he went and
threw salt into the water, saying, 'Thus speaks the Lord: "I
make this water pure."' And it was so and still is so today.

From Jericho Elisha went to Bethel. On the way up the
hill to the town a crowd of small boys came out and jeered
at him, 'Up you go, baldy! Up you go, baldy!' He turned
round, cursed them in the Lord's name, and two she-bears
came out of a wood and attacked forty-two of the boys.

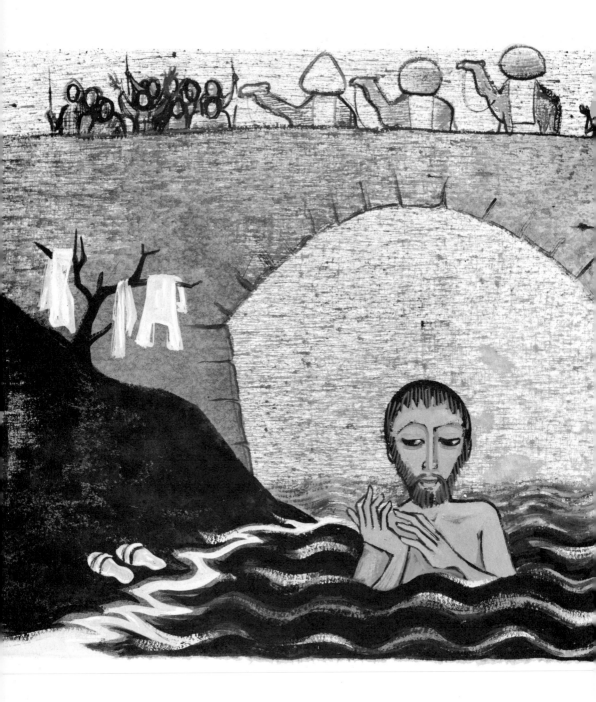

ELISHA AND NAAMAN

Naaman was army commander to the king of Aram. The king respected him and was very pleased with him, because he had won many victories for the Aramaeans. But Naaman was a leper. Now on one of their raids, the Aramaeans had carried off a little Israelite girl who had become a servant of Naaman's wife. She said to her mistress, 'If only my master would go and see the prophet of Samaria! He would cure his leprosy.' Naaman's wife told him about this and he went and told the king what the girl had said. 'Go by all means;' said the king of Aram 'I will send a letter to the king of Israel.' So Naaman left, taking with him ten talents of silver, six thousand shekels of gold and ten special dresses for festivals. The letter said: 'With this letter, I am sending my servant Naaman to you for you to cure his leprosy.' When the king of Israel read this, he tore his clothes in dismay. 'Am I supposed to be a god to give death and life?' he said 'Listen to this! He is sending a leper to me and asks me to cure him! Obviously he intends to pick a quarrel.'

When Elisha heard about all this, he sent word to the king to say, 'Why did you tear your clothes? Send Naaman to me, and he will find there is a prophet in Israel.' So Naaman went off with his chariot and horses and drew up at the door of Elisha's house in Ophel. Elisha did not come out himself but only sent a message: 'Go and bathe seven times in the Jordan, and your body will become clean once more.' Naaman was indignant and shouted at his men, 'Here was I, thinking he would certainly come out to me, call on the Lord his God, wave his hand over the leprous spot and actually cure me. Bathe in the Jordan? Surely the Abana and Pharpar rivers of Damascus are better than any water in Israel? Why should I not bathe in them?' And he turned round and went

off in a rage. But his servants said to him, 'Master, if the prophet had asked you to do something difficult, would you not have done it? All the more reason, then, when he simply says to you, "Go and bathe." ' So Naaman went and bathed seven times in the Jordan. And his body became as clean as that of a little child again.

Then he returned to Elisha's house with his whole escort, went in, and said to Elisha, 'Now I know that there is no God in all the earth except in Israel. Now, please, accept a present from me.' But Elisha replied, 'As the Lord lives, whom I serve, I will accept nothing.' Naaman pressed him, but he still refused. Then Naaman said, 'In that case, may I please take with me two mule-loads of earth, because I will no longer offer sacrifice to any god except the Lord. Only ask the Lord to forgive me this: when my master, the king of Aram, goes to the temple of Rimmon to worship, he leans on my arm; so I have to bow down in the temple of Rimmon when he does.' 'Go in peace' Elisha answered.

When Naaman had gone a small distance, Gehazi, Elisha's servant, thought, 'My master has let this foreigner Naaman off too lightly, by not accepting his offer. By the Lord, I will run and get something out of him.' So Gehazi set off in pursuit of Naaman. When Naaman saw Gehazi running after him, he jumped down from his chariot to meet him. 'Is all well?' he asked. 'All is well.' Gehazi said 'My master has sent me to say, "This very moment two young prophets have arrived from the highlands of Ephraim. Be kind enough to give them a talent of silver." ' 'Please accept two talents' Naaman replied, pressing him to accept, and tying up the silver in two bags. Then he sent two of his servants to carry the bags in front of Gehazi. When they got back to Elisha's house, Gehazi took the bags and hid them. Then he sent the men away and went to his master. 'Gehazi, where have you

been?' said Elisha. 'Nowhere' he replied. But Elisha said, 'I saw in my mind's eye that a certain person got out of his chariot to meet you. Now you have taken the money, you can buy gardens with it, and olive groves, sheep and oxen, men and women slaves. But you and your descendants will have Naaman's leprosy for ever.' And as Gehazi left Elisha he became a leper, white as snow.

GOD ASKS THE HELP OF ISAIAH

In the year when Uzziah, king of Judah, died, the prophet Isaiah had a vision: I saw the Lord seated on a high throne; his train filled the sanctuary; above him stood angels of fire, each one with six wings: two to cover his face for fear of seeing the Lord, two to cover his nakedness and two for flying. And they cried out one to another in this way, 'Holy, holy, holy is the Lord. His glory fills the whole earth.' The foundations of the threshold shook with the voice of the angel who cried out, and the Temple was filled with smoke. I said: What a wretched state I am in! I am lost, for I am a man who has lost his hold on the truth and I live among a people to whom the truth means nothing, and my eyes have looked at the Lord who is the king of all things.

Then one of the angels flew to me, holding in his hand a live coal which he had taken from the altar with a pair of tongs. With this he touched my mouth and said: 'See now, this has touched your lips, your faults are wiped out, the evil in you is taken away.'

Then I heard the voice of the Lord saying, 'Whom shall I send? Who will be our messenger?' I answered: Here I am,

send me. The Lord said: 'Go, and say to the people, "Hear my voice over and over again, but do not understand; see my works over and over again, but fail to see what they mean." You are to make the heart of this people slow, make its ears dull and shut its eyes; so that it will not see with its eyes, hear with its ears, understand with its heart; so that it will not be converted and healed.' Then I said: For how long, Lord? He answered: 'Until towns have been laid waste and deserted, houses left empty, countryside made desolate, and until the

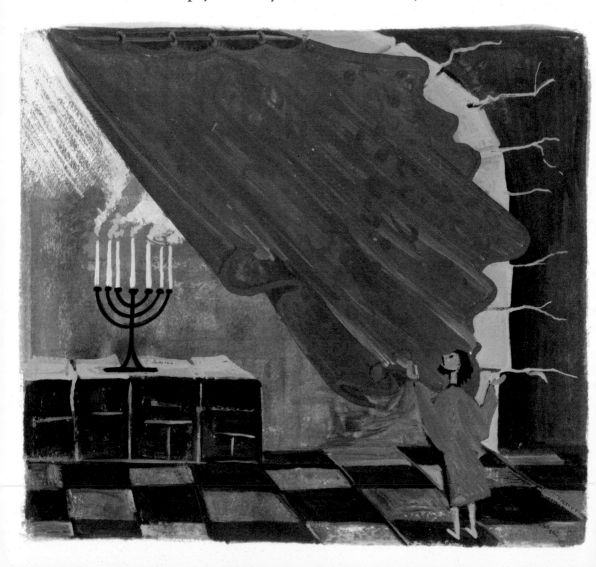

Lord drives the people out. There will be a great emptiness in the country and, though a tenth of the people remain, it will be stripped like a great tree with only a stump left after it is felled. But the stump is a holy seed which will grow again.'

GOD ASKS THE HELP OF JEREMIAH

The Lord said to me, 'Before I formed you in your mother's body, I had thought of you and blessed you. You are to be my prophet to the nations.' I said: Ah Lord, look, I do not know how to speak; I am a child! But he replied, 'Do not say, "I am a child". Go now wherever I send you and say whatever I command you. Do not be afraid, for I am with you to protect you.' Then he touched my mouth with his hand and said, 'There! I put my words into your mouth. Today I set you over nations and kingdoms, to tear up and knock down, to destroy and overthrow, to build and to plant.'

The Lord asked me, 'Jeremiah, what do you see?' I see a branch of the watchful almond tree, I answered. The Lord said, 'Well seen! I too watch over my word to see it fulfilled.' The Lord asked me again, 'What do you see?' I answered: I see a cooking pot on the boil, with its contents tilting from the North. Then the Lord said, 'The North is where disaster is boiling over for all who live in this land. I will give my judgements against Israel for all their wickedness, because they have left me to worship what their own hands have made. Today I will make you into a fortified city in face of all Israel; they will fight against you, but they shall not overcome you, for I am with you to help you—it is the Lord who speaks.'

JEREMIAH'S CALL TO ISRAEL

The Lord spoke to me saying, 'Shout this to the House of Israel: "Thus says the Lord: What faults did your fathers find in me that made them desert me? I brought you to a fertile country to enjoy its produce and good things; but no sooner had you entered than you spoiled my land. The priests have never asked: Where is the Lord? The prophets have prophesied in the name of Baal. Has there ever been anything like this? Does a nation change its gods for what are not gods at all? My people have exchanged their Glory for what has no power in it. My people have committed a double crime: they have abandoned me, the fountain of living water, only to dig wells for themselves, leaky wells that hold no water. So I must put you on trial once more, and your children's children too." '

JEREMIAH AND THE POTTER'S JUG

The Lord said to me, 'Get up and make your way down to the potter's house.' So I went, and there was the potter, working at his wheel. And whenever the pot he was making came out wrong, he would start it over again. Then the Lord said to me, 'House of Israel, can I not do what this potter does? As the clay is in the potter's hand, so you are in mine, House of Israel. At times I decide to tear up, knock down, destroy a nation, but if the people of that nation give up their wickedness, then I change my mind about the trouble which I was going to send. At other times I decide to build up a nation and make it grow; but if that nation displeases

me and refuses to listen to my voice, then I change my mind about the good which I was going to send. So now, go and say to the men of Judah and the citizens of Jerusalem, "The Lord says: Listen, I have been preparing a disaster for you, I have been working out a plan against you. So now, each one of you turn back from your evil ways, change the way you live and act." They, however, will say, "What is the use of talking? We are going to do exactly as we please, each one of us." Go, Jeremiah, and buy an earthenware jug. Take some of the elders of the people and some priests with you. Go out towards the Valley of Ben-hinnom, as far as the entry of the Gate of the Pots-herds. There you are to break this jug in front of the men who are with you, and say to them, "The Lord says this: I am going to break this people and this city just as one breaks a potter's pot, so that it cannot be mended." '

Now the priest Pashhur who was in charge of the Temple police, heard Jeremiah making this prophecy. So he had Jeremiah beaten and put in the stocks.

ISRAEL HELD CAPTIVE IN BABYLON

Jehoiachin king of Judah was eighteen years old when he came to the throne, and he reigned for only three months in Jerusalem. He failed to obey the Lord's commands and he did things which were not pleasing to the Lord, just as his father Jehoiakim had done.

At that time, Nebuchadnezzar king of Babylon was extending his power over all the neighbouring lands and his troops marched on Jerusalem and besieged it. While they were surrounding the city, Nebuchadnezzar himself came to direct the attack on the city personally. Then Jehoiachin king of Judah surrendered to the king of Babylon, together with his mother, his officers and all his court, and they were taken prisoner. This was in the eighth year of King Nebuchadnezzar's reign.

Just as the Lord had foretold through his prophets, Nebuchadnezzar carried off all the treasures of the Temple and of the royal palace, and broke up all the golden furnishings that Solomon had made for the sanctuary of the Lord. He also took away all the people of Jerusalem into exile. Ten thousand nobles and other people of importance were exiled, together with all the blacksmiths and metalworkers, one thousand of them, and all these were men capable of bearing arms. Only the poorest people in the country were left behind. He sent Jehoiachin to Babylon, and the king's mother and the court. He made them all leave Jerusalem for exile in Babylon. It was because of the anger of the Lord that this disaster came about in Jerusalem and in Judah, so that in the end the Lord cast his people aside.

Nebuchadnezzar made Mattaniah, Jehoiachin's uncle, king of Judah and changed his name to Zedekiah. But Zedekiah offended the Lord just as Jehoiakim had done.

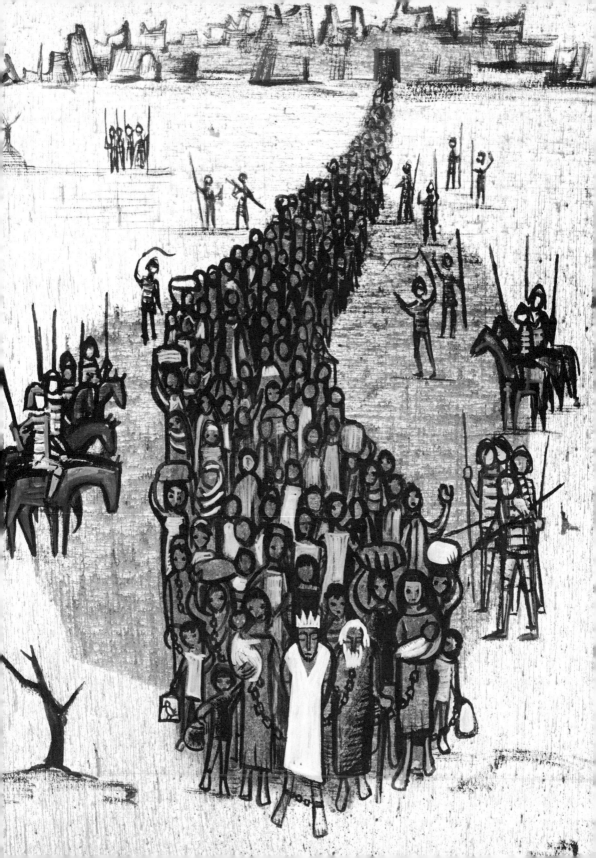

THE DESTRUCTION OF JERUSALEM

Zedekiah, king of Jerusalem, rebelled against the king of Babylon. In the ninth year of his reign, in the tenth month, on the tenth day, Nebuchadnezzar king of Babylon came with the whole Chaldean army to attack Jerusalem. He made camp in front of the city, built up earthworks to surround it, and kept the city under siege till the eleventh year of King Zedekiah. In the fourth month, on the ninth day, when famine was raging in the city and there was no food for the people, a break was made in the city wall. At once, the king made his escape under cover of dark, with all the fighting men, by way of the gate between the two walls, which is near the king's garden, and made his way towards the Arabah. The Chaldean troops hunted the king and caught up with him in the plains of Jericho, where all his troops deserted. The Chaldeans captured the king and took him to Riblah, where the king of Babylon passed sentence on him. He had the sons of Zedekiah killed, then he blinded Zedekiah and, loading him with chains, led him off to Babylon.

In the fifth month, on the seventh day,—it was in the nineteenth year of Nebuchadnezzar king of Babylon— Nebuzaradan, commander of the guard, an officer of the king of Babylon, entered Jerusalem. He burned down the Temple of the Lord, the royal palace and all the houses in Jerusalem. The Chaldean troops who accompanied the commander of the guard broke down the walls surrounding Jerusalem. Nebuzaradan, commander of the guard, deported the remainder of the population left behind in the city, the deserters who had gone over to the king of Babylon, and the rest of the common people, as vineyard workers and ploughmen. They also took the ash containers, the scoops, the knives, the incense boats, and all the bronze furnishings used

in worship. The commander of the guard took the censers and the sprinkling bowls, everything that was made of gold and everything made of silver.

DANIEL AT NEBUCHADNEZZAR'S COURT

In the third year of the reign of Jehoiakim king of Judah, Nebuchadnezzar king of Babylon marched on Jerusalem with the Chaldaean army and besieged and captured the city and Jehoiakim himself.

King Nebuchadnezzar ordered Ashpenaz, his chief servant, to select a certain number of Israelite boys of royal or noble families to become servants in the palace. They had to be without any physical fault, of good appearance, trained in every kind of wisdom, well-informed, quick at learning. For three years Ashpenaz himself was to teach them the language and writings of the Chaldaeans, and they were to receive a daily allowance of food and wine from the king's own table. Then they were expected to be fit for the king's presence. Among them were four boys of Judah: Daniel, Hananiah, Mishael and Azariah. The chief servant gave them other names, calling Daniel Belteshazzar, Hananiah Shadrach, Mishael Meshach, and Azariah Abednego. Daniel was most anxious not to go against the Hebrew laws about food and drink, and he begged the chief servant to allow them to eat only the vegetables and drink only water. But the chief servant was afraid and said, 'The king has provided food and drink, and if he sees you looking thinner in the face than the other boys of your age, my head will be in danger.' At this

Daniel turned to the man who guarded the four boys and said, 'Please allow your servants a ten days' trial. You can then compare our looks with those of the boys who eat the king's food. Go by what you see, and treat your servants accordingly.' The man agreed. When the ten days were over, they looked and were in better health than any of the boys who had eaten from the royal table; so the guard stopped the allowance of food and wine, and gave them vegetables. And God helped these four boys with knowledge and intelligence in all the things they had to learn, and in wisdom. Daniel himself had the gift of interpreting all visions and dreams.

When the period ordered by the king for the boys' training was over, the chief servant presented them to Nebuchadnezzar. The king spoke with them, and among all the other boys he found none to equal Daniel, Hananiah, Mishael and Azariah. So they became members of the king's court, and on whatever point of wisdom or information he might question them, he found them ten times better than all the magicians and sorcerers in the kingdom. Daniel remained at the court until the first year of the reign of King Cyrus.

THE THREE MEN IN THE FIERY FURNACE

While the people of Israel—the Jews—were held captive in Babylon, Nebuchadnezzar the king had a golden statue made, on the plain of Dura. He then proclaimed by his herald: 'Men of all peoples, nations, languages! When you hear the music sound, you must bow down and worship the golden statue. Those who disobey will at once be thrown into the burning fiery furnace.' And all the people obeyed.

Some Chaldeans of Babylon then came and told the king,

'O king, there are certain Jews, Hananiah renamed Shadrach, Mishael renamed Meshach, and Azariah renamed Abednego, who refuse to worship the golden statue.' Furious with rage, the king sent for them and asked, 'Is it true that you refuse to worship the golden statue? If you refuse, you must be thrown at once into the furnace. There is no god who can save you from my power.' The three Jews replied, 'If our God is able to save us from the furnace and from your power, O king, then he will save us. Even if he does not, O king, we will not serve your god or worship the golden statue.' These words made the king so furious that he gave orders for the furnace to be made seven times hotter than usual, and commanded the soldiers to bind the three Jews and throw them in at once. The heat was so fierce, that the soldiers were themselves burnt to death.

The three Jews started to walk about in the heart of the flames, praising and blessing the Lord. The king sprang to his feet in amazement. He said to his advisers, 'Did we not have these three men bound?' They replied, 'Certainly, O king.' 'But' he went on 'I can see four men, and they are walking about unharmed. The fourth looks like a son of the gods.' The king shouted into the furnace, 'Shadrach, Meshach and Abednego, servants of the Most High God, come out, come here!' So the three Jews came out. The fire had had no effect on their bodies: not a hair of their heads had been singed, their cloaks were not scorched, no smell of burning hung about them. The king exclaimed, 'Blessed be the God of Shadrach, Meshach and Abednego; he has sent his messenger to rescue his servants who put their trust in him and defied my order and preferred to lose their bodies rather than worship any god but their own. I therefore command this: Men of all peoples, nations, and languages! If anyone speaks disrespectfully of the God of Shadrach,

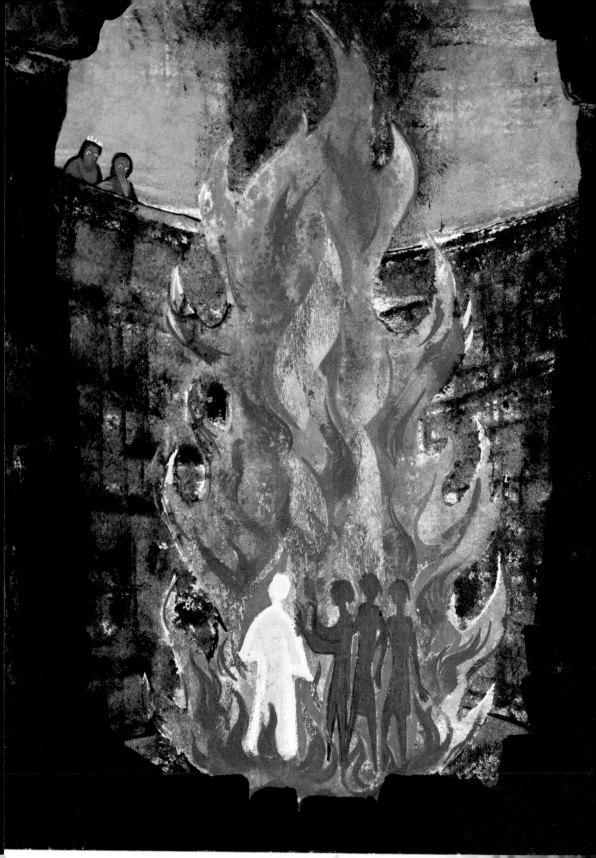

Meshach and Abednego, I will have him torn limb from limb and his house destroyed, for no other god can save like this.' Then the king heaped honours on Hananiah, Mishael and Azariah.

BELSHAZZAR'S FEAST

While the Jews were held captive in Babylon, Belshazzar the king gave a great banquet for a thousand of his noblemen. As he sipped his wine, Belshazzar gave orders for the gold and silver vessels to be brought, which his father Nebuchad-nezzar had looted from the sanctuary in Jerusalem. When the king and all his guests were drinking out of them, the fingers of a human hand suddenly appeared on the palace wall directly behind the lampstand, and began to write on the plaster. The king could see the hand and he turned pale with terror. He shouted for his wise men and said, 'Anyone who can read this writing and tell me what it means shall be dressed in purple, and wear a gold chain round his neck, and be third in rank in the kingdom.' They all crowded forward, but they could not even read the writing. Greatly alarmed, the king turned even paler, and his guests also. Then the queen, attracted by all the noise, came into the banqueting hall. 'O king,' said the queen 'do not be alarmed. In your kingdom there is a man in whom lives the spirit of the Most Holy God. Your father made him head of the wise men. This man Daniel will be able to tell you what the writing means.'

Daniel was brought in and the king said, 'Are you the Daniel who was brought by my father from Judah? If you can read the writing and explain it, you shall receive all the

rewards I have offered.' Daniel said 'I will read the writing to the king without rewards or gifts and tell him what it means. O king, the Most High God gave Nebuchadnezzar your father greatness. But because his heart grew swollen with pride, he lost his throne and lived with the wild donkeys and fed on grass like the oxen. But you, Belshazzar, in spite of knowing all this, you have defied the Lord. You and your guests have drunk your wine out of the vessels from the Lord's Temple; but you have given no glory to God. That is why he has sent the hand which has written: Mene, Mene, Thekel and Parsin. The meaning is this: Mene: God has set a limit to your greatness; Thekel: you have been weighed on the scales and found too small; Parsin: your kingdom has been divided between the Medes and the Persians.'

Belshazzar kept his word; Daniel was dressed in purple, a gold chain was put round his neck and he was made third in rank in the kingdom. But that same night Belshazzar was murdered and Darius the Mede took over his kingdom.

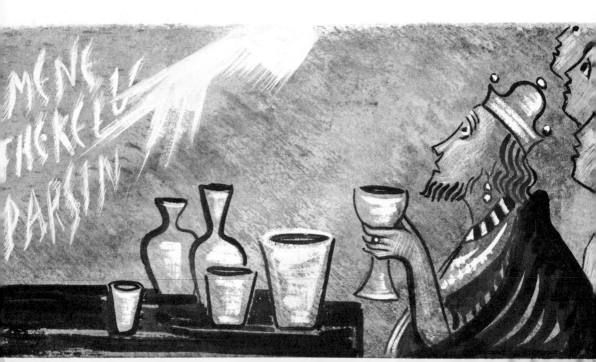

DANIEL IN THE LION PIT

It pleased Darius, king of the Medes, to appoint a hundred and twenty prefects for the various parts of his kingdom, and over them three presidents—of whom Daniel was one. This was to make certain that no harm should come to the king. Daniel was so much better than the others that the king considered appointing him to rule the whole kingdom. The prefects tried to find fault with Daniel; but they could discover nothing against him. The presidents and nobles then went in a body to the king. 'King Darius,' they said 'we are all agreed that the king should issue a command saying: Whoever within the next thirty days prays to anyone, god or man, other than to yourself O king, is to be thrown into the lions' pit.' King Darius accordingly signed the document.

When Daniel heard that the document had been signed, he retired to his house. The windows of his upstairs room faced towards Jerusalem. Three times each day he continued to pray and give praise to God as he had always done. The presidents and nobles came along in a body and found Daniel praying and pleading with God. They then came to the king and said, 'Have you not just signed a command forbidding any man for the next thirty days to pray to anyone, god or man, other than to yourself O king, on pain of being thrown into the lion pit?' 'Yes', the king replied. Then they said to the king, 'O king, this man Daniel takes no notice of your law. He is at his prayers three times each day.' Then the king was deeply saddened, and he determined to save Daniel.

The king then ordered Daniel to be fetched and thrown into the lion pit. He said to Daniel, 'Your God himself, whom you have served so faithfully, will have to save you.' A stone was then brought and laid over the mouth of the pit; and the king then sealed it with his own signet and with that

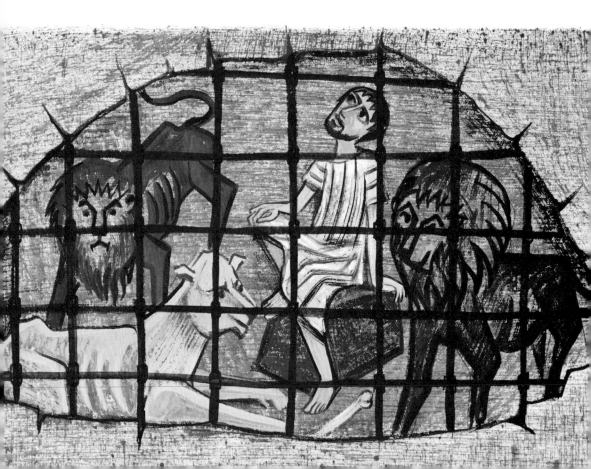

of his noblemen, so that there could be no going back on the original decision about Daniel. The king returned to his palace, and spent the night in fasting. At the first sign of dawn he was up, and hurried off to the lion pit. He called, 'Daniel, servant of the living God! Has your God, whom you serve so faithfully, been able to save you from the lions?' Daniel replied, 'My God sent his angel to protect me. The lions did me no harm.' The king was overjoyed, and

ordered Daniel to be released from the pit. Daniel was found to be quite unhurt, because he had trusted in his God. The king sent for the men who had accused Daniel and had them thrown into the lion pit, they, their wives and their children; and they had not reached the floor of the pit before the lions seized them and crushed their bones to pieces.

King Darius then wrote to men of all nations: 'May peace be always with you! Let all tremble with respect before the God of Daniel.'

Daniel lived in the reign of Darius the Mede and the reign of Cyrus the Persian.

THE JEWS RETURN FROM CAPTIVITY

It was sixty years since Nebuchadnezzar had captured Jerusalem and taken the Jews away to Babylon. Cyrus, king of the Persians, conquered Babylon. Then, as the prophet Jeremiah had foretold, one of his first acts was to issue a proclamation about the Jews. It was publicly displayed throughout the kingdom, and it said: 'Thus speaks Cyrus king of Persia, "The Lord God of heaven has ordered me to build him a Temple in Jerusalem, in Judah. Whoever there is among you of all his people, may his God be with him! Let him go up to Jerusalem in Judah to build the Temple of the Lord, the God of Israel—he is the God who is in Jerusalem. And let each survivor, wherever he lives, be helped by his neighbours with silver and gold, with goods and cattle, as well as offerings for the Temple of God which is in Jerusalem." '

Then the heads of families of Judah and of Benjamin, the

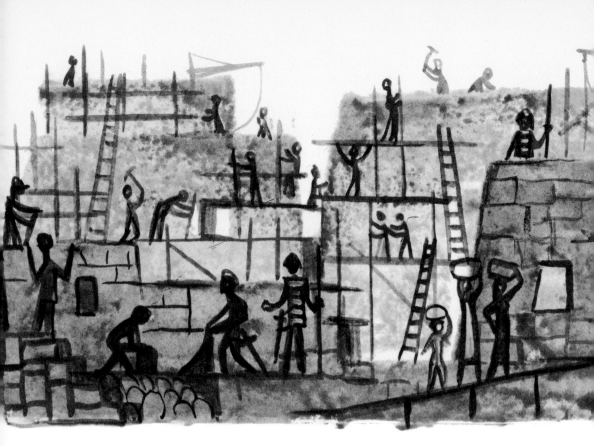

priests and the Levites, in fact all whose spirit had been roused by God, prepared to go and rebuild the Temple of the Lord in Jerusalem; and all their neighbours gave them every assistance with silver, gold, goods, cattle, quantities of costly gifts and offerings of every kind.

Cyrus king of Persia took the vessels of the Temple of the Lord, which Nebuchadnezzar had carried away from Jerusalem and had dedicated to the temple of his own god. Cyrus handed them over to Mithredath, his treasurer, who counted them out to Sheshbazzar, the prince of Judah. Among the more important items on the list were: thirty golden bowls for offerings; one thousand and twenty-nine silver bowls for offerings; thirty ordinary golden bowls; four hundred and ten ordinary silver bowls. In all, with other items, there were five thousand four hundred vessels of gold

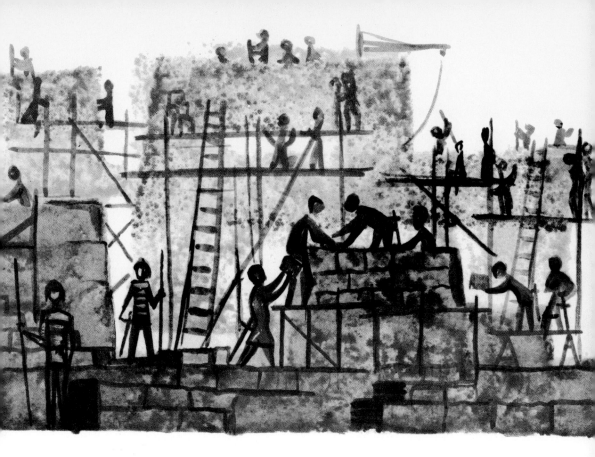

and silver. Sheshbazzar took all these with him from Babylon back to Jerusalem.

The number of the Jewish exiles who travelled back to their home country again was forty-two thousand three hundred and sixty people, with a further seven thousand five hundred and thirty-seven slaves and maidservants and singers, and many thousands of animals, horses, mules, camels and donkeys. When they reached their own country, each family returned to its own town. Then, when the seventh month of the year arrived, everyone down to the last man gathered in Jerusalem and there, although the foundations of the new Temple had not yet been laid, they set up the altar again on its old site and began offering sacrifices to the Lord just as they had always done before they were taken away and held captive in Babylon.

FROM THE
NEW TESTAMENT

THE BIRTH OF JOHN THE BAPTIST IS
FORETOLD

In Jerusalem in the days of King Herod of Judaea there lived
a priest called Zechariah, and he had a wife, Elizabeth. They
were both good people in the eyes of God, and carefully kept
all the commandments and customs of the Lord. But they
had no children: Elizabeth had never borne a baby and they
were getting on in years.

It was Zechariah's turn to serve in the Temple. During
his period of duty he was chosen by lot, as was the custom,
to enter the holiest place and burn incense there. At this time
the whole congregation was outside, praying.

Suddenly the messenger of the Lord appeared to Zechariah
and stood on the right of the incense altar. Zechariah was
worried and overcome with fear. But the messenger said to
him, 'Zechariah, do not be afraid, your prayer has been
heard. Your wife Elizabeth is to bear you a son and you are
to name him John. He will bring you joy and many people
will rejoice at his birth, for he will be great in the eyes of the
Lord. He is not to drink wine or any strong drink. Even
before he is born he will be full of the Holy Spirit, and he
will bring back many of the people of Israel to the Lord
their God. With the spirit and power of Elijah, he will go
ahead of the Messiah to warm the hearts of fathers towards
their children and to turn disobedient people back to the
wisdom of honest people. In this way he will make a people
ready for the Lord.' Zechariah said to the messenger 'How
can I be sure of this? I am an old man and my wife is getting
on in years.' The messenger replied, 'I am Gabriel who
stands in God's presence, and I have been sent to bring you
this good news. Listen! At the proper time my words will
come true, and because you have not believed them you will

be silenced and will not be able to speak until this has happened.' Meanwhile the people outside were waiting and waiting for Zechariah and were surprised that he had stayed in the holiest place so long. When he came out he could not speak to them, and they realised that he had received a vision in the holiest place. He could only make signs to them, and he remained dumb.

When the time of Zechariah's temple service came to an end, he returned home. Some time later his wife Elizabeth realised she was going to have a baby, and for five months she kept away from other people. She said to herself, 'The Lord has done this for me; it has pleased him to take away the shame I felt in front of other people for having no children.'

THE BIRTH OF JESUS IS FORETOLD

Six months after Elizabeth, the wife of Zechariah, knew she was going to have a child, God sent his messenger Gabriel to a town in Galilee called Nazareth, to a young girl called Mary who was engaged to be married to a man called Joseph. Joseph was a distant descendant of the David who had been king of Israel and Judah about a thousand years before.

Gabriel said to Mary, 'Rejoice; you are highly honoured! The Lord is with you.' Mary was very worried by these words and asked herself what all this could mean, but the messenger said to her, 'Mary, do not be afraid; God is to do you a great honour. Listen! You are to have a son and you are to name him Jesus. He will be a great man and will be called

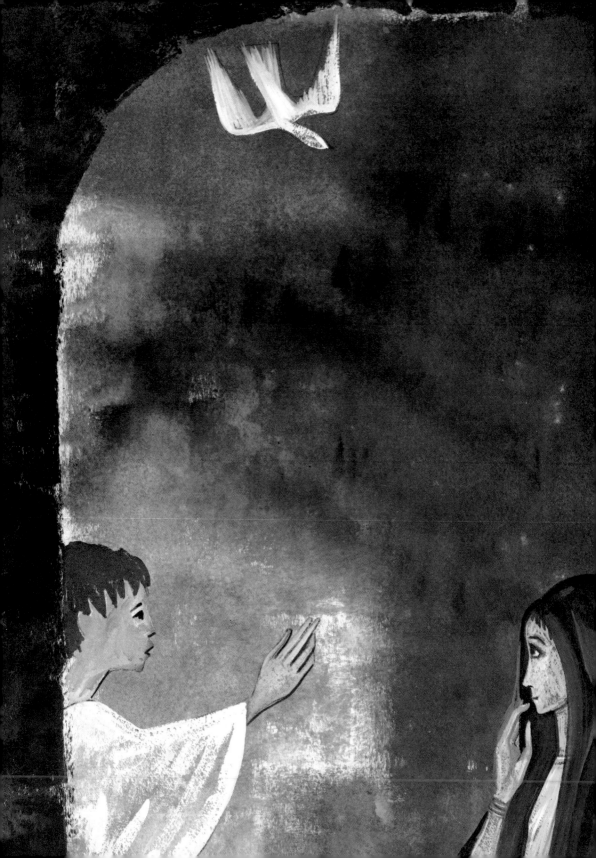

Son of the Most High. The Lord God will give him the throne of his ancestor David; your son will rule over the descendants of Jacob for ever and his reign will have no end.' Mary said to the messenger, 'But how can this come about, since I do not yet have a husband?' The messenger answered, 'The Holy Spirit will come to you and the power of the Most High God will be at work within you. And so the child will be holy and will be called Son of God.' Mary said 'I am at the service of the Lord for him to do to me what you have said.' Then the messenger left her.

THE BIRTH OF JOHN THE BAPTIST

Zechariah the priest had been dumb for nine months—ever since he refused to believe God's messenger Gabriel who had told him that his wife Elizabeth would have a child. And now the time had come for Elizabeth to have her child, and she gave birth to a son. When her neighbours and relations heard that the Lord had been so kind to her, they rejoiced with her.

The family all wanted to name him Zechariah after his father. But his mother spoke up and said, 'No, he is to be called John.' They said to her, 'But no one in your family is called John', and they made signs to his father to try to find out what he wanted the boy to be called. Zechariah asked for a writing-tablet and wrote, 'His name is John.' They were all astonished at this, and at that very same instant Zechariah's power of speech returned and he spoke and praised God. All their neighbours were rather frightened by this and news of it spread all over the hill country of Judaea and those who

heard the story could think and talk about nothing else. 'Whatever will this child turn out to be?' they wondered. And indeed they soon saw that the Lord was taking good care of the boy John.

His father Zechariah was filled with the Holy Spirit and spoke this prophecy: 'Blessed be the Lord, the God of Israel, for he has visited his people. And you, little child, you will go ahead to prepare God's way for him.'

JESUS IS BORN

While Mary was engaged to be married to Joseph, God's messenger Gabriel had visited her to tell her that God wanted to give her a son, and Mary had agreed. Quite some time later, Joseph realised that Mary was going to have a baby. This worried Joseph a great deal because he knew that he was not the baby's father; so he decided to break off his engagement to Mary and not to take her as his wife. But while he was sleeping one night, a messenger from God came to him in a dream and said, 'Joseph, do not be afraid to take Mary home to be your wife. God's Holy Spirit gave her the baby she is going to have. It will be a son and, because he is the one who is to rescue his people from their sins, you are to name him Jesus, 'the-Lord-rescues'. When Joseph woke up he decided to do as God's messenger had said.

Now at this time Herod was king of Judaea and Caesar Augustus was Emperor of Rome. Augustus ordered that for the first time ever all the people in the Roman world should be counted. So everyone had to go to his own town to be counted. Since Joseph was a descendant of King David, he

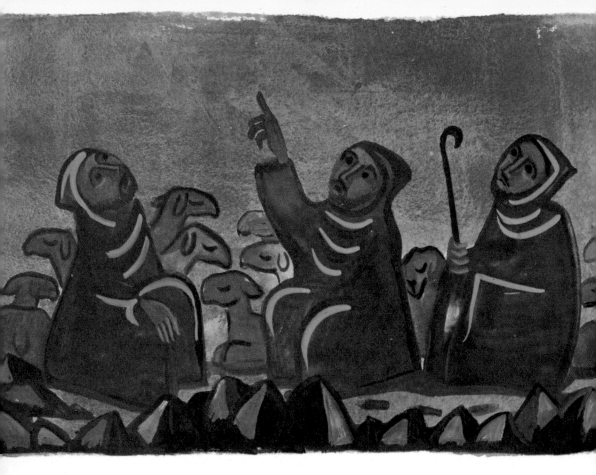

set out with Mary from the town of Nazareth in Galilee and travelled up to Judaea to David's town of Bethlehem to be counted there. At Bethlehem they found that the only inn in the town was full and there was no room for them; so they had to shelter in a cattleshed. While they were there, the time came for Mary to have her child and in the cattleshed she gave birth to a son. She wrapped him up and laid him in the box where food was put for the cattle to eat. They named him Jesus.

In the countryside close by there were shepherds who lived in the fields and took it in turns to watch their flocks during the night. When Jesus was born, God's messenger visited

them and God's glory shone all round them. They were terrified, but the messenger said, 'Do not be afraid. I bring you news to make you and all the people rejoice. Today in Bethlehem someone has been born who will rescue you from your sins; he is Christ the Lord. If you find a baby all wrapped up and lying in a box for cattlefood, that is him.' Then suddenly there was a great crowd of other messengers from God, who praised God and sang, 'Glory to God in the highest heaven, and peace to men whom he loves well.' When the messengers had gone, the shepherds said, 'Let's go to Bethlehem to see this.' So they went, and they found Mary and Joseph, and the baby in the box in the cattleshed, and

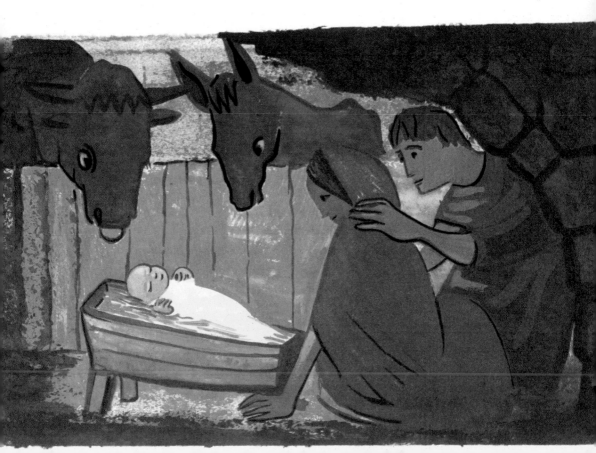

they told them what the messenger had said. Everyone was astonished at this news, and Mary stored up all these things in her mind and thought about them over and over again. The shepherds left and went back to their flocks, praising God because of all they had heard and seen.

THE WISE MEN FROM THE EAST

After Jesus was born at Bethlehem, some wise men came to Jerusalem from the east. They were asking everyone, 'Where is the baby who is king of the Jews? We saw his star rising in the sky and have come to do him honour.' This really upset King Herod and the people of Jerusalem when they heard it because Herod was himself the reigning ruler. Herod called together all the chief priests and the Law-teachers and asked them where the Christ was to be born. 'At Bethlehem in Judaea,' his advisers told him 'for this is what the prophet wrote: And you, Bethlehem, in the land of Judah, you are by no means least among the leaders of Judah, for out of you will come a leader who will be a shepherd to my people Israel.' Then Herod summoned the wise men to see him privately. He asked them the exact date on which the star had appeared, and sent them on to Bethlehem. 'Go and find out all about the child,' he said 'and when you have found him, let me know, so that I too may go and do him honour.' Then the wise men set out on their journey once more. The star moved ahead of them and at length stopped over the place where the child was to be found. The sight of the star filled the wise men with delight, and going into the house they saw the child with his mother

Mary. They fell to their knees in front of him, as to a king. Then they offered him their gifts: gold, frankincense, and myrrh. That night while they were sleeping they were warned in a dream not to go back to Herod, so they returned to their own country by a different way.

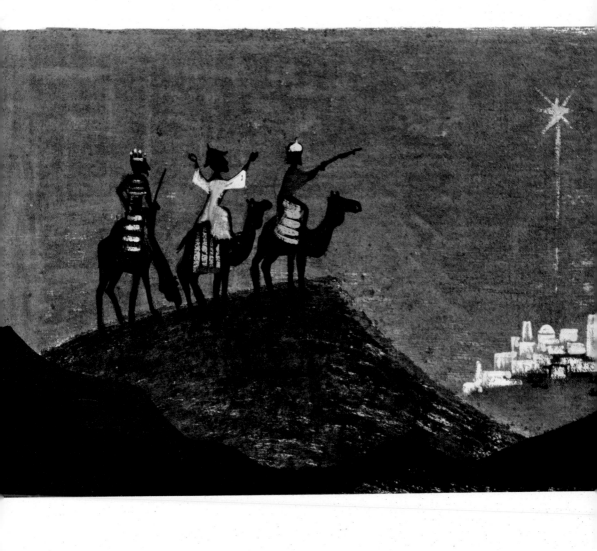

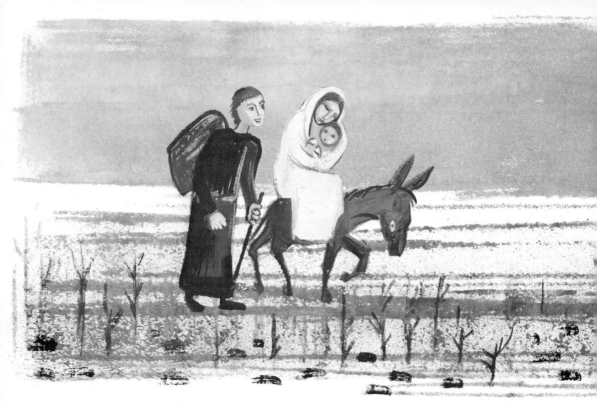

THE FLIGHT INTO EGYPT

After the three wise men who visited Jesus had left to go back to their own country, the Lord's messenger appeared to Joseph in a dream and said, 'Get up, take the child and his mother with you, and escape into Egypt. Stay there until I tell you, because Herod is going to search for the child to kill him.' So during that same night Joseph took Jesus and his mother and left for Egypt. He stayed there until Herod was dead. In this way the words spoken many many years before by the prophet Hosea came true: 'I called my son out of Egypt.'

When he realised that the three wise men had deceived him, Herod was furious. He sent soldiers to Bethlehem and all the country nearby to kill all the boy children who were two years old or under. In this way the words of the prophet Jeremiah came true: 'A voice was heard in Ramah, sobbing

and loudly lamenting; it was Rachel weeping for her children, refusing to be comforted because they were all dead.'

After Herod's death, the messenger of the Lord appeared in a dream to Joseph in Egypt and said, 'Get up, take the child and his mother with you and go back to the land of Israel, for those who wanted to kill the child are now dead.' So Joseph got up, took the child and his mother with him, and went back to the land of Israel. But when he learnt that Archelaus the son of Herod had become the ruler of Judaea he was afraid to go there. Again Joseph was warned in a dream and he went to another part of the country called Galilee instead. There he settled in a town called Nazareth. In this way the words spoken through the prophets were proved true: 'He will be called a Nazarene.'

THE BOY JESUS IN THE TEMPLE

After Joseph had brought the family back from Egypt, they all lived together at Nazareth. Once a year, like many other Jewish people, they used to travel to take part in the Passover festival at Jerusalem rather than at home.

Now as Jesus got older it became clear that he would grow up into a very wise man for God was looking after him in every way. When he was twelve years old, his parents went up to Jerusalem for the Passover festival as usual. But when they started on their way home again, Jesus stayed behind in Jerusalem without his parents knowing about it. They did not miss him because they thought he must be with friends somewhere in the long line of donkeys and camels slowly making its way back to Nazareth. It was only when they did not see him after a whole day's journey that they went to look for him among their relatives and friends. When they failed to find him they went back to Jerusalem.

Three days later they found him in the Temple, sitting among the learned teachers, listening to them, and asking them questions. All those who heard him were amazed at what he said and how intelligent he was. Joseph and Mary were almost speechless with surprise, astonishment and joy when they found him and his mother said: 'My child, why have you done this to us? See how worried your father and I have been while we looked for you.' 'Why were you looking for me?' Jesus replied 'Did you not know that I must be busy with my Father's affairs?' But they did not understand.

Then Jesus returned with them to Nazareth and lived obediently with them at home. His mother stored up all these things in her heart. Jesus himself went on growing both in mind and in body. All people came to like him more and more and it seemed that God gave him all that he needed.

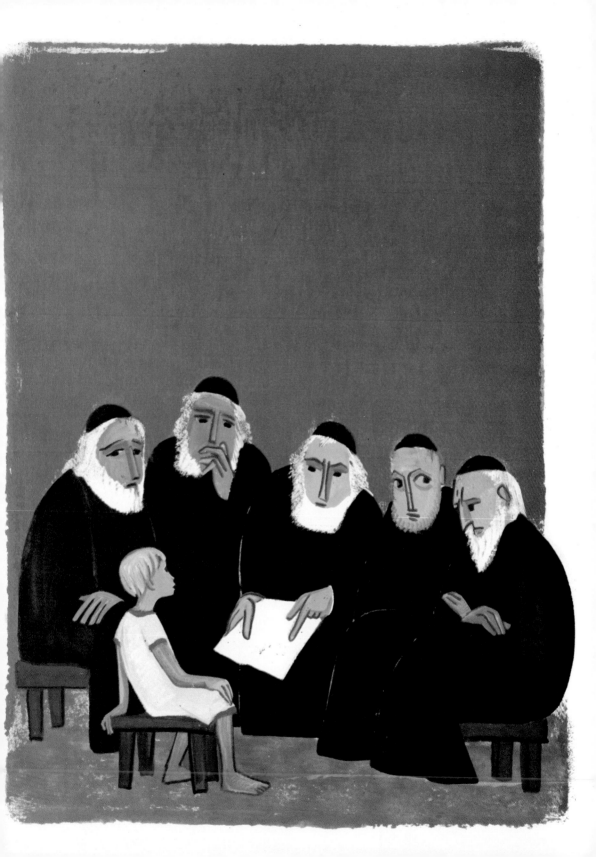

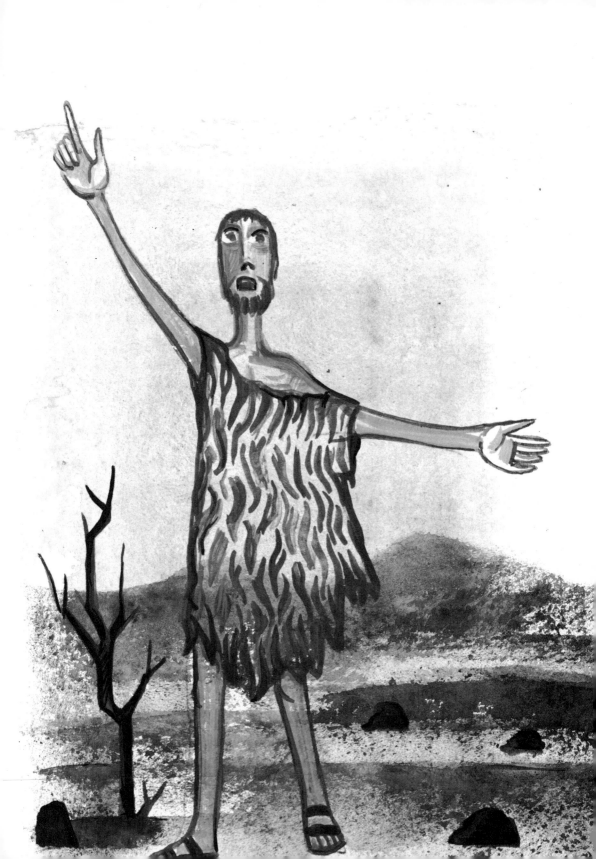

THE MESSAGE OF JOHN THE BAPTIST

John the son of the priest Zechariah and his wife Elizabeth had grown up into a man and he lived in the desert of Judaea. The Spirit of God came to him and he began to preach in the desert to anyone who would listen. This was his message: 'Change your hearts and leave your sinful way of living, for the kingdom of heaven is close at hand.'

This was the man the prophet Isaiah spoke of when he said: 'A voice cries in the wilderness: Prepare a way for the Lord, make his paths straight.' John wore a garment made of camel-hair with a leather belt round his waist, and his food was locusts and wild honey. People from Jerusalem and all over Judaea and the whole Jordan district went to hear him, and as they were baptised by him in the river Jordan they owned up to the wrong things they had done.

But when he saw a number of learned members of the Pharisee and Sadducee parties coming for baptism he called to them, 'Brood of vipers, who warned you to fly from God's anger that is coming? If you really intend to change

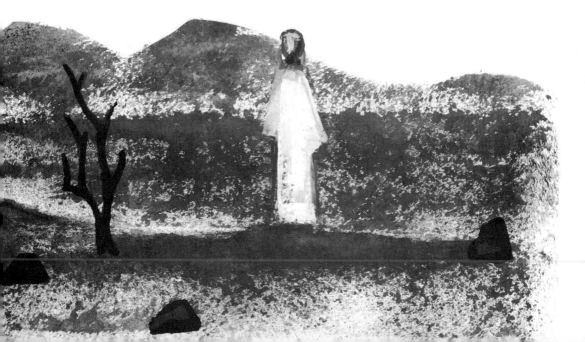

your sinful way of living, then prove it and do not try to get out of it by saying, "We have Abraham for our father." I tell you, if he wishes to, God can raise children for Abraham from these stones. I warn you, God's axe is now already poised to strike the roots of the trees, so that any tree which fails to produce good fruit will be cut down and thrown on the fire.

'I baptise you in water so that you may change your way of life for the better; but the one who follows me is more powerful than I am, and I am not fit to carry his sandals. He will baptise you with the Holy Spirit and with fire. The breath of his Spirit will blow the chaff from his threshing floor and he will gather his wheat into the barn; but he will burn the chaff in a fire that will never go out.'

THE BAPTISM OF JESUS

When John, the son of Zechariah and Elizabeth, was baptising people from all over Judaea in the river Jordan, Jesus came to him from Galilee to be baptised. John was very unwilling to baptise Jesus and said to him, 'It is I who need baptism from you and yet you come to me!' But Jesus replied, 'Leave it like this for the time being; it is better that we should in this way do all that is demanded by the Law.' At this, John agreed to do as Jesus asked.

As soon as Jesus was baptised and came up out of the water, the heavens suddenly opened and he saw the Spirit of God descending like a dove and coming down on him. And a voice spoke from heaven, 'This is my Son, the one I love; and my blessing stays with him.'

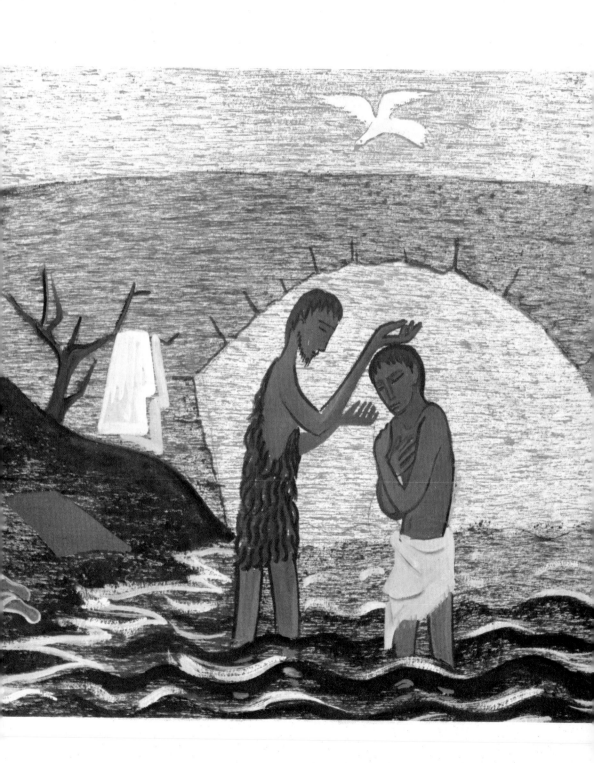

JESUS DEFEATS THE DEVIL

After Jesus had been baptised by John in the river Jordan the Spirit of God led him out into the desert to come face to face with the devil. There Jesus took no food for forty days and forty nights, so he became very hungry. Then the devil came to him and said, 'If you really are the Son of God, tell these stones to turn into loaves of bread.' But Jesus replied, 'Scripture says: Man does not live only on bread but he lives on every word that comes from God.'

The devil came to Jesus a second time and took him to Jerusalem and brought him right up onto the edge of the roof of the Temple. 'Now, if you are the Son of God,' he said 'throw yourself down there to the ground. For scripture also says: God will put you in the care of his angels, and they will hold you up so that you will not even bruise your foot against a stone.' Jesus said to him, 'Scripture also says: You must not try to test the Lord your God.'

The devil came to Jesus a third and last time and took him to a very high mountain from where he could see all the kingdoms of the world and their many splendours. 'I will give you all of these' the devil said 'if you will fall at my feet and worship me.' Then Jesus replied, 'Get out, Satan! For scripture says: You must worship the Lord your God, and serve only him.' On hearing this the devil knew that Jesus had defeated him and he left him in peace. Then messengers from God came and looked after Jesus.

After this, Jesus went to live at Capernaum in Galilee. He was filled with the Spirit of God and at once began to proclaim his message: 'Change your hearts and leave your sinful way of living, for the kingdom of heaven is close at hand.' And one by one he began to choose the men he wanted to train as helpers in the task before him.

PETER'S CATCH OF FISHES

Jesus stayed for some time in Capernaum, giving his message to all who would listen. One night he stayed at the house of Simon Peter, a fisherman, and he cured the mother of Peter's wife of a fever. People were becoming more and more interested in what he said and he travelled all through Judaea to give his message to everyone.

One day he was standing by the Lake of Gennesaret, with the crowd pressing round him listening as he preached the word of God, when he caught sight of two boats close to the land. The fishermen had climbed out on to the shore and were washing their nets. Jesus got into Simon Peter's boat —Andrew was in it too—and asked him to pull out a little from the shore. Then he sat down and began teaching the crowds from the boat.

When he had finished speaking he said to Peter, 'Put out into deep water and throw out your nets for a catch.'

'Master,' Peter replied 'we have worked hard all night long and have caught nothing, but if you say so, I will throw out the nets as you ask.' When they had done this they pulled in such a huge number of fish that their nets began to break, so the fishermen signalled to their companions in the other boat to come and help them. Even when these men joined in to help, they still filled the two boats with so many fish that they nearly sank.

When Peter saw this he fell on his knees in front of Jesus saying, 'Leave me, Lord; I am a sinful man.' For he and all his companions were completely overcome by amazement at the size of the catch they had made. So also were James and John, the sons of Zebedee, who were Peter's partners. Then Jesus said to Peter, 'Do not be afraid. Listen to me;

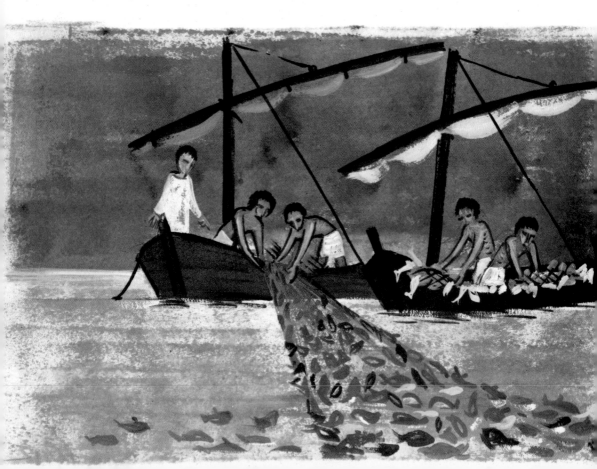

from now on it is not fish you will catch but men.' Then, after bringing their boats back to land, Peter and his three friends left everything and followed Jesus.

JESUS HEALS A PARALYSED MAN

After Jesus had been away for some time giving his message to the different towns and villages in Judaea, he returned to Capernaum. Word went round the district that he was back and so many people began to gather outside the house where he was staying that there was no room left, even in front of the door.

Jesus was preaching the word of God to the crowd when some people brought along a paralysed man on a stretcher carried by four of his friends. Now because the crowd made it impossible to get the man close to Jesus, his friends stripped the roof over the place where Jesus was. When they had made an opening, they lowered the stretcher on which the paralytic lay through the roof. Seeing their faith, Jesus said to the paralysed man, 'My child, your sins are forgiven.' Now there were some Law-teachers sitting nearby in the crowd and they thought to themselves, 'How can this man talk like that? He is insulting God. Who can forgive sins except God?' Jesus knew that this was what they were thinking, and he said to them, 'Why do you have these thoughts in your hearts? Which of these is easier: to say to this paralysed man: "Your sins are forgiven" or to say to him: "Get up, pick up your stretcher and walk"? But just to prove to you that the Son of Man has the power on earth

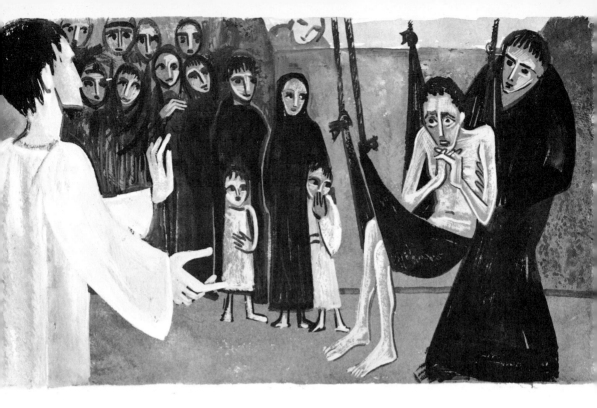

to forgive sins,'—and here he turned and spoke to the para-
lytic—'I order you: get up this very moment, pick up your
stretcher, and go off home.' And the man got up, picked up
his stretcher at once and walked out in front of everyone.
All the people there were astounded and praised God and
chattered to one another, saying, 'We have never seen
anything like this before.'

JESUS ASKS THE HELP OF MATTHEW

After Jesus had cured the paralysed man at Capernaum he
went out of the house to the shore of the Lake of Tiberias,
and all the people followed him and he taught them. As he
was walking along he saw a tax collector named Matthew,
the son of Alphaeus, sitting beside the customs house. Jesus

called to him, 'Follow me.' Then Matthew immediately left his work and followed Jesus.

Later, Matthew gave a big party at his house in honour of Jesus, and at table with Jesus and his disciples there was a large gathering of tax collectors and others with a bad name. Now the Pharisees despised these people and when they saw this, they said to Jesus' disciples, 'Why ever does your master eat with tax collectors and scum like these?' When Jesus heard them talking like that, he replied, 'It is not healthy people who need a doctor, but sick people. Go and think hard about the meaning of these words of Hosea in the scriptures: "What I want from you is that you should learn to show mercy. This is better than offering sacrifices.' And indeed it is not to the good people that I came to give my message about changing their way of living, but to the bad people.'

JESUS TALKS ABOUT FASTING

After the big party that Matthew the tax collector gave for Jesus and his disciples, some disciples of John the Baptist came to find Jesus and they asked him, 'Why is it that on some days we and the Pharisees take no food but your disciples eat just the same as on other days?' Jesus replied with words that held a hidden meaning about himself and his task, 'Surely at a wedding the bridegroom's friends and helpers would never think of going into mourning as long as the bridgroom is still with them? But the time will come for the bridegroom to be taken away from them, and then his friends will fast. Remember also that no one sews a piece

of unshrunken new cloth on to an old cloak to patch a hole, because the patch pulls away from the cloak and the tear gets worse. Nor do people put new wine into old wineskins; if they do, the wine will burst the skins and the wine runs out, and the skins are destroyed. No; they put new wine into fresh wineskins and both are kept safe.' Jesus wanted to set them thinking about who he was and what he had come to do.

THE CENTURION AND HIS SICK SERVANT

On account of all the things Jesus had been saying and doing he was becoming very well known throughout the whole country and he was coming into conflict more and more with the members of the Pharisee and Sadducee parties who were always trying to catch him out on points of law. At about this time he went up into the hills near Capernaum and spent the whole night up there in prayer. After this he chose twelve out of his followers to be his special helpers or apostles. Then he came down from the hills and large crowds gathered to listen to what he had to say.

When Jesus had come to the end of all he wanted the people to hear, he went into Capernaum. A Roman centurion who was stationed there had a favourite servant who was sick and close to dying. Having heard about Jesus, the centurion sent some Jewish elders to him to ask him to come and heal his servant. When they came to Jesus they pleaded earnestly with him, 'He deserves this of you' they said 'because he is friendly towards our people; in fact, he is the one who built our synagogue.' So Jesus went with them, and

was not very far from the man's house when the centurion sent word to him by some friends: 'Sir,' he said 'do not put yourself to any more trouble, because I am not worthy to have you under my roof. For this same reason I did not presume to come to you myself; but give the word and let my servant be cured. For I am under authority myself, and I have soldiers under me; and I say to one man: Go, and he goes; to another: Come here, and he comes; to my servant: Do this, and he does it.' When Jesus heard these words he was astonished and, turning round, he said to the crowd, 'I tell you, not even in Israel have I found faith like this.' And when the messengers got back to the centurion's house they found the servant in perfect health.

JESUS BRINGS A WIDOW'S SON BACK TO LIFE

Soon after Jesus had healed the centurion's servant in Capernaum he went to a town called Nain. When he was near the town gate, a dead man was being carried out for burial. He was the only son of a widow.

When the Lord saw her he felt sorry for her. 'Do not cry' he said. Then he went up and put his hand on the coffin and the bearers stood still, and he said to the dead man, 'Young man, I tell you to get up.' And the dead man sat up and began to talk, and Jesus gave him to his mother.

The crowd was filled with wonder and just a bit afraid, and they all praised God saying, 'A great prophet has appeared among us; God has visited his people.' This opinion of him spread throughout Judaea and all over the countryside, and John the Baptist sent two of his own disciples to

Jesus to ask if he was the Messiah. Jesus did not answer them directly but told them to go back to John and report all the happenings they had seen.

JESUS CALMS A STORM

Once when Jesus had been giving his message to large crowds by the Lake of Tiberias nearly all day, he said to his disciples when evening came, 'Let us cross over to the other

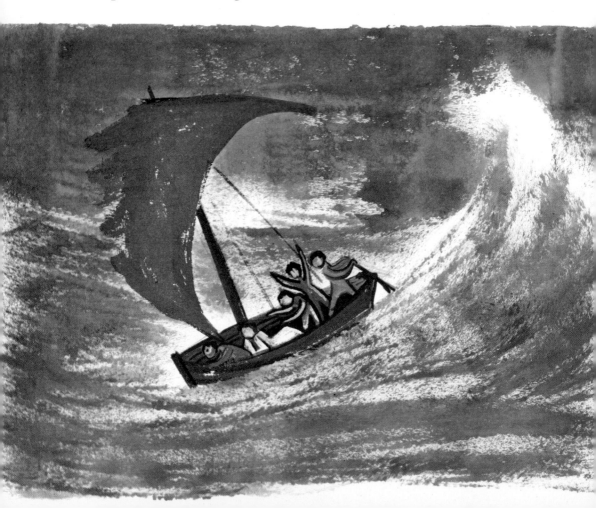

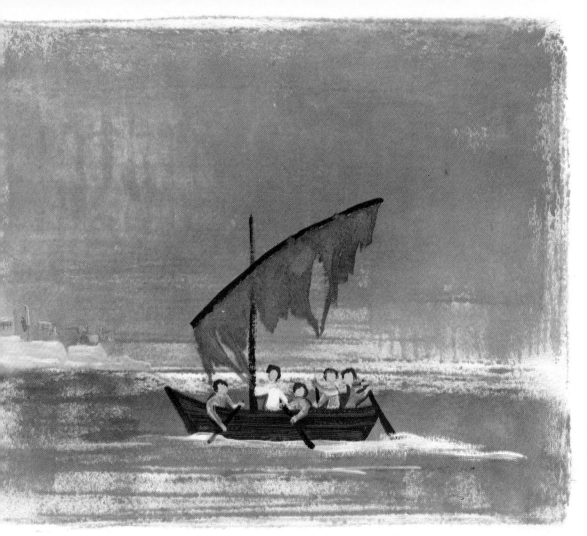

side.' Leaving the crowd behind they took him over in the boat and other boats went with them. Then it began to blow a gale and the waves were breaking into the boat so that it was almost swamped. Jesus was in the stern, his head on a cushion, asleep. They woke him and said to him, 'Master, do you not care? We are going down!' And he woke up and said to the wind and the sea, 'Quiet now! Be calm!' And the wind dropped, and all was calm again. Then he said to them, 'Why are you so frightened? How is it that you have no faith?' They were filled with wonder and fear and said to one another, 'Who can this be? Even the wind and the sea obey him.'

JAIRUS' DAUGHTER

When Jesus crossed back again to the Capernaum side of the Lake of Tiberias after healing a madman on the far side, a large crowd gathered round him again to listen to him. Then a synagogue official named Jairus came up to Jesus, fell at his feet and pleaded with him saying, 'My little daughter is desperately sick. Do come and lay your hands on her to make her better and save her life.' Jesus went with him and the crowd followed; they were pressing all round him.

While he was on the way with Jairus, some people arrived from the man's house to say, 'Your daughter is dead; why put the Master to any further trouble?' But Jesus overheard this remark of theirs and he said to Jairus, 'Do not be afraid; only have faith.' And he allowed no one to go with him except Peter and James, and John the brother of James. So they came to Jairus' house and Jesus noticed all the distress and people loudly weeping. He went in and said to them, 'Why all this fuss and crying? The child is not dead, but asleep.' But they laughed at him. So he turned them all out and, taking with him the child's father and mother and his own companions, he went into the place where the child lay. He took the child by the hand and said to her, 'Talitha, kum!' which means, 'Little girl, I tell you to get up.' The little girl got up at once and began to walk about; she was twelve years old. At this they were overcome with astonishment, and he ordered them strictly not to let anyone know about it, and told them to give her something to eat.

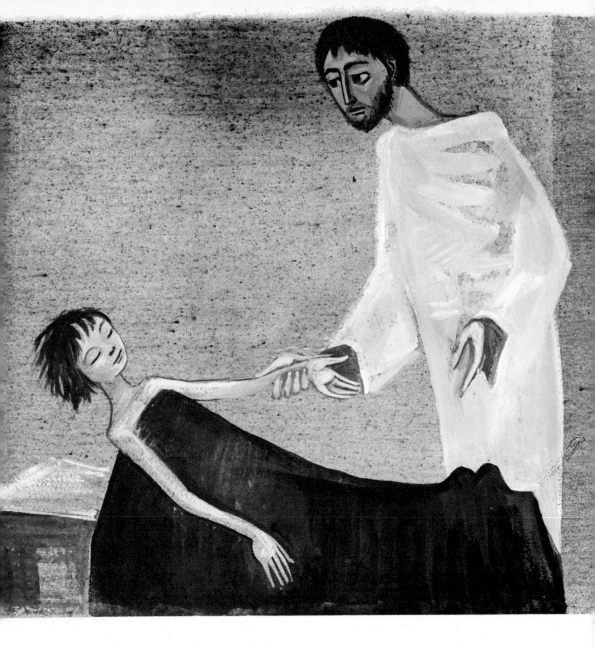

JESUS FEEDS FIVE THOUSAND PEOPLE

After Jesus had brought Jairus' little daughter back to life again at Capernaum, he left and went with his disciples to his home town of Nazareth. There he preached in the synagogue, but he could do no more than cure a few sick

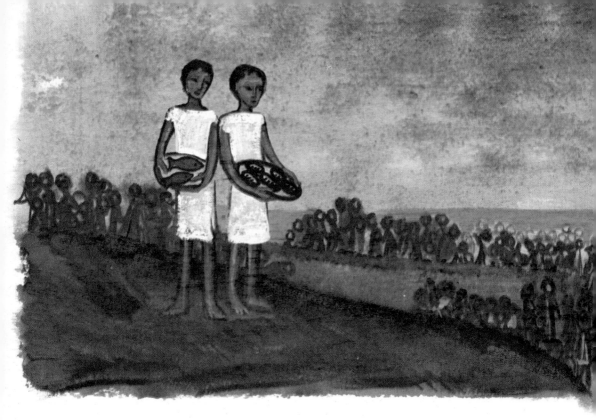

people, because most of the inhabitants had no faith in him. Then, after making a tour of the nearby villages, he collected his twelve specially chosen disciples and sent them out in pairs on their own for the first time, to pass on his teaching and heal the sick. So the twelve set off to preach Jesus' message about changing one's way of living, and they healed many people, both those who were sick in their mind and those who were sick in their body. Then they came back to Jesus and told him all they had done and taught.

Then Jesus said to the disciples, 'You must come away with me to some lonely place all by yourselves and rest for a while.' There were so many people coming and going that the disciples had no time even to eat. So they went off in a boat to a lonely place where they could be by themselves. But people saw them going, and many began to guess where; and from every town they all hurried to the place on foot and reached it before them. So when Jesus stepped ashore he

saw a large crowd. He took pity on them because they seemed like sheep without a shepherd, and he set himself to teach them very carefully in well-chosen words. By now it was getting very late, and his disciples came up to him and said, 'This is a lonely place and it is getting very late, so send these people away, and they can go to the farms and villages round about, to buy themselves something to eat.' He replied, 'Give them something to eat yourselves.' They answered, 'Are we to go and spend two hundred pence on bread for them to eat?' 'How many loaves have you?' he asked 'Go and find out.' And when they had done this, they said, 'Five barley loaves and two fishes.' Then he ordered them to gather all the people together in groups on the grass. They sat down on the ground in squares of hundreds and fifties. Then he took the five barley loaves and the two fishes, and he said the blessing. Then he broke the loaves and handed them to his disciples to share out among the people.

He also blessed and divided up the two fishes among them all. They all ate as much as they wanted. Afterwards the disciples collected twelve basketfuls of scraps of bread and pieces of fish. Those who had eaten the loaves numbered five thousand people.

WALKING ON THE WATER

Immediately after Jesus had fed the five thousand people, he made the disciples get into the boat and go on ahead to the other side while he sent the crowds home. When the crowds were gone Jesus went up into the hills by himself to pray. When evening came, he was still there alone, while the boat carrying his friends was by then far out on the Lake of Tiberias, battling its way against a heavy sea and a strong head-wind. In the small hours Jesus came down from the hills and walked across the lake to meet the disciples in the boat. When they saw him walking on the water they were terrified. 'It is a ghost' they said, and cried out in fear. At once Jesus called out to them, saying, 'Courage! It is I! Don't be afraid.' It was Peter who answered. 'Lord,' he said 'if it is you, tell me to come to you across the water.' 'Come' said Jesus. Then Peter got out of the boat and started walking towards Jesus across the water, but as soon as he felt the force of the wind, he took fright and began to sink. 'Lord! Save me!' he shouted. Jesus put out his hand at once and held him. 'Man of little faith,' he said, 'why did you doubt?' And as Jesus and Peter got into the boat the wind dropped. The men in the boat bowed down before Jesus and said, 'Truly, you are the Son of God.'

JESUS HEALS A DEAF AND DUMB MAN

After Jesus had walked on the water to the disciples' boat, they all landed on the other side of the Lake of Tiberias at Gennesaret. The crowds soon gathered again, bringing many sick people who touched him or even his clothes and were cured. Then he set out for the district round the sea-port of Tyre and tried to get away from the crowds by hiding in a house, but everywhere people recognised him. Returning from there towards the lake again, he went by way of the neighbouring sea-port of Sidon and right through the region of the Ten Towns.

On the way some people brought him a deaf man who was also unable to speak properly. The man's friends asked Jesus to lay his hand on him for healing. Jesus took him aside in private, away from the crowd, put his fingers into the man's ears and touched his tongue with spittle. Then he prayed and turned to the man and said to him, 'Ephphatha' which means 'Be opened'. Immediately the man was able to hear again, and the muscles of his tongue were freed and he could speak clearly. Then Jesus ordered the people not to tell anyone about this, but the more he insisted, the more they talked about it everywhere. There was no limit to their admiration of him. 'Everything he does is wonderful;' they said 'he even makes the deaf hear and the dumb speak.'

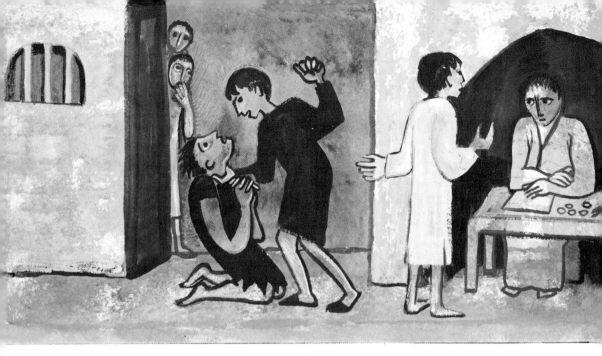

THE UNFORGIVING SERVANT

One day Jesus was teaching his disciples about how to help in building the kingdom of heaven. Peter asked him, 'Lord, how often must I forgive my brother if he does wrong to me? As many as seven times?' Jesus answered, 'Not seven times, I tell you, but many, many, many times more often than that. Listen to this: the kingdom of heaven is rather like a king who decided to settle his accounts with the officials who were his servants looking after his affairs. When the reckoning began, the first man to come before him owed him ten thousand talents; but this man had no means of paying, so his master gave orders that he should be sold, together with his wife and children and all his possessions, in order to pay the debt. At this, the servant threw himself down at his master's feet. "Give me time" he said "and I will pay the whole sum." And the servant's master felt so sorry for him that he let him go and cancelled the debt altogether. Now as this servant went out, he happened to meet a fellow servant who in turn owed him one hundred

denarii; and he seized him by the throat and began to throttle him. "Pay what you owe me" he said. His fellow servant fell at his feet and begged him, saying, "Give me time and I will pay you." But the other would not agree; instead, he had the debtor thrown into prison till he should pay. All the other servants were horrified when they saw what had happened, and they went to their master and reported the whole thing to him. Then the master sent for the first servant. "You wicked servant;" he said "I cancelled all that debt of yours when you pleaded with me. Ought you not, then, to have had pity on your fellow servant just as I had pity on you?" Then in his anger the master handed this servant over to the jailers till he should pay all his debt. And that is how my heavenly Father will deal with you unless you each really forgive your brother with all your heart.'

THE GOOD SAMARITAN

Once when Jesus was giving his message to a group of people sitting round him, there was a lawyer who stood up and tried to catch him unprepared by asking an awkward question. The lawyer said, 'Master, what must I do to have eternal life?' Jesus said to him, 'Tell me, what do the writings of the Law say about this? What do you read there?' He replied 'You must love the Lord your God with all your heart, with all your soul, with all your strength, and with all your mind, and you must care for your neighbour just as much as you care for yourself.' 'You have answered right.' said Jesus 'Do this, and eternal life is yours.'

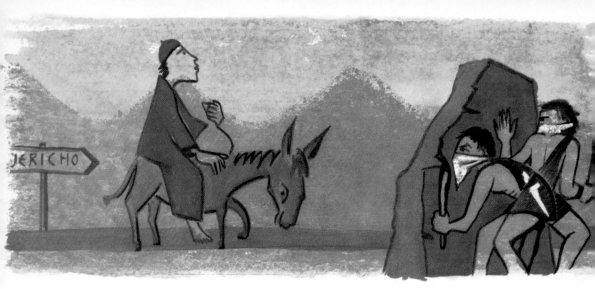

But the lawyer did not like such a simple answer which made his own question seem unnecessary; so to keep his end up, he asked another question, 'And who is my neighbour?' Jesus replied by making up a story on the spot: 'A Jewish man was once on his way down the road from Jerusalem to Jericho when he was attacked by a band of robbers. They took all he had, beat him up and then made off, leaving him half dead by the roadside. Now a priest happened to be travelling that way, but when he saw the man, he avoided him and passed by on the other side of the road. In the same way a man of the Levites came to the place, saw him, and passed by on the other side. Then a third

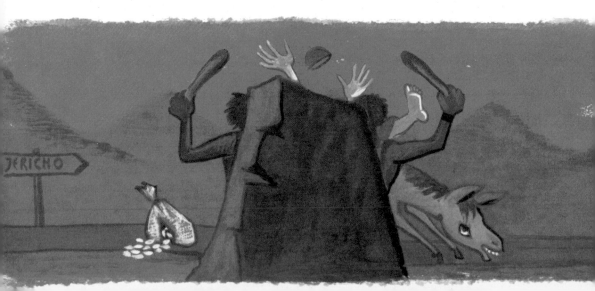

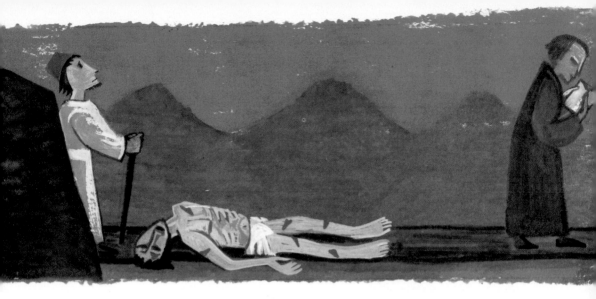

traveller came along, and he was a foreigner from Samaria where they hate us and despise our faith in God. He felt so sorry for the poor man that he immediately came to help him. He dressed the man's wounds with oil and wine, and bandaged them. Then he lifted him on to his own donkey, brought him to the nearest inn and looked after him. Next day, he took out two denarii and handed them to the inn-keeper. "Look after him," he said "and on my way back I will pay any extra expense you may have." Which of these three, do you think, had the right answer to your question?' 'The one who took pity on him' replied the lawyer. Jesus said to him, 'Go, and do the same yourself.'

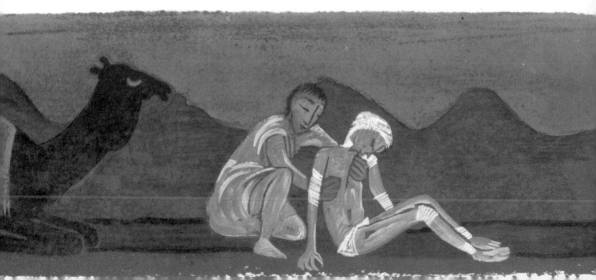

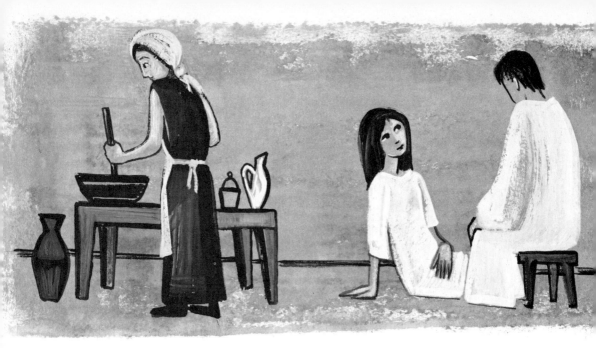

MARTHA AND MARY

In the course of his long final journey towards Jerusalem
with his disciples, Jesus came to a village called Bethany
where a woman named Martha lived with her brother
Lazarus and her sister Mary. All three of them were friends
of Jesus, and Martha welcomed the travellers into her house.
Her sister took the opportunity to sit down at Jesus' feet and
listen to him speaking. Now Martha was very busy with all
the serving for the guests and she got annoyed and said to
Jesus, 'Lord, do you not care that my sister is leaving me to
do the serving all by myself? Please tell her to help me.' But
Jesus answered her, 'Martha, Martha, you worry and fret
about so many things, and yet there is no need to prepare
such a lot of things for us. Indeed only one thing is really
necessary, and Mary has seen what it is and chosen it. You
are not to take it away from her.'

THE RICH FARMER

One day, Jesus was speaking to a large gathering of people when a man in the crowd shouted to him, 'Master, tell my brother he ought to let me have a share of the family property.' Jesus answered him, 'My friend, who made me your judge to decide between your claims?' and he said to the crowd, 'Watch out and be on your guard against greed of any kind, for nobody's life is made safe by all the things that belong to him, even when he has more of them than he needs.'

Then he told them a story: 'There was once a rich farmer. One year he had such a good harvest from his land that he thought to himself, "What am I to do? I do not have enough room to store my crops." Then he said, "I know what I will do; I will pull down all my barns and build bigger ones, and store all my grain and all my goods in them, and then I will have plenty of good things stored away for many years to come; and I will be able to take things easy, eat, drink, and have a good time." But God said to him, "You fool! This very night your life will be demanded of you; and this wealth of yours, whose will it be then?" This is how it is when someone stores up possessions for himself instead of making himself rich in God's eyes.'

He said to his disciples, 'That is why I am telling you not to worry about your life and how you are to get food and clothing. Think of the ravens. They do not sow seed or reap harvest; they have no storehouses and no barns; yet God feeds them. And how much more are you worth than the birds! You must not set your heart on all these things; it is the unbelievers of this world who do that. Your Father well knows you need them. No, set your hearts on God's kingdom, and these other things will be given to you as well.'

THE GREAT DINNER-PARTY

Jesus was a guest one sabbath at a meal in the house of one of the leading members of the Pharisee group. He had been discussing the kingdom of God when a remark by someone showed him how much most of the guests misunderstood what it was all about. So he told this story.

'There was a man who planned a great dinner-party and invited a large number of people. When the time came, he sent his servant to say to the invited guests, "Come round; everything is ready now." But all of them started to make excuses. The first said, "I have bought a piece of land and I must go and see it. Please accept my apologies." Another said, "I have bought five pairs of oxen and I am just going to try them out. Please accept my apologies." Yet another said, "I have just got married and so I am unable to come."

'The servant returned and reported this to his master. Then the host got angry and said to his servant, "Go out quickly into the streets and back alleys of the town and bring in the poor, the crippled, the blind and the lame people." The servant did this and reported, "Sir, your orders have been carried out and there is still room." Then the master said, "Go out and press any travellers on the open road and any tramps under the hedges to come in. I tell you my house must be filled, so that not one of those who were invited shall have a taste of the dinner I have prepared."'

THE LOST SHEEP AND THE LOST PENNY

As a result of Jesus' teaching about how a lot of unexpected people would succeed in entering the kingdom of God and a lot of others who expected to get in would fail to do so, a great many tax collectors and other people with a bad name were trying to meet Jesus to hear what he had to say. The Pharisees and the Law-teachers complained bitterly about this. 'This man' they said 'welcomes people with a bad name and even eats with them.'

Jesus decided to try to teach them a lesson, and he said, 'If any man among you had a hundred sheep and lost one, would he not leave the ninety-nine in the desert and go searching for the missing one till he found it? And when he found it, would he not joyfully take it on his shoulders and then, when he got home, call together his friends and neighbours? "Rejoice with me;" he would say "I have found my sheep that was lost." In the same way, I tell you there will be more rejoicing in heaven over one bad man who decides to change his ways than over ninety-nine good men whose lives do not need to be changed.

'Or again, if a woman had ten pennies and lost one of them, would she not light a lamp and sweep out the house and search thoroughly till she found it? And then, when she had found it, would she not call together her friends and neighbours? "Rejoice with me;" she would say "I have found the penny I lost." In the same way, I tell you, there is rejoicing among God's messengers over anyone who decides to change from bad to good.'

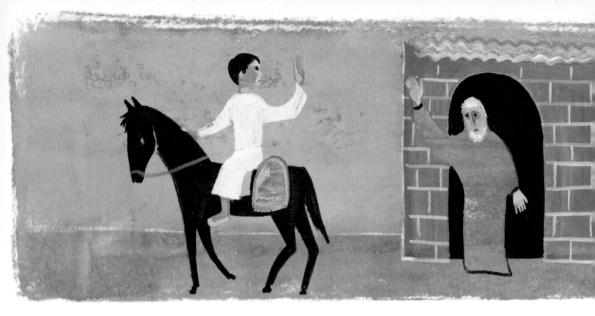

THE SON WHO CAME BACK

After the stories about the lost sheep and the lost penny, Jesus told his listeners yet another story with the same meaning: 'A man had two sons. The younger said to his father, "Father, let me have my share of our property now." So his father divided it between them. A few days later, the younger son collected all he had and left for a distant country where he wasted all his money on riotous living.

'When he had spent every penny, there was a severe famine in that country and the young man began to feel

hard up, so he hired himself out to one of the local farmers who put him to feed the pigs. He got so hungry that he would willingly have eaten the husks the pigs ate, but no one offered him anything. Then he came to his senses and said to himself, "Think of all my father's paid servants who have more food than they want, and here am I dying of hunger! I will leave and go back to my father and say: Father, I have done wrong against heaven and against you; I no longer deserve to be called your son. Treat me as one of your paid servants." So he set out.

'While he was still a long way off, his father saw him

coming and was filled with pity. He ran to the young man, took him in his arms and kissed him. "Father," said the young man "I have done wrong against heaven and against you. I no longer deserve to be called your son." But the father said to his servants, "Quick! Bring out the best clothing and put it on him; put a ring on his finger and sandals on his feet. Bring the calf we have been fattening, and kill it. We are going to have a feast because this son of mine was dead and has come back to life; he was lost and is found." And they began to celebrate.

'Now the elder son was out in the fields, and on his way back he heard music and dancing. He asked one of the servants what it was all about. "Your brother has returned" replied the servant "and your father has killed the fattened calf because he has got him back safe and sound." The brother was angry and refused to go in, and his father came out to plead with him; but he answered his father, "Look, all these years I have slaved for you and never once disobeyed your orders, yet you never offered so much as a kid for me to celebrate with my friends. But when my brother comes back after swallowing up your property—he and his women—you kill the calf we had been fattening." The father said, "My son, you are with me always and all I now have is yours. It was only right we should celebrate and rejoice, because your brother here was dead and has come to life; he was lost and is found."'

THE GRATEFUL LEPER

Still on his final journey to Jerusalem, Jesus was travelling along the border between Samaria and Galilee. As he entered one of the villages, ten lepers came out to meet him. Because they were lepers they stood some way off and called to him, 'Jesus! Master! Take pity on us.' When Jesus saw them standing there he said, 'Go and show yourselves to the priests.' They went off to do this, and as they went they were healed. One of the men finding himself cured, turned back again, shouting praises to God at the top of his voice; and he threw himself at the feet of Jesus and thanked him. Now this man was a foreigner from Samaria. So Jesus said, 'Were not all ten of them made clean? Where have the other nine gone? It seems that not one of them has come back to give praise to God, except this foreigner.' And he said to the man, 'Stand up and go on your way. Your faith has saved you.'

THE PHARISEE AND THE TAX COLLECTOR

Jesus told this story to some people who were proud because they thought they were very good, and who despised everyone else. 'Two men went up to the Temple to pray,' he said 'one a Pharisee, the other a tax collector. The Pharisee stood there and said this prayer: "I thank you, God, that I am not greedy and unjust and bad-living like everyone else, and particularly that I am not like this tax collector here. I fast twice a week; and to help other people I give away a tenth of all I get." The tax collector stood at a distance and did not

even dare to look up. He felt weighed down by his own faults and could only repeat, "God, have mercy on me, I am a bad man." I tell you, this tax collector went home again in good favour with God, but the Pharisee did not. Everyone who thinks highly of himself will be humbled, but the man who sees his own faults and is sorry for them, will be given a higher place.'

JESUS AND THE CHILDREN

Jesus and his disciples were making their way through the district of Galilee and he was teaching and training them as they went. When they arrived at the village of Capernaum they went into a friend's house and Jesus asked them, 'What were you arguing about on the road?' They did not answer because they had been arguing about which of them was the most important. Jesus realised this, so he called the twelve specially chosen ones to him and said, 'If anyone wants to be first, he must make himself last of all and servant of all.' Then he took a little child, placed him in front of them and put his arms round him, and said, 'Anyone who welcomes a little child in my name, welcomes me; and anyone who welcomes me welcomes the one who sent me. But anyone getting in the way and tripping up one of these little ones who has faith in me, would be better thrown into the sea to drown with a great millstone round his neck.'

From there they went on again and passed through the district of Judaea to the country on the far side of the river Jordan. And again the crowds gathered round Jesus and he taught them. And people started to bring little children to

him for him to touch them. The disciples turned them away, but when Jesus saw this his temper rose and he said to the disciples, 'Let the little children come to me; don't stop them. It is to people who are just like them that the kingdom of God belongs. I tell you, anyone who does not welcome the kingdom of God like a little child will never enter it.' Then he put his arms round the children, laid his hands on them and gave them his blessing.

THE SERVANTS AND THEIR POUNDS

When Jesus was passing through the town of Jericho, a man named Zacchaeus came along because he was anxious to see what kind of a man Jesus was. Zacchaeus was one of the top tax collectors and very wealthy. He was also rather a short man and he could not see Jesus because of the crowd; so he ran ahead and climbed up a sycamore tree to catch a glimpse of Jesus as he passed. When Jesus reached the spot, he looked at the tree and called up to him, 'Zacchaeus, come down. Hurry, because I must stay at your house today.' Zacchaeus hurried down and welcomed him joyfully. When they saw this, all the people complained and said, 'He's going to stay at the house of that wicked man.' But Zacchaeus stood firm and said to Jesus, 'Look, sir, I am going to give half my property to the poor, and if I have cheated anybody I will pay him back four times over.' Jesus replied, 'Today God has come to your rescue, for even you, a tax collector, belong to God's people.'

Everybody was listening to this, so Jesus took the opportunity to tell another story because he was now nearly at Jerusalem and he knew they all thought the kingdom of God was going to set itself up then and there. So he began, 'A nobleman went to a distant country to be made king and then return again. He summoned ten of his servants, gave them one pound each and told them, "Do business with this until I get back." On his return as king, he sent for them to find out what profit each had made. The first said, "Sir, your one pound has brought in ten." "Well done, my good servant!" replied the king "Since you have proved yourself faithful in a very small thing, you shall be governor of ten cities." The second said, "Sir, your one pound has made five." To this one also the king said, "And you shall be in

charge of five cities." Next came another who said, "Sir, here is your pound. I put it away safely because I was afraid of you, for you expect a great deal of your servants." "You bad servant!" said the king "You knew I expected a lot, so why did you not put my money in the bank? Then I could have taken it out again with interest." And the king said to those standing by, "Take the pound from him and give it to the man who has ten pounds."'

BARTIMAEUS THE BLIND MAN

As Jesus and the disciples left Jericho a large crowd followed them. Sitting at the side of the road was a blind beggar named Bartimaeus, and when he heard that it was Jesus of Nazareth approaching, he began to shout and cry out, 'Son of David, Jesus, have pity on me.' Many of the crowd scolded him and told him to keep quiet, but he only shouted all the louder, 'Son of David, have pity on me.' Jesus stopped and said, 'Call him here.' So they called to the blind man, 'Take courage! Get up; Jesus is calling you to come over to him.' So Bartimaeus threw off his cloak, jumped up and made his way to Jesus. Jesus said to him, 'What do you want me to do for you?' 'Master,' the blind man said to him 'let me see again.' Jesus said to him, 'Go on your way; your faith has saved you.' And immediately his sight returned and he followed Jesus along the road.

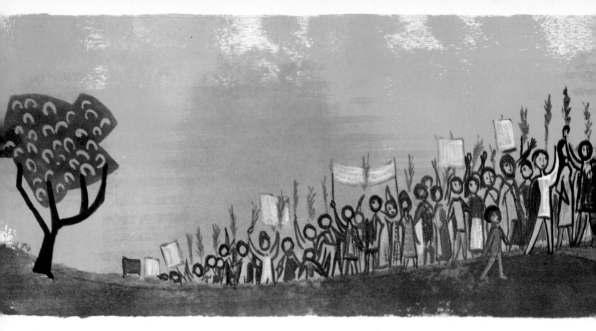

JESUS ENTERS JERUSALEM

When Jesus and his disciples were near Jerusalem and had come in sight of Bethphage on the Mount of Olives, he sent two of them on ahead and told them, 'Go to the village over there, and you will immediately find a donkey tethered and a colt with her. Untie them and bring them to me. If anyone says anything to you, you are to say, "The Master needs them and will send them back directly."' This fulfilled the prophecy of Zechariah who said, 'Say to the daughter of Zion: Look, your king comes to you; he is humble, he rides on a donkey and on a colt, the foal of a beast of burden.'

So the disciples went off and did as Jesus had told them. They brought the donkey and the colt, then they laid their cloaks over the animals' backs and Jesus mounted the donkey and rode on towards Jerusalem.

Great crowds of people had gathered and were waiting to welcome him; they spread their cloaks on the road in front of him to do him honour so that he might ride over them, and others cut branches from the trees and spread

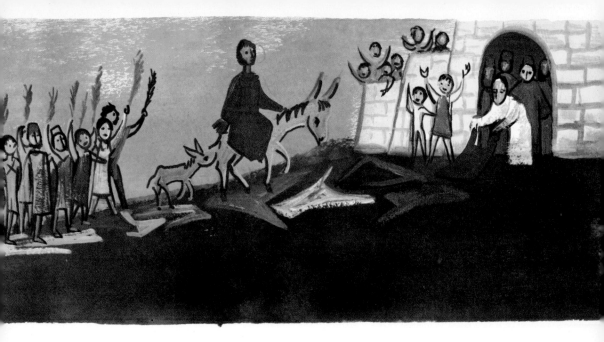

them on the road too. The crowds who went in front of Jesus were all shouting: 'All praise to the Son of David! Blessings on him who comes in the name of the Lord! All praise to him in the highest heavens!' But some Pharisees in the crowd said to Jesus, 'Master, restrain your followers.' Jesus replied, 'I tell you, if they keep silence, the stones will cry out.'

As he came in sight of the city he shed tears over it and said, 'Jerusalem, if on this day you had only understood the message of peace! A time is coming when your enemies will not leave one stone standing on another within you—and all because you did not recognise your opportunity when God offered it!' And when he entered Jerusalem itself, the whole city was in turmoil. Those who did not know what it was all about asked, 'Who is this man?' and the crowds answered, 'This is the prophet Jesus from Nazareth in Galilee.'

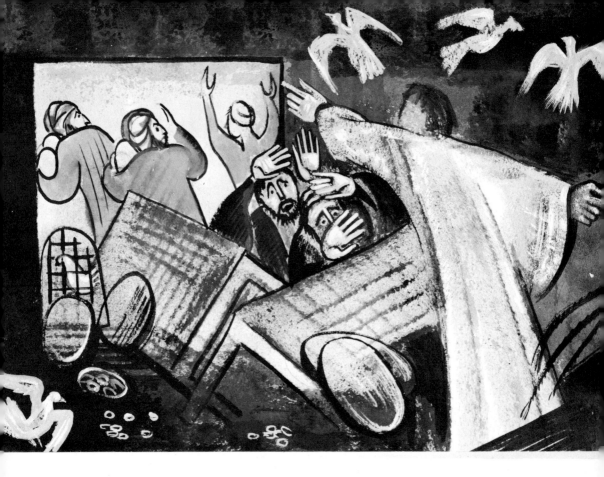

JESUS CLEARS OUT THE TEMPLE

Just before the festival of the Passover, Jesus went into the Temple in Jerusalem. He found people selling cattle and sheep and pigeons there, and the money-changers sitting at their counters. Making a whip out of some cord, he drove them all out of the Temple, and the cattle and sheep as well. He scattered the money-changers' coins, knocked their tables over and said to the pigeon-sellers, 'Take all this out of here and stop turning my Father's house into a market.' Then his disciples remembered the words of the psalm which said: 'Burning care for your house will seize hold of me.' The Jews interrupted him and said, 'What sign can you show us to prove that you have any right to do this?' Jesus answered,

'Destroy this holy place and in three days I will raise it up.'
The Jews replied, 'It has taken forty-six years to build this
holy Temple; are you going to raise it up again in three
days?' But Jesus was speaking of his own body as a holy
place, and of when he himself would rise from the dead.
Later his disciples remembered that he had said this, and
they saw that the scripture and the words Jesus had just said
were true.

THE TWO SONS

Jesus was teaching in the Temple in Jerusalem one day, when
the chief priests and elders challenged his right to do so. He
in turn put them a very awkward question about why they
had refused to accept the teaching of John the Baptist. Then
he told them a story to show that he saw through their dis-
honesty. 'A man had two sons. He said to the first, "My
boy, you go and work in the vineyard today." The son
answered, "I will not go", but afterwards he changed his
mind and went. The man then said the same to the second
son who answered, "Certainly, sir"; but he never went.
Which of the two did the father's will?' 'The first' they
replied.

Then Jesus said to them 'I tell you in earnest, the wretched
tax collectors and women of the streets are making their way
into the kingdom of God ahead of you. For John came to
you to show how to live but you did not believe him; yet
these wretched people did, and even after that, you refused
to change your minds and believe in him.'

THE WICKED VINEYARD TENANTS

After the story of the two sons, Jesus continued his teaching with another story for the chief priests and the elders, and all the people who were listening.

'There was a certain man,' he said 'a landowner, who planted a vineyard. He fenced it all round, dug a winepress in it and built a watch-tower. Then in exchange for a payment of rent he arranged with some people that they could use it, and he went abroad. When harvest time drew near he sent some of his servants to these people, his tenants, to collect his share of the produce as payment. But the tenants seized his servants, beat up one, killed another and stoned a third. Then he sent some more servants, this time a larger number, and the tenants dealt with them in the same way. Finally the owner sent his son to them. "I am sure they will respect my son" he said. But when the tenants saw the son, they said to each other, "This is the heir. Come on, let us kill him and take over his inheritance." So they seized him and threw him out of the vineyard and finally killed him.

'Now,' said Jesus 'when the owner of the vineyard returns, what will he do to those tenants?' The people answered, 'He will bring those wretches to a harsh end and he will hire out the vineyard to other tenants who will deliver the produce to him when the right season arrives.' Then Jesus said to them, 'Have you never read the words of the psalm which says, "It was the stone rejected by the builders that became the corner-stone. This was the Lord's doing and it is wonderful to see"? I tell you, then, that the kingdom of God will be taken from you and given to a people who will produce its fruit.'

When they heard the stories Jesus was telling, the chief priests and the Law-teachers realised he was speaking about

them; but though they would have liked to arrest him they were afraid of the crowds, who looked on him as a prophet.

THE WIDOW'S PENNY

It happened that one day after he had finished teaching, Jesus went and sat down opposite the treasury and watched the people putting money into the treasury collection box. Many of the rich people put in a great deal of money, but there was one poor widow who came and put in two small coins, worth about as much as a penny.

Then Jesus called his disciples together and said to them, 'I tell you in earnest, that poor widow has put in more than all the others who have given something to the treasury. They have all put in money they had to spare, but from the little she had she has put in everything she possessed, all she had left to live on.'

THE TEN BRIDESMAIDS

Jesus was teaching his disciples more about the kingdom of heaven, and he told them a story. 'The kingdom of heaven will be like this:' he said 'Ten bridesmaids took their lamps and went to meet the bridgroom. Five of the bridesmaids were foolish and five were sensible: the foolish ones did take their lamps, but they forgot to buy any oil, whereas the sensible ones took care to provide themselves with bottles of oil as well as their lamps. Now the bridegroom was late, and all the bridesmaids grew drowsy and fell asleep.

When midnight came there was a cry, "The bridegroom

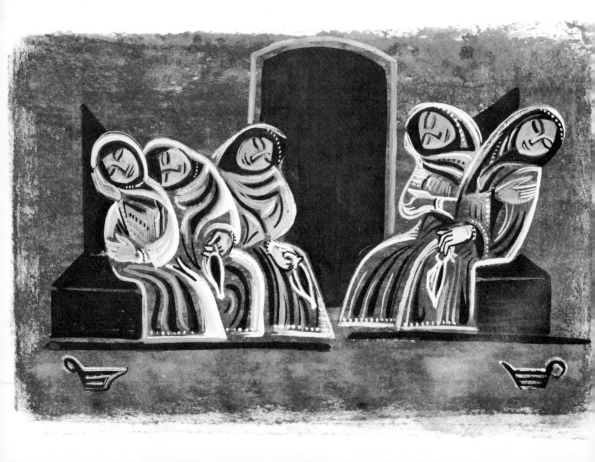

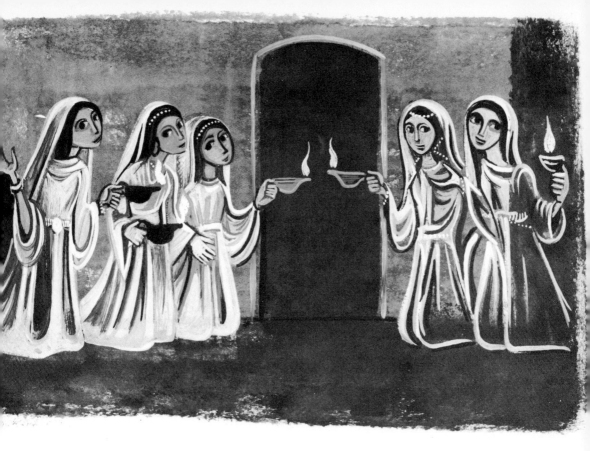

is here! Go out and meet him." At this, all those brides-
maids woke up and adjusted their lamps. Then the foolish
ones said to the sensible ones, "Give us some of your oil;
our lamps are going out." But the sensible ones replied,
"There may not be enough for us as well as for you; you
had better go to the merchants who sell it and buy some
more for yourselves." The five foolish bridesmaids hurried
off to buy some oil and in the meantime the bridegroom
arrived whilst they were away. The other five who were
ready with their lamps, went in with him to the wedding
hall and then the door was closed.

'The foolish bridesmaids arrived back later only to find

they were shut out from the celebrations. "Lord, Lord," they cried "open the door for us." But he answered, "I tell you truly, I do not know you." So' said Jesus 'stay awake, because you do not know either the day or the hour when the kingdom of heaven will arrive.'

THE LAST JUDGEMENT

Jesus was teaching his disciples about the end of time, when everyone will have to account for what he has done with his life. He said to them, 'When the Son of Man comes in his glory, with all his messengers round him, then he will take his seat on his throne of glory. All the nations will be assembled before him and he will separate men one from another just as the shepherd separates sheep from goats. He will place the sheep on his right hand and the goats on his left.

'Then the King will say to those on his right hand, "Come, you whom my Father has blessed, take your share in the kingdom made ready for you since the beginning of the world. When I was hungry, you gave me food. When I was thirsty you gave me drink. When I was a stranger you made me welcome; when I was naked you clothed me, when I was sick you visited me, when I was in prison you came to see me."

'Then these good people will say to the King, "Lord, when did we see you were hungry and feed you; or thirsty and give you drink? When did we see you were a stranger and make you welcome; or find you naked and clothe

you; when were you sick or in prison and we went to see you?" The King will answer, "I tell you for sure, whenever you did this to the lowliest of these my brothers, then you did it to me."

'Next the King will say to those on his left hand, 'Go away from me to be with the devil and his own helpers. For I was hungry and you never gave me food; I was thirsty and you never gave me anything to drink; I was a stranger and you never made me welcome, I was naked and you never clothed me, I was sick and in prison and you never visited me."

'Then it will be their turn to ask, "Lord, when did we see you hungry or thirsty, a stranger or naked, sick or in prison, and did not come to your help?" Then the King will answer, "Whenever you failed to do this to one of the lowliest of these my brothers, you failed to do it to me." And they will go away to eternal punishment, and the good people to eternal life.'

JESUS IS ANOINTED AT BETHANY

There were still two days before the Passover and the feast of Unleavened Bread, and the chief priests and the Law-teachers were trying hard to think of a way to arrest Jesus. They were hoping to trick him into betraying himself and then they planned to put him to death. They agreed on one point: 'It must not be during the festivities' they said 'or there will be a riot among the people.'

Now Jesus was at Bethany in the house of his friend Simon the leper. They were all at dinner when a woman came to them with an alabaster jar of very expensive ointment. It was called nard. The woman broke the jar and poured the ointment on the head of Jesus. Immediately some who were present said to one another indignantly, 'Why does she waste the ointment? Nard such as this could have been sold for more than three hundred denarii and the money could then be given to the poor.' Everyone became angry with her.

But Jesus said to them, 'Leave her alone. Why are you upsetting her? What she has done for me is one of the good works, an act of kindness. Look about you and see that you have the poor with you always, and you can be kind to them whenever you wish; but you will not always have me. This woman has done what honour it was in her power to do. She has anointed my body beforehand for its burial. I tell you in earnest, wherever throughout all the world the Good News is proclaimed, this act of kindness that she has done will be told also, in remembrance of her.'

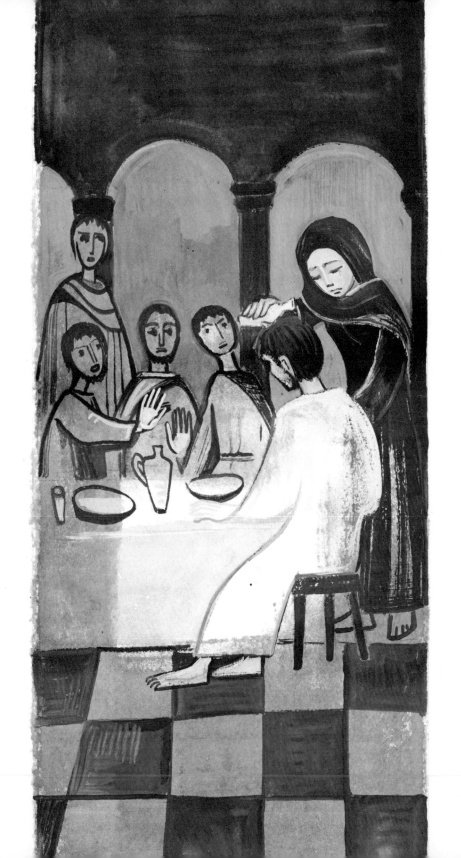

JUDAS OFFERS TO BETRAY JESUS

Judas Iscariot, one of the twelve apostles, went to make contact with the chief priests. He offered to betray Jesus to them. They were delighted to hear this, and promised to give him money. Then Judas began to think out the best way of betraying Jesus when a convenient opportunity should occur.

THE LAST SUPPER

On the first day of Unleavened Bread, when the Passover lamb was sacrificed, the disciples said to Jesus, 'Where shall we make ready to eat the Passover?' Then Jesus called two of his disciples and said to them, 'Go into the city. There you will meet a man carrying a pitcher of water. Follow him, and say to the owner of the house which the man enters, "The Master says: Where is my dining room in which I can eat the Passover with my disciples?" The man will show you a large upper room furnished with couches for the feast. Make everything ready for us there.' The disciples went to the city and found everything as their Master had told them, and they prepared the Passover.

When evening came Jesus arrived with the Twelve. Whilst they were eating, he said, 'I tell you solemnly, one of you is about to betray me, one of you who is even now eating with me.' They were upset and asked him, one after another, 'Not I surely?' He said, 'It is one of the Twelve, one who is dipping into the same dish with me. Truly I tell you, the Son of Man is going to his fate, exactly as the scriptures

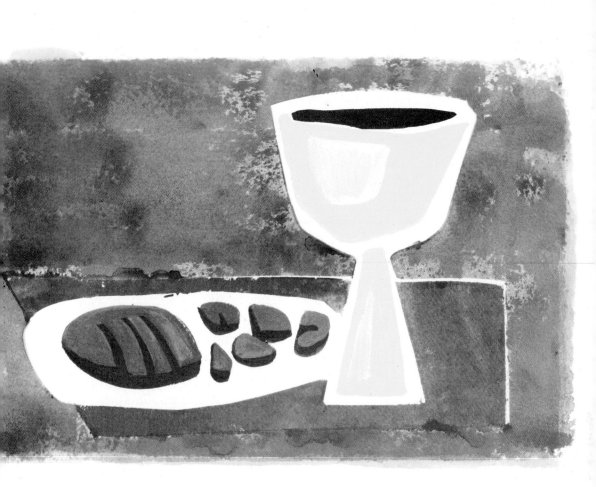

say he will, but alas for that man who is betraying the Son of Man. Better for him that he had never been born!'

And as they were eating, Jesus took some bread, and when he had said the blessing he broke it and gave it to them. 'Take it,' he said 'this is my body.' Then he took a cup, and when he had given thanks he handed it to them, and they all drank from it. Then he said to them, 'This is my blood, the blood of the covenant, which is to be poured out for many. I tell you solemnly, I shall not drink any more wine until the day I drink the new wine in the kingdom of God.' After psalms had been sung they left for the Mount of Olives.

JESUS IN GETHSEMANE

When Jesus and his disciples had finished their meal in the upper room of a house in Jerusalem, they sang some psalms together and then they left to go up onto the Mount of Olives. On the way there, Jesus said to them, 'You will all lose your faith in me, for the scripture says: "I shall strike the shepherd and the sheep will be scattered." However, after I have risen from the dead, I shall go ahead of you to Galilee.' Then Peter said, 'Even if everyone else loses faith, I will not.' And Jesus said, turning to him, 'I tell you in earnest, this day, this very night in fact, before the cock crows twice, you will have said three times that you do not know me.' But Peter repeated still more firmly, 'If I have to die with you, I will never say I do not know you.' And the others all said the same.

As they walked along they came to a small plot of land called Gethsemane, and Jesus said to his disciples, 'Stay here while I go and pray.' Then he took Peter and James and John with him. Suddenly fear came over him and he was in great distress. And he said to his friends, 'I feel so full of sadness that I could die. Wait here, and keep awake.' Then he went on a little further and he threw himself on the ground and prayed that, if it were possible, he might not have to go through the time that lay ahead. 'Father!' he cried 'Everything is possible for you. Let me escape this bitter fate. But let it be only if you will it, not if it is just my wish.'

Then he came back and found the three men sleeping. He said to Peter, 'Simon, are you asleep? Had you not the strength to keep awake one hour? You should be awake, and praying not to be put to the test. The spirit is willing, but the body is weak.' There was no reply. Again he went

away and prayed, saying the same words.

Once more he came back and found them sleeping, for their eyes were very heavy; again they were too sleepy to be able to answer him. He came back a third time and said to them, 'You can sleep on now and take your rest. It is all over. The time has come. Now the Son of Man is to be betrayed into the hands of bad men. Get up! Let us go! The man who will betray me is already close at hand.'

JESUS IS ARRESTED

Jesus was talking with his disciples in Gethsemane at night after he had been praying there. Before he had finished speaking, Judas, one of the twelve, came towards him with a number of men armed with swords and clubs. They had been sent by the chief priests and Law-teachers and the elders of the Sanhedrin council.

Judas the traitor had arranged a signal with them. 'The man whom I kiss,' he had said 'he is the man you want. Arrest him, and see he is well guarded when you lead him away.' So when Judas found the group of friends in the garden, he went straight up to Jesus and said, 'Rabbi!' and kissed him. The soldiers seized Jesus and took him into their charge. Then one of those who stood nearby drew his sword and struck out at the high priest's servant who was leading Jesus away, and cut off the man's ear.

Then Jesus spoke. 'Am I a brigand' he said 'that you had to set out to capture me with swords and clubs? When I was among you teaching in the Temple, day after day, you never tried to lay hands on me. But this deed that you are

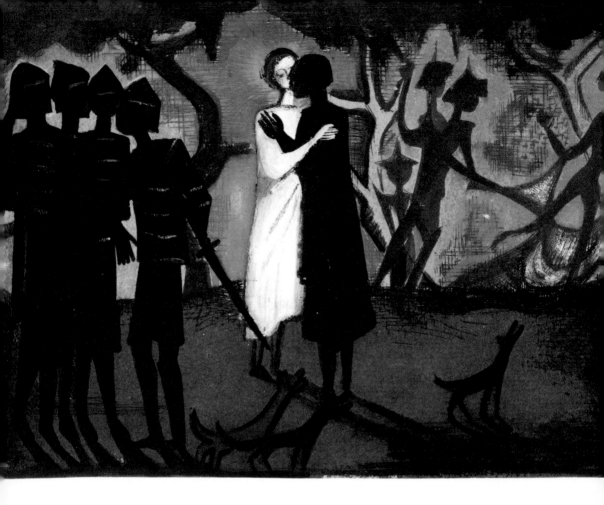

doing now is to fulfil the scriptures.' Then all his friends deserted him and ran away.

A certain young man followed behind Jesus and the soldiers, watching what would happen. The youth had nothing on but a linen cloth, and when the soldiers seized hold of him, he pulled himself free but left the cloth in their hands and ran away naked.

JESUS ON TRIAL BEFORE THE SANHEDRIN

From Gethsemane the soldiers led Jesus off to the high priest. All the chief priests and the elders and the Law-teachers had assembled in council. Peter had followed behind him at a distance hoping to see what would happen. He went right into the high priest's palace, and sat with the attendants, warming himself at the fire.

The chief priests and the whole Sanhedrin wanted to get evidence against Jesus so that they might find fault with him and then pass the death-sentence upon him. But they could not find anything wrong. Several people, indeed, even lied about what he had said or done but always their stories conflicted and were proved untrue.

Some stood up and gave false evidence thus: 'We heard him say, "I am going to destroy this Temple made by human hands, and in three days build another, not made by human hands."' But even on this point their stories did not agree. In spite of this the high priest stood up before the whole assembly and asked Jesus, 'Have you no answer to that? What is this evidence these men are trying to bring against you?' But Jesus was silent and would make no answer at all.

Then the high priest put a second question to Jesus, 'Are you the Christ,' he said 'the Son of the Blessed One?' 'I am,' said Jesus 'and you will see the Son of Man seated at the right hand of the Power and coming with the clouds of heaven.'

The high priest was so shocked and angry at this answer that he tore his robes to show his disapproval. 'What need of witnesses have we now?' he said 'You heard the blasphemy of this man. What is your finding?' And all the council shouted out that Jesus deserved to die.

Some of the crowd started spitting at Jesus. Then they blindfolded him and began hitting him with their fists and shouting, 'Play the prophet if you can!' And the attendants beat him up savagely.

PETER DENIES HE KNOWS JESUS

When Jesus was on trial before the Sanhedrin council in the middle of the night at the chief priest's palace, Peter was waiting down below in the courtyard all the time. It was cold and the servants and guards had lit a charcoal fire and and were standing there warming themselves. After a while one of the high priest's servant-girls came along, and when she saw Peter standing there warming himself with the others she stared at him and said, 'You too were with Jesus, the man from Nazareth.' Peter denied it saying, 'I don't know him, I don't understand what you're talking about' and he went out into the forecourt. But the servant-girl saw him go and started telling the onlookers round the fire, 'This fellow is one of the followers of Jesus.' But again Peter denied it. After some discussion the onlookers themselves said to Peter, 'You are one of them for sure! Why, you're a Galilean.' But he started calling down curses on himself and swearing, 'I do not know the man you are speaking about.' At that moment the cock crew for the second time, and Peter remembered how Jesus had said to him, 'Before the cock crows twice, you will have said three times that you do not know me.' Then Peter left and went outside and wept bitterly for shame and disgust at himself.

PILATE QUESTIONS JESUS

The chief priests together with the elders and the Law-teachers, in fact the whole Sanhedrin council, had held their trial of Jesus during the night. First thing in the morning they were ready with their plan for dealing with him.

They had him bound and took him away and handed him over to Pilate, the Roman governor.

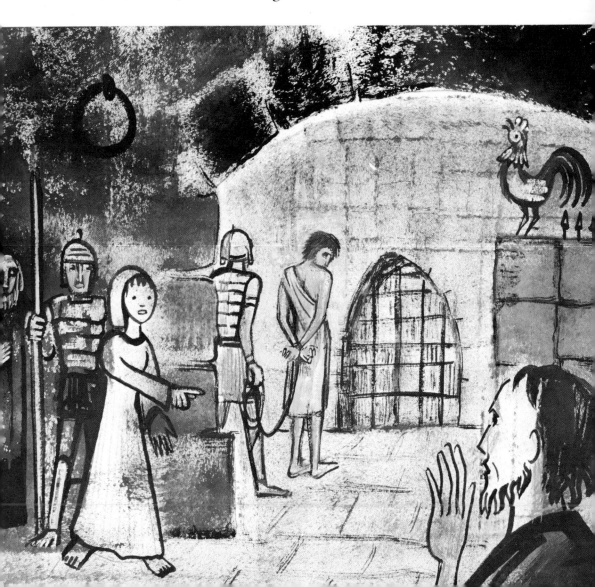

When Jesus was brought before him, Pilate questioned him, 'Are you the king of the Jews?' 'It is you who say it' Jesus answered. Immediately the chief priests began to bring many accusations against him. Pilate questioned Jesus again, 'Have you no reply at all to these statements? See how many accusations they are bringing against you!' But, to Pilate's amazement, Jesus made no further reply.

At festival times it was a custom for Pilate to release one prisoner for the people; the crowd could name anyone they wished. Now at this time there was a man called Barabbas in prison. He had been arrested with the rioters who had committed murder during a recent uprising. When the crowd gathered and began to ask of Pilate the usual favour, Pilate answered them, 'Do you want me to free the king of the Jews for you?' He said this because he realised it was only out of jealousy that the chief priests had handed Jesus over to him for judgement. The chief priests, however, had worked on the crowd and persuaded them to demand that Pilate should release Barabbas for them and not Jesus. So when the crowd shouted for the release of Barabbas, Pilate spoke to them and said, 'But in that case, what am I to do with the man you call king of the Jews?' 'Crucify him! Crucify him!' shrieked the crowd. 'Why?' Pilate asked them 'What harm has he done?' But they shouted all the louder, 'Crucify him!' Pilate was very worried by the violent attitude of the crowd and he was anxious to do something to put them in a better mood, so he released Barabbas for them. Then he ordered that Jesus was to be beaten with whips, and handed him over to the soldiers to be crucified.

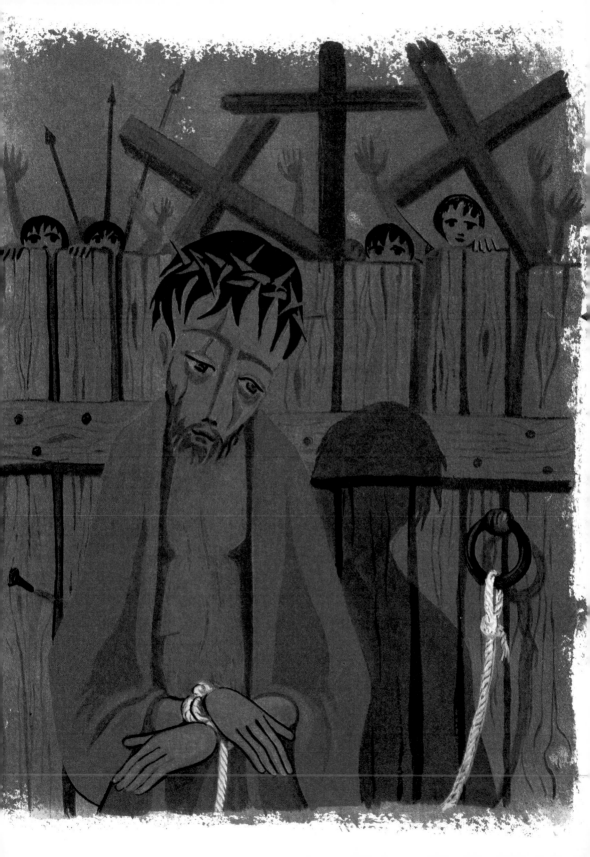

THE SOLDIERS MAKE FUN OF JESUS

After Pilate had condemned Jesus to death, the soldiers led
him away to the inner part of the palace, the part which was
called the Praetorium. There, the whole troop of soldiers
was called together. They dressed Jesus in purple clothing
as if he were an emperor; and they twisted some long thorn
stems into a rough crown and pressed it on his head. Then
they began saluting him and calling out, 'Hail, king of the
Jews!' They struck him on the head with a rod and spat on
him and went down on their knees in front of him as if he
were a king. And when they had finished making fun of
him, they took off the purple robe and dressed him in his
own clothes. They then brought two heavy wooden beams
which had been fastened together to make a cross onto which
he was to be nailed. They loaded this cross onto his shoulders
and led him away through the streets of Jerusalem to the
place of execution.

JESUS IS EXECUTED AS A CRIMINAL

As Jesus was carrying the wooden cross through the streets
of Jerusalem, the soldiers seized a passer-by and made him
carry the cross instead, because they thought Jesus was too
weak after all the beating he had received. This man was
coming into Jerusalem from the country and was named
Simon; he was from Cyrene.

Finally the soldiers arrived with Jesus at the place called
Golgotha, which means 'place-of-the-skull'. Large numbers
of people followed him and there were women among them

too, who mourned and lamented for him. At Golgotha someone offered him wine mixed with myrrh as a drug to deaden the pain, but Jesus refused it. Then the soldiers fixed him to the cross with nails. It was quite early in the morning. The soldiers shared out his clothing amongst themselves by throwing dice to decide what each man should get. A notice fixed to the top of the cross gave a description of the charge against Jesus. It read: 'This is the king of the Jews'. At the same time two robbers were crucified with him; one was placed on his right side and one on his left.

The people passing by jeered at him; they shook their heads and called to him: 'Aha! So you would destroy the Temple and rebuild it in three days! Well then, save yourself! Come down from the cross!' The chief priests and the Law-teachers laughed at him among themselves in the same way. 'He saved others,' they said to each other 'but he cannot save himself. Let the Christ, the king of Israel, come down from the cross now for us to see it, and then we will believe what he teaches.' Even the two thieves who were crucified with him taunted him in the same way.

THE DEATH OF JESUS

Jesus had been hanging nailed to his cross in the sun since quite early in the morning. At midday darkness came over the whole land and it lasted until the middle of the afternoon. And in the middle of the afternoon Jesus cried out in a loud voice, 'My God, my God, why have you deserted me?' When some of those who stood nearby heard this, they said, 'Listen, he is calling on the prophet Elijah.' Someone ran and

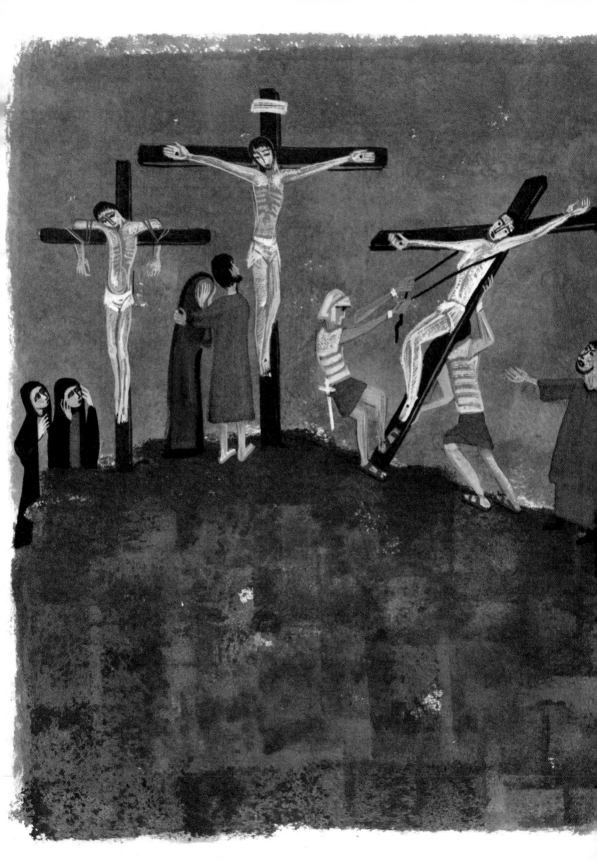

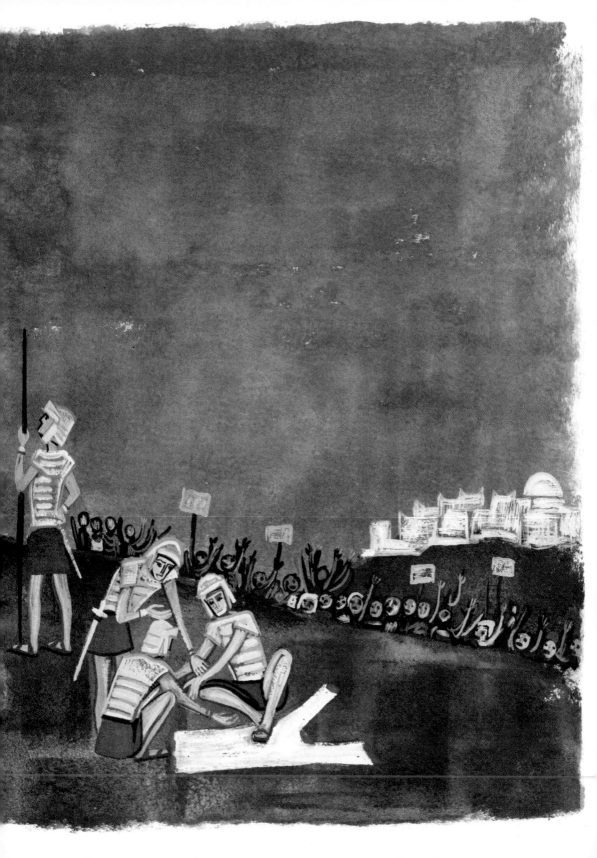

soaked a sponge in vinegar and put it on a stick and raised it to him to drink, saying, 'Wait and see if Elijah will come to take him down.' But Jesus gave a loud cry and breathed his last. At that moment the veil over the holiest place in the Temple was torn in two from top to bottom. The centurion who was standing in front of the cross had seen how Jesus had died, and he said, 'In truth this man was a son of God.'

There were a number of women who watched all this from a distance. Among them were Mary of Magdala, Mary who was the mother of James the younger and Joset, and Salome. These all used to follow Jesus in his travels and look after him when he was in Galilee. And there were many other women there who had come up to Jerusalem with him.

THE BURIAL OF JESUS

There was a man called Joseph who lived at Arimathea about twenty miles north of Jerusalem. He was a rich man and an important member of the Sanhedrin council. But he was also one of Jesus' followers, who himself lived in the hope of seeing the kingdom of God, and he was in Jerusalem on the Friday when Jesus was crucified.

Now Jesus had died in the middle of that afternoon and Joseph realised that unless something was done that same day, Jesus' body would be left hanging on his cross all the next day, Saturday, because it was sabbath and no one would be allowed to do any work like taking the body down until the third day, Sunday. So Joseph boldly went to Pilate the Roman governor and asked that the body of Jesus should be taken down and given to him. Pilate was astonished that

Jesus should have died so soon, because most people died much more slowly. So he sent for the centurion on duty at the cross and asked if Jesus really was dead. The centurion said that he was, so Pilate agreed to Joseph's request.

Joseph then went and bought a large sheet of cloth. He took the body of Jesus down from the cross, carried it away and wrapped it in the sheet. Then he laid it in a tomb which had been hewn out of the rock, and rolled a large stone against the entrance to close it. Mary of Magdala and Mary the mother of Joset watched all this and carefully noticed where Jesus was laid.

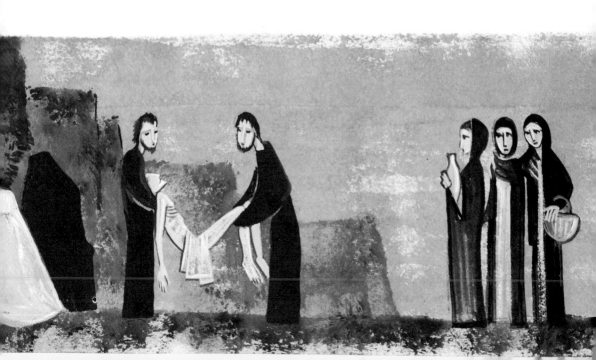

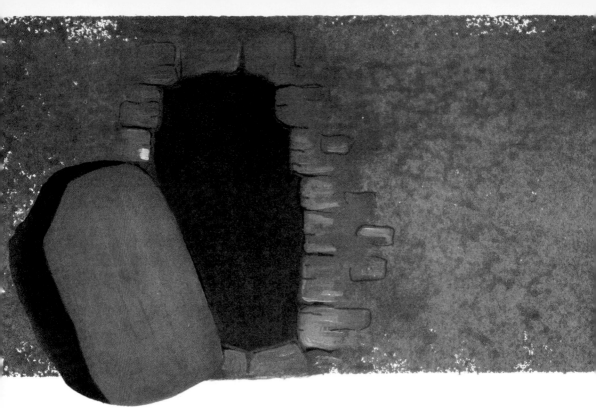

THE EMPTY TOMB

On the night of the Friday when Jesus died, Joseph of Arimathea had buried Jesus in his own tomb. The next day, the second, was Saturday, the day of the Jewish sabbath which lasted until early evening. While it was still sabbath, no one was supposed to do any kind of work at all. In the evening, when sabbath had ended, Mary of Magdala, Mary the mother of James, and Salome went and bought spices to put on the body of Jesus as a sign of respect. On Sunday, the third day, very early in the morning so as not to be seen by anyone, they went together to the tomb, just as the sun was rising.

On the way there, they were saying to one another, 'Who will roll away the stone for us from the entrance to the tomb?' But when they reached the tomb they could see that the stone—which was very big—had already been rolled

back. They entered the tomb and there they saw a young man in white clothes seated on the right-hand side. They were completely amazed at this and rather frightened. But he said to them, 'There is no need for alarm. You are looking for Jesus of Nazareth, who was crucified: well, he has risen, he is not here. Look, here is the place where they laid his body. Now you must go and tell his disciples and Peter that he is going ahead of you to Galilee; it is there you will see him, just as he promised you.'

The three women came out of the tomb and ran away because they were completely terrified. They hurried to tell the news to the other disciples, but their story seemed pure nonsense and the others did not believe them. However, Peter and John set out to go back to the tomb. John ran

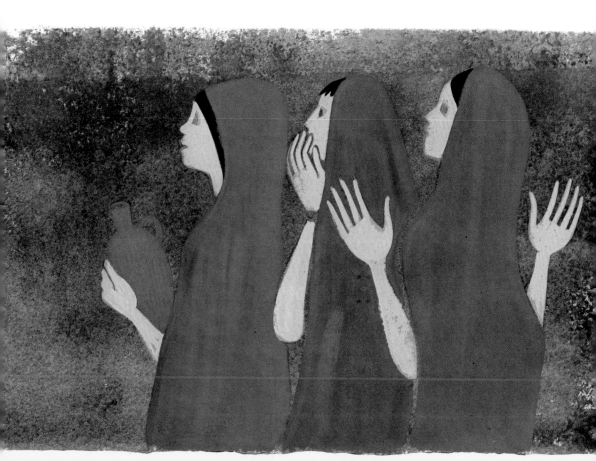

faster than Peter and reached the tomb first. He bent down and saw the linen cloths in which Jesus' body had been wrapped, lying on the ground. Then Peter came up and went right into the tomb and John followed him. Till this moment they had failed to understand the teaching of the scriptures that Jesus would rise from the dead, but now they saw and they believed. Then the two disciples went home again.

ON THE ROAD TO EMMAUS

On the very same day that Peter and John visited the tomb of Jesus and found it empty, Cleopas and a friend, both of them followers of Jesus, were on their way to a village called Emmaus, seven miles from Jerusalem. The two friends were talking together about all that had happened. As they talked it over, Jesus himself came up and walked by their side, but somehow they did not recognise him. He said to them, 'What are you discussing as you walk along?' At this question they stopped quite suddenly and their faces showed how sad they were.

Then Cleopas said, 'You must be the only person staying in Jerusalem who does not know the things that have been happening there these last few days.' 'What things?' Jesus asked. 'All about Jesus of Nazareth' they answered 'who proved he was a great prophet by the things he said and the miracles he did in the sight of God and of the whole people. Have you not heard how our chief priests and our leaders handed Jesus over to the Romans to be sentenced to death, and then had him crucified? Our own hope had been that he

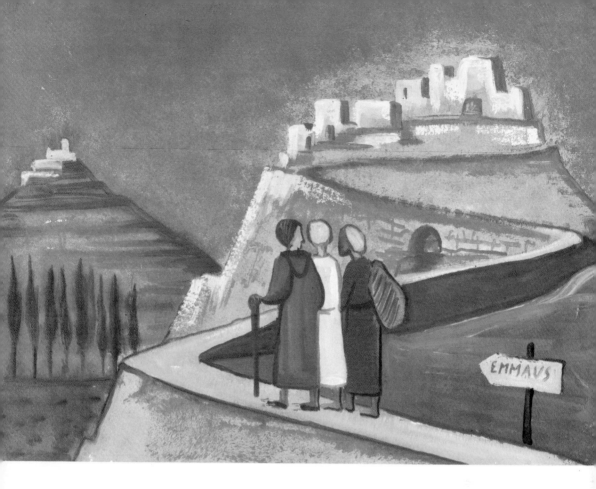

would be the one to set Israel free. And this is not all: two whole days have gone by since it all happened; and some women from our group have amazed us with the story that they went to the tomb in the early morning and found the body was not there, but instead they saw a vision of God's messengers who declared that even now Jesus was alive. Some of our friends went to the tomb and found everything exactly as the women had reported; but they saw no trace at all of Jesus.'

Then Jesus said to the two friends, 'You foolish men! You are so slow to believe the full message of the prophets! Was it not planned that the Christ should suffer and so enter into his glory?' Then, starting with the history of Moses and going through each one of the prophets, Jesus explained to

them the many places in the scriptures that all had some meaning about himself.

When they drew near to the village to which they were going, he pretended that he was travelling on; but the friends pressed him to stay with them. 'It is nearly evening' they said 'and the day is almost over.' So he went in to stay with them. Now while he was with them at table, he took the bread and said the blessing; then he broke it and handed it to them. At this their eyes were opened and they recognised that he was Jesus; and in that moment he vanished from their sight. They turned to each other and said 'Did not our hearts glow within us as he talked to us on the road and explained the scriptures to us?'

So at that very instant they set out and returned to Jerusalem. There they found the eleven disciples assembled together with their companions. The disciples said to them, 'Yes, it is true. The Lord has risen and has appeared to Simon.' Then Cleopas and his friend told their own story of what had happened on the road and how they had recognised Jesus at the breaking of bread.

MARY OF MAGDALA AT THE TOMB

Early on the Sunday morning following the Friday when Jesus had been crucified, Mary of Magdala and two other women had gone to the tomb where Jesus had been buried and they found it empty. Peter and John had come later to see for themselves. When all the others had gone home, Mary stayed outside in the garden near the tomb, weeping. Then, still in tears, she stooped to look inside the tomb.

There, sitting where the body of Jesus had been, one at the head, the other at the feet, she saw two of God's messengers clothed in white. They said to her: 'Woman, why are you weeping?' 'Someone has taken my Lord away' Mary replied 'and I don't know where they have put him.' As she spoke, she turned round and Jesus was standing there, but she did not recognise him. Then Jesus said to her, 'Woman, why are you weeping? Who are you looking for?' Thinking that probably he was a gardener, Mary said, 'Sir, if you have taken him away, tell me where you have put him, and I will go and remove him.' Then Jesus said, 'Mary!' Immediately she recognised him and spoke to him in Hebrew, 'Rabbuni!'— which means Master. Jesus said to her, 'Do not cling to me, because I have not yet gone away to the Father. But go and find our friends and tell them these words: I am leaving to go to my Father and to your Father, to my God and to your God.' So Mary of Magdala went and told the disciples that she had seen the Lord, and that he had said these things to her.

JESUS IS TAKEN TO HEAVEN

Luke the apostle had written an account of Jesus' life for a man named Theophilus, and he then wrote to the same man to tell him about what happened to the followers of Jesus later on. This is how he began his second account: I wrote you an earlier account telling you everything Jesus had done and taught from the beginning until the day he gave his instructions to the apostles whom he had chosen through the Holy Spirit. After he was crucified he had shown himself alive to the apostles many times, and for forty days he had continued

to appear to them and to tell them about the kingdom of God. When he had sat at table with them while they ate, he had told them not to leave Jerusalem, but to wait there for what God the Father had promised. And he had said, 'It will be what you have heard me speak about. Do you remember that John baptised with water? Well, not many days from now, you will be baptised with the Holy Spirit.'

Now, to continue my story, one day when all the apostles were gathered together with Jesus on the Mount of Olives, they asked him, 'Lord, has the promised time come at last? Are you going to set up Israel again as God's kingdom?' He replied, 'It is not for you to know the times or the dates. The Father has decided these things by his own authority, but you will receive power when the Holy Spirit comes to you. And then you will be my witnesses not only in Jerusalem but throughout Judaea and Samaria, and indeed even to the ends of the earth.'

As Jesus was saying this to the apostles, he rose in the air as they watched. Then a kind of cloud formed round him and hid him from their sight and he disappeared. They were still staring up into the sky when suddenly two men in white were standing near them and said to them, 'Why are you men from Galilee standing here gazing into the sky? Jesus who has been taken from you to heaven, this very same Jesus will come back in the same way as you have seen him go there.' The names of the apostles who witnessed this were Peter and John, James and Andrew, Philip and Thomas, Bartholomew and Matthew, James son of Alphaeus, Simon the Zealot, and Jude son of James. They all walked back to Jerusalem and when they reached the city they went to the upstairs room where they were staying. There they spent a long time in prayer, and several women were also praying with them, including Mary the mother of Jesus.

THE COMING OF THE HOLY SPIRIT

Fifty days after the Passover festival and seven weeks after Jesus had been crucified, the Jewish harvest festival came round when the first-fruits of crops and the first-born of animals were offered to God. On this festival day, all the original apostles except Judas met in a room. Suddenly they heard what sounded like a powerful wind coming from above them, and the noise of it filled the entire house in which they were sitting. Then there appeared before them all something that seemed like a burning fire with tongues of flame coming from it. The tongues of flame separated and came to rest one on the head of each of them. At this they were all filled with the Holy Spirit, and quite suddenly they all began to speak in different foreign languages, whichever ones the Spirit made them able to speak.

Now there were good and holy men living in Jerusalem from every nation under heaven, and when they heard what was happening, they all came and crowded round the apostles, and each one was amazed to hear these men speaking his own language. They were bewildered and astonished. 'Surely' they said 'all these men speaking are Galileans? How does it happen that each of us hears them speaking in our own native languages? Parthians, Medes, Elamites; people from Mesopotamia, Judaea and Cappadocia, Pontus and Asia, Phrygia, Pamphylia, Egypt and parts of Libya round Cyrene; as well as visitors from Rome—Jews both by birth and by choice—Cretans and Arabs. We hear them preaching in our own languages about the marvels of God.' Everyone was amazed and no one was able to explain it; they asked one another what it all meant. Some, however, tried to laugh it off and said, 'These men have been drinking too much new wine!'

Then Peter stood up with the Eleven and addressed the crowd in a loud voice:

'Men of Judaea' he said 'and all you who live in Jerusalem, make no mistake about this, but listen carefully to what I am saying. These men are not drunk, as you imagine; why, it is only nine o'clock in the morning! On the contrary, this is what the prophet Joel spoke of when he said: "In the days to come—it is the Lord who speaks—I will pour out my spirit on all mankind. Sons and daughters shall prophesy, your young men shall see visions, your old men shall dream dreams. In those days, I will pour out my spirit even on those men and women who are still slaves!" '

'Men of Israel,' said Peter 'listen to me. Jesus of Nazareth came to you with God's approval, as was shown by the miracles and signs God worked through him when he was among you. You took this man and had him crucified by the Roman unbelievers. You killed him. But God raised this man Jesus to life, and all of us here are witnesses to that. Now that Jesus is with God, he has received the Holy Spirit from the Father. What you now see and hear is the outpouring of that Spirit as Jesus promised. For this reason the whole House of Israel can now be certain that God has made this Jesus both Lord and Christ.'

All those who heard these words felt a burning shame in their hearts. They turned to Peter and the apostles and asked, 'What must we do, brothers, to make up for the wrongs of the past?' Peter answered, 'You must be sorry for what happened, and every one of you must be baptised in the name of Jesus Christ for the forgiveness of your sins. When that has been done, you will receive the gift of the Holy Spirit.'

Peter's arguments made them feel sure in their minds, and they accepted what he said and were baptised. That same

day about three thousand were added to the followers of Jesus, and all these remained faithful to the teaching of the apostles, to the breaking of bread and the prayers, and to the other followers of Jesus.

PETER HEALS A LAME MAN

One day when Peter and John were going up to the Temple for mid-afternoon prayers, it happened that there was a man being carried past. He was a cripple from birth; and his friends used to put him down every day near the Temple entrance called the Beautiful Gate, so that he could beg from the people going inside. When this man saw Peter and John on their way into the Temple he begged from them. Both Peter and John looked straight at him and said, 'Look at us.' He turned to them expectantly, hoping to get some money from them, but Peter said, 'I have neither silver nor gold, but I will give you what I do have: in the name of Jesus Christ the Nazarene, get up and walk!' Peter then took him by the hand and helped him to stand up. Instantly the man's feet and ankles became firm, he jumped up, stood, and began to walk. Then he went with Peter and John into the Temple, walking and jumping and praising God. Everyone could see him walking and praising God, and they recognised him at once as the crippled man who used to sit begging at the Beautiful Gate of the Temple.

All the people were astonished and unable to explain what had happened to him, and in great excitement everyone came running to Peter and John at the Portico of Solomon, as it is called, where the man was still clinging to them.

When Peter saw the people gathering he spoke to them, 'Why are you so surprised at this? Why are you staring at us as though we had made this man walk by our own power or holiness? Do you remember that you killed Jesus, the prince of life? God, however, raised him from the dead, and to that fact we here are the witnesses; and it is the name of this same Jesus which, through our faith in it, has brought back the strength of this man whom you see here and who is so well known to you. It is faith in the name of Jesus that has restored this man to health, as you can all see.

'Now I know, brothers, that neither you nor your leaders had any idea what you were doing when you had Jesus crucified. But it was for you in the first place that God sent his servant Jesus to bless you by turning every one of you from your wicked ways.'

While they were still talking to the people the priests came up to them, accompanied by the captain of the Temple guard and the Sadducees. All these officials were extremely annoyed that the two disciples were proclaiming that Jesus had risen from the dead and teaching the people that they too could hope for this themselves. So the officials arrested Peter and John. But many of those who had listened to them believed in Jesus as a result of their teaching, and the total number of believers was now something like five thousand.

THE FIRST CHRISTIANS

The whole group of those who believed and held meetings with the apostles was united, heart and soul, with one another. Nobody tried to claim for his own use anything

that he possessed, because everything they had was treated as belonging to all of them and was brought for sharing wherever there was need.

The apostles continued to tell about how the Lord Jesus rose to life again after dying, and they spoke with great power. All the crowds treated them with great respect.

Not a single follower of Jesus was ever in need, because all those who owned land or houses would sell when it seemed necessary, and bring the money from the sale to present it to the apostles. Then the money was given out to any believers who might be needing help of any kind.

For example, there was a Levite whose family had come from Cyprus. He was called Joseph and the apostles renamed him Barnabas (which means 'he-who-can-give-encouragement'). He owned a piece of land and he sold it and brought the money and presented every penny of it to the apostles to be used for the rest of the followers.

There was another man, however, called Ananias. He and his wife, Sapphira, agreed to sell a piece of land; but he kept back part of the money and only gave the rest to the apostles. And his wife knew about this. Peter realised what was happening and said, 'Ananias, how can Satan have got such a hold on you that you tell a lie and keep back part of the money? It is not to men that you have lied, but to God.' When he heard this, Ananias fell down dead. About three hours later his wife came in, not knowing what had taken place. Peter challenged her, 'Tell me, was this the price you sold the land for?' 'Yes' she said. Then Peter said, 'So you and your husband agreed on this! What made you do it? You hear the footsteps of those men? They have just been to bury your husband; they will carry you out, too.' Instantly she dropped dead at his feet. All who heard of this were greatly shaken by it.

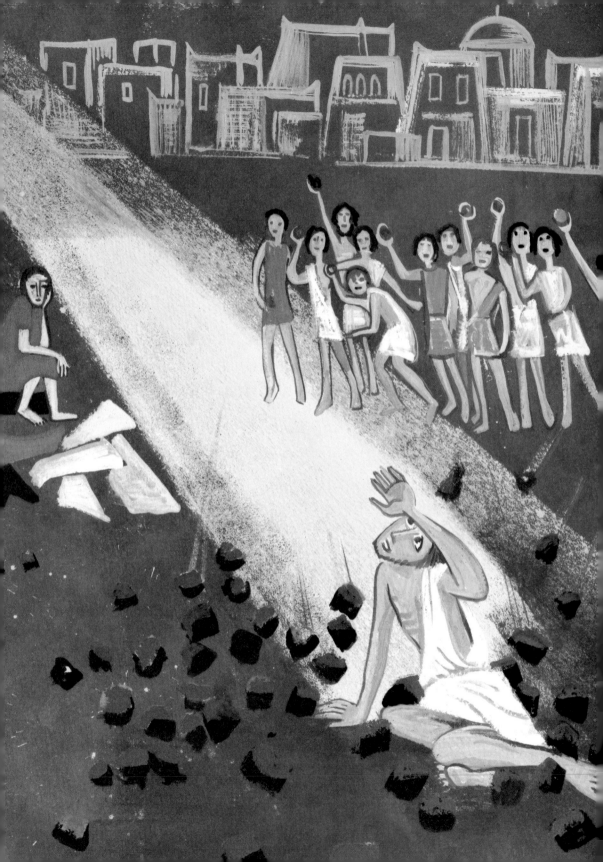

THE DEATH OF STEPHEN

The teachings of the Lord continued to spread and the number of disciples in Jerusalem increased greatly; so much so, in fact, that it was necessary to appoint seven men specially to help in handing out food to the poorer believers.

Stephen was one of these helpers. He was full of the Lord's power and began to work miracles. Certain people from far-away places then came to Stephen and argued with him. Because of his wisdom, and because he was guided by the Spirit in what he said, they found they could not get the better of him. So they persuaded some men to tell lies about him and say, 'We heard him use insulting language against Moses and against God.' By these lies Stephen's enemies turned the people and the elders and Law-teachers against him. Then they took Stephen by surprise, arrested him and brought him before the Sanhedrin council. There they falsely accused him, saying, 'This man is always making speeches against the Temple and the Law.'

The high priest asked, 'Is this true?' Stephen replied, 'You stubborn people, with your unbelieving hearts and ears. You are always going against the Holy Spirit, just as your ancestors used to do. Can you name a single prophet your forefathers did not persecute? They killed those who fore-told the coming of Jesus to bring justice, and now you too have betrayed and murdered him. You who had the Law brought to you by God's messengers, you are the very ones who have not kept it.' When they heard all that Stephen said, they ground their teeth with fury.

But Stephen, filled with the Holy Spirit, gazed upwards and saw the glory of God, and Jesus standing at God's right hand. 'I can see heaven thrown open' he said 'and the Son of Man standing at the right hand of God.' At this all the mem-

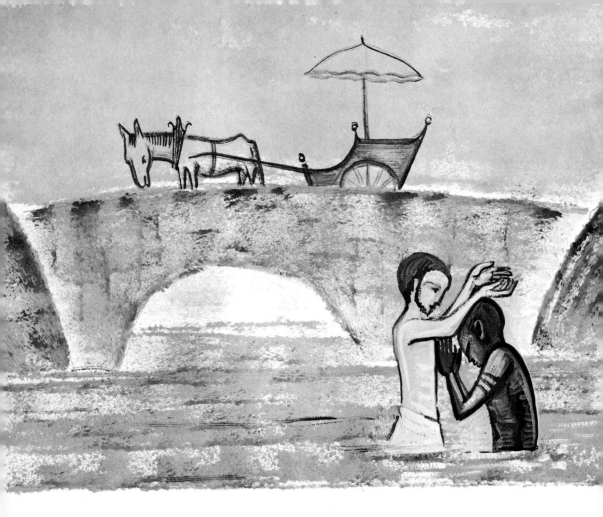

bers of the council gave a great shout and stopped their ears
with their hands. Then they rushed him out of the city to
stone him. The men who had accused him had by law to
throw the first stones and they put down their clothes at the
feet of a young man called Saul. As they were stoning him,
Stephen prayed aloud: 'Lord Jesus, receive my spirit.' Later
on, he knelt down and said aloud, 'Lord, do not hold this
sin against them.' With these words he died. As for Saul, he
felt sure that the killing of Stephen was a good thing.

THE TREASURER FROM ETHIOPIA

The messenger of the Lord spoke to Philip saying, 'Be ready to set out at noon along the road that goes from Jerusalem down to Gaza, the desert road.' So Philip set off on his journey. Now it happened that an Ethiopian had been to visit the holy places in Jerusalem; he was the chief treasurer of the queen of Ethiopia. On his way home, sitting in his chariot as it bumped along, he was reading aloud from the book of the prophet Isaiah. The Holy Spirit said to Philip, 'Go and meet that chariot.' When Philip ran up, he heard the Ethiopian reading and asked, 'Do you understand what you are reading?' 'How can I' he replied 'unless I have someone to explain it to me?' So he invited Philip to get in and sit by his side. Now the passage he was reading was this: 'Like a sheep that is led to the slaughter-house, like a lamb that is dumb in front of the man who shears it, like these he never opens his mouth. He has been humiliated and has no one to defend him. Who will ever talk about his descendants, since his life on earth has been cut short!'

The Ethiopian turned to Philip and said, 'Tell me, is the prophet referring to himself or someone else?' So Philip began to explain the Good News of Jesus to him, starting from this piece of Isaiah.

Further along the road they came to some water, and the Ethiopian said, 'Look, here is some water; is there anything to stop me being baptised?' He ordered the chariot to stop. Then they both went down into the water and Philip baptised him. After they had come up out of the water again, Philip disappeared. The treasurer never saw him again, but went on his way full of joy.

SAUL'S CHANGE OF HEART

On the same day as Stephen was stoned to death, a bitter campaign against all the Christians in Jerusalem was started, using every possible method. All of them except the apostles fled to the country districts of Judaea and Samaria.

Saul, who had stood and watched the killing of Stephen and had felt sure it was a good deed, now began to take action to stamp out the group of Christians in Jerusalem completely. He was continually threatening to kill the Lord's disciples, and he went from house to house arresting both men and women and sending them to prison. He applied to the high priest and obtained letters addressed to all the Jewish places of worship in Damascus. These letters gave him power to arrest any followers of the Christian way that he could find, men or women, and take them to Jerusalem.

While he was on his way to Damascus to carry out his plans, just before he reached the city a light from heaven suddenly shone all round him. Saul fell to the ground, and then he heard a voice saying, 'Saul, Saul, why are you attacking me?' 'Who are you, Lord?' he asked, and the voice answered, 'I am Jesus, and you are attacking me. Get up now and go into the city, and you will be told what you have to do.' The men travelling with Saul stood there speechless, for though they heard the voice they could see no one. Saul got up from the ground, but even with his eyes wide open he could see nothing at all, and they had to lead him by the hand into Damascus. For three days he was without his sight, and took neither food nor drink.

In Damascus a follower of Jesus called Ananias had a vision in which he heard the Lord say to him, 'Ananias!' When he replied, 'Here I am, Lord', the Lord said, 'You must go to Straight Street and ask at the house of Judas for

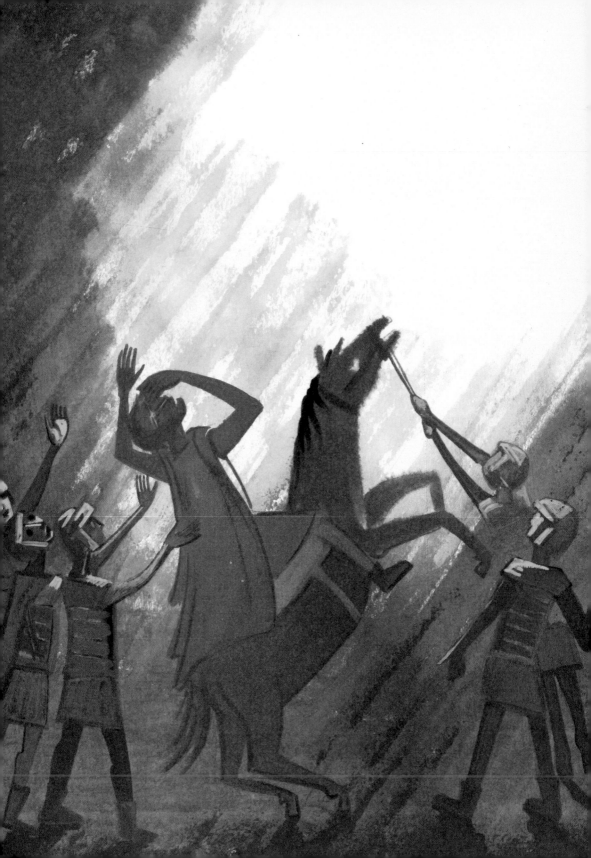

someone called Saul, who comes from Tarsus. At this moment he is praying, because he has had a vision of a man called Ananias coming in and laying hands on him to give him back his sight.'

When he heard that, Ananias said, 'Lord, several people have told me about this man and all the harm he has been doing to your followers in Jerusalem. He has only come here because he holds a warrant from the chief priests to arrest everybody who believes in you.' The Lord replied, 'All the same, you must go because I have specially chosen this man to bring news of me to the unbelievers and their kings and to the people of Israel itself. I myself will show him how much he must suffer for my sake.' Then Ananias went. He entered the house and at once laid his hands on Saul and said, 'Brother Saul, I have been sent by the Lord Jesus who appeared to you on your way here, so that you may recover your sight and be filled with the Holy Spirit.' Immediately Saul found he could see again; it was as though scales fell away from his eyes. So he was baptised then and there, and after taking some food he regained his strength.

After he had spent only a few days with the disciples in Damascus, he began to preach in the synagogues there, giving the message: 'Jesus is the Son of God.' From then on he became known to the Christians as Paul.

TAKING THE GOOD NEWS TO ALL NATIONS

AN ADVENTURE OF PAUL AND SILAS

Paul and Silas and I, Luke, were travelling on one of our journeys to tell people the Good News about Jesus. One night when we were in Troas, Paul had a vision: a Macedonian man appeared and appealed to him in these words, 'Come across to Macedonia and help us.' Once he had seen this vision we lost no time in arranging a passage by ship to Macedonia. We were sure that God had called us to bring the Good News to the people there.

Sailing from Troas we made a straight run for Samothrace, the next day for Neapolis, and from there we reached Philippi, a Roman colony and the principal city of that part of Macedonia. After a few days in this city we went along the river outside the gates as it was the sabbath and this was a usual place for prayer. We sat down and told the Good News to all the women who had gathered there. One of these women was called Lydia, a very good woman who was in the purple-dye trade. She listened to us, and the Lord opened her heart to accept what Paul was saying. After she and her household had been baptised she sent us an invitation: 'If you really think me a true believer in the Lord,' she said 'come and stay with us'; and she would not take no for an answer.

One day as we were going to prayer, we met a slave-girl who was a fortune-teller and made a lot of money for her masters. This girl started following Paul and the rest of us and shouting, 'Here are the servants of the Most High God; they have come to tell you how to be saved!' She did this every day afterwards until Paul lost his temper one day and turned round and said to the spirit which controlled her, 'I order you in the name of Jesus Christ to leave that woman.'

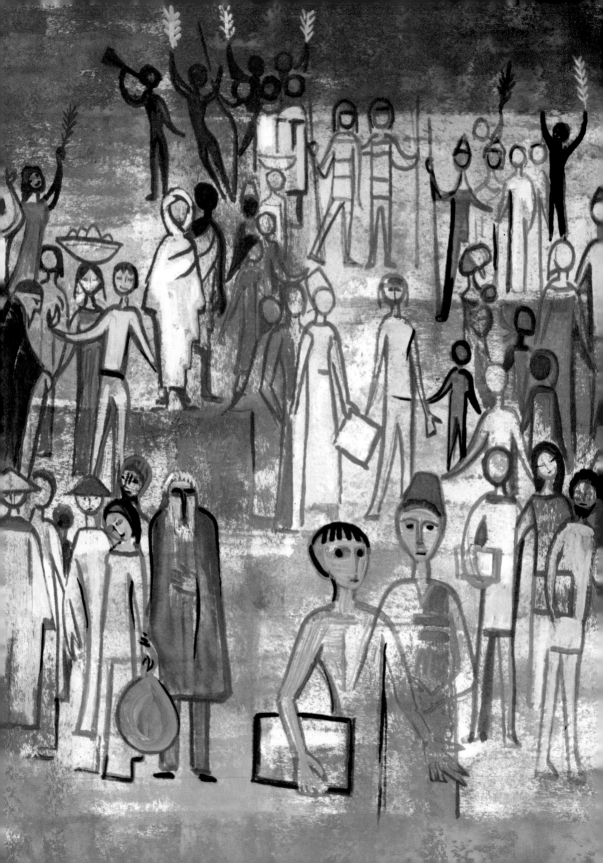

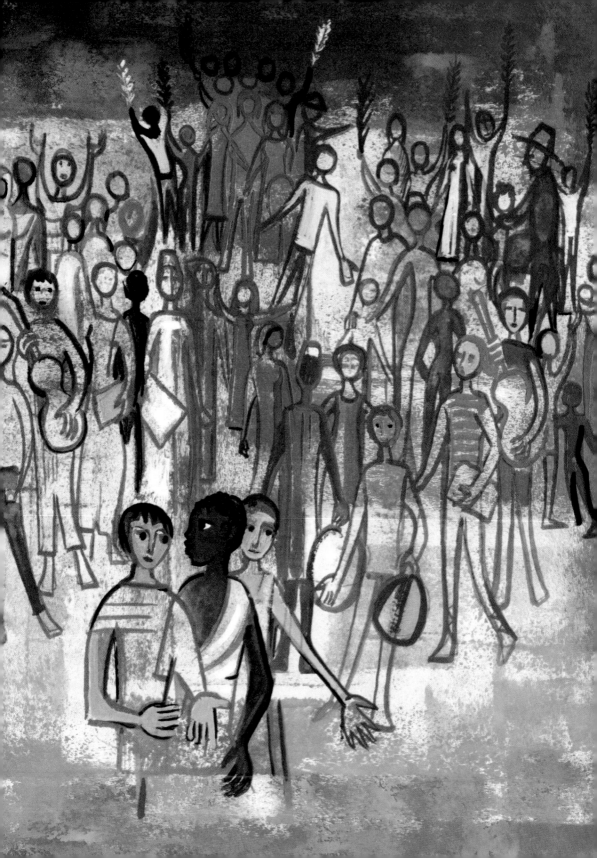

The spirit went out of her then and there.

When her masters saw that there was no hope of making any more money out of her, they seized Paul and Silas and dragged them to the law courts in the market place where they accused them before the magistrates and said, 'These people are causing a disturbance in our city. They are Jews and are teaching things which are against our Roman laws.' The crowd joined in and showed that it hated Paul and Silas, so the magistrates had their clothes stripped off and ordered them to be whipped. They were given many lashes and then thrown into prison. The jailer was told to keep a close watch on them, so he put them in the inner prison and fastened their feet in the stocks.

Late that night Paul and Silas were praying and singing God's praises, while the other prisoners listened. Suddenly there was an earthquake that shook the prison to its foundations. All the doors flew open and the chains fell from all the prisoners. When the jailer woke and saw the doors wide open, he thought that the prisoners must have escaped, so he drew his sword to kill himself. But Paul shouted at the top of his voice, 'Don't do yourself any harm; we are all here.'

The jailer called for lights, then rushed in, threw himself trembling at the feet of Paul and Silas, and escorted them out of the prison, saying, 'Sirs, what must I do to be saved?' They told him, 'Become a believer in the Lord Jesus, and you will be saved, and your household too.' Then they preached the words of Jesus to him and all his family. Late as it was, he took them to wash their wounds, and he was baptised then and there with all his household. Afterwards he took them home and gave them a meal, and the whole family had a party together in the middle of the night to mark the beginning of their belief in God. Then Paul and

Silas returned to the prison.

When it was daylight the magistrates sent officials with an order to release the two men. The jailer told Paul, 'The magistrates have sent an order for your release; you can go now and be on your way.' 'What!' Paul replied 'They whip Roman citizens in public and without trial, and throw us into prison; and then they think they can push us out on the quiet! Oh no! They must come and let us out themselves.'

The officials reported this to the magistrates who were horrified to hear that the two men were Roman citizens. So the magistrates themselves came and begged Paul and Silas to leave the town. From the prison the two men went to Lydia's house where they met all the local followers of Jesus and gave them encouragement. Then we all left and continued our long journey to bring the Good News to all the nations.